The Illustrated Guide to
Victorian Parian China

The Illustrated Guides to Pottery and Porcelain
General Editor
GEOFFREY A. GODDEN

Subjects include

LOWESTOFT PORCELAIN by Geoffrey A. Godden
WORCESTER PORCELAIN 1751–1793 by Henry Sandon
LIVERPOOL HERCULANEUM POTTERY by Alan Smith
ROCKINGHAM POTTERY AND PORCELAIN by Dennis G. Rice
MASON'S PATENT IRONSTONE CHINA by Geoffrey A. Godden
STAFFORDSHIRE SALT-GLAZED STONEWARE
by Arnold R. Mountford

others in preparation

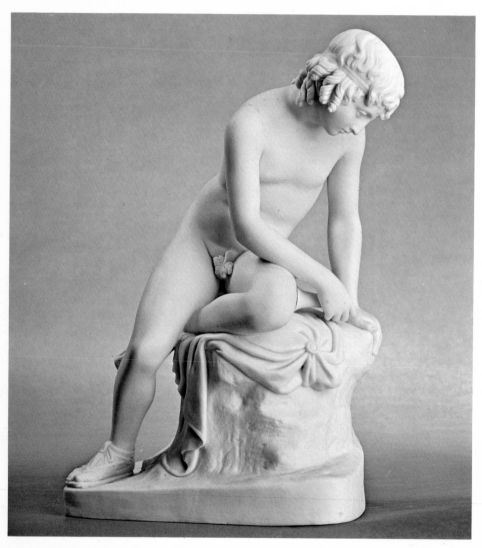

Frontispiece. John Gibson's "Narcissus" reproduced by Messrs. Copeland & Garrett in their Parian body in 1846, for the Art Union of London. See page 11. $12\frac{1}{4}$ inches high.

The Illustrated Guide to

VICTORIAN
PARIAN CHINA

Charles and Dorrie Shinn

BARRIE & JENKINS LTD
LONDON

© *1971 by Charles and Dorrie Shinn*
with additional material by Geoffrey A. Godden

First published 1971 by
Barrie & Jenkins Ltd
2 Clement's Inn, London W.C.1
Printed and bound in Great Britain by
Butler & Tanner Ltd
Frome and London
Colour printing by Colour Workshop Ltd
Hertford
Set in Monotype Imprint

ISBN 0.257.65121.7

This book is dedicated to
our two grand-daughters,
Virginia and Rebecca,
in the hope that they will
grow up to appreciate and
collect beautiful things

'Further, you learnt—you know you did—in the same visit, how the beautiful sculptures in the delicate new material called Parian, are all constructed in moulds; how, into that material, animal bones are ground up, because the phosphate of lime contained in the bones makes it translucent; how everything is moulded, before going into the fire, one-fourth larger than it is intended to come out of the fire, because it shrinks in that proportion in the intense heat; how, when a figure shrinks unequally, it is spoiled—emerging from the furnace a misshapen birth; a big head and a little body, or a little head and a big body, or a Quasimodo with long arms and short legs, or a Miss Biffin with neither legs nor arms worth mentioning.'

CHARLES DICKENS, *Household Words*, April 1852

[Written after Dickens had paid a visit to the works of Messrs. Copeland.]

Contents

List of Plates

All between pages 80 and 81

COLOUR PLATES

MONOCHROME PLATES

BISCUIT-CHINA

PARIAN WARE, *listed in alphabetical order of makers' names*

Preface

Around the middle of the nineteenth century an entirely new form of porcelain—which became known as Parian ware—made its appearance on the English ceramic market. It is now becoming much sought by collectors. The growing interest, particularly in relation to the figures produced in this medium, has been engendered not only by the fact that Parian was a special feature of the Victorian period and is appealing as such but also because the inherent beauty of the finer specimens is in direct opposition to the many mass-produced articles of the present day.

Following a somewhat precarious launching on the market, Parian porcelain finally captivated the taste of the more affluent families. Indeed, there came a time when no Victorian parlour was considered to be in the fashion unless it displayed at least one reproduction in Parian of a famous work of art. The fact that Parian did not attract a great deal of attention initially is somewhat puzzling when it is considered how much it differed from some of the inartistic work which was being manufactured during that period.

Parian figures had the added attraction of being produced by ceramic manufacturers of the high standard of Minton, Copeland and Wedgwood, as well as at the Coalport and Worcester factories. The Parian work produced by such firms reached a standard of excellence difficult to find in the twentieth century.

Another interesting feature relating to Parian ware, and one which appeals to collectors, is that it was an entirely British product. Furthermore, apart from a small amount made in America during the later stages of its popularity, its making was confined to the British Isles.

During the Victorian age, the beginning of the great industrial revolution brought with it a consequential change and upheaval in public taste. It made it possible to produce articles of artistic and utilitarian value in quantity instead of laboriously and singly and so brought within reach of the general public products which had previously been looked upon as the sole privilege of the richer classes.

A further feature of Parian which appeals to the collector is that very good

specimens can still be found and bought at prices which can be considered reasonable. It is true that good quality Parian is not to be found in every antique shop; but there is still a fair amount to be discovered by judicious hunting, and pieces can be bought at prices which range upwards from a few pounds.

Whatever price a collector may pay for good quality Parian, within reason, all the indications are that the value will rise steadily in the future. Certainly the discriminating buyer will gain much visual pleasure from the as yet inexpensive ceramic figures and groups, examples of which have a delightful nineteenth century charm—a charm that is nevertheless surprisingly timeless, for these typically Victorian ornaments appear quite at home in a modern setting.

The aim of this *Illustrated Guide* is not only to explain the historical facts of the introduction of the Parian china body but also to enable the collector and casual purchaser to gain added enjoyment from his Parian—enjoyment such as we have experienced over many years of collecting.

Acknowledgments

We appreciate the kindness and help we have received during the preparation of this book and would like to tender our thanks to Mr. K. R. Gilbert of the Science Museum, Kensington; Mr. R. J. Charleston, Keeper of Ceramics, the Victoria and Albert Museum; Mr. G. H. Tait, Assistant Keeper, Department of medieval and later antiquities, the British Museum; Mrs. R. A. James of H.M. Patent Office; Helena Gibbon, F.M.A., F.R.S.A., Art Director & Curator, the Harris Museum and Art Gallery, Preston; the Curator of the Birmingham Museum; Mr. H. Appleyard, Curator of the Lichfield Museum; the Committee of the Shipley Art Gallery, Gateshead, for permission to photograph exhibits in the Saltwell Park Museum. Thanks are also extended to Mr. J. E. Johnson of Messrs Minton Ltd., Stoke-on-Trent; Mr. Henry Sandon, Curator of the Museum, Worcester Royal Porcelain Co., Ltd., Worcester; Mr. William A. Billington, Museum Curator, Messrs. Josiah Wedgwood & Sons Ltd.; and the editor of this series, Mr. Geoffrey A. Godden—all of whom have helped us with information and allowed us to use photographs we could not otherwise have included. The source of each illustration is given in the caption.

Our thanks are also due to the many friends we have made in the antique shops we have visited, who have shown enthusiasm and given us much encouragement.

CHARLES AND DORRIE SHINN,
DURHAM CITY, 1970.

Chapter I

The Origin and Development of Parian

Parian[1] is a porcelainous body which is slightly translucent. In a diluted state, termed 'slip', it was ideal for casting in plaster of Paris moulds. It was normally employed in its natural creamy-white state, but it could be tinted and also glazed. Additionally, the matt surface was sometimes set off against decorated and glazed porcelain: thus, one might find porcelain centrepieces and the like with Parian-figure stems. Such expensive articles are shown in Colour Plate II and Plates 40, 48, 55 and 96.

Although the Parian body was introduced within five years of Queen Victoria's accession, and although all Parian objects have a decidedly Victorian charm, neither the body nor the idea of white unglazed china figures and groups was entirely new. It was, rather, an adaptation of earlier ceramics —a slight change to conform with new tastes and manufacturing processes.

In the second half of the eighteenth century, the Sèvres factory in France, in common with other Continental factories, produced well-modelled white unglazed porcelain 'biscuit' figures. In Great Britain, from the 1770s, the Derby porcelain factory produced a large range of delicately modelled and finely executed biscuit figures and groups. Even twenty years earlier, the Bow factory in London had issued some unglazed and uncoloured porcelain figures. By way of example, although this book is not concerned with eight-eenth-century ceramics, some typical Derby biscuit porcelain is shown in Plates 1, 2 and 3.

Derby figures were continued into the nineteenth century, and it is inter-esting to learn from the factory price lists that undecorated and unglazed Derby models were more expensive than the self-same models in a glazed and coloured state. This was because the white examples had to be perfect, without any kiln-staining or shrinkage-cracks—defects which could be hidden in the standard decorating processes.

The Derby factory was by no means the only English manufactory to

[1] The pronunciation of the word, Parian, is given in the dictionaries we have con-sulted as, phonetically, 'payrian' but the phonetic pronunciation of 'pairian' seems to have been more generally accepted and this does slip more easily from the tongue.

produce white unglazed, or biscuit figures. The well known Rockingham and Worcester factories made examples, now rare. The Swansea factory also produced Parian-like unglazed and undecorated porcelain in the 1813–17 period.

The transition from eighteenth century and early nineteenth century biscuit porcelain to Victorian Parian ware is well documented in the surviving records of the Minton factory at Stoke-on-Trent, in Staffordshire. These most interesting archives, which have been published by Geoffrey Godden in his *Minton Pottery and Porcelain of the First Period, 1793–1850* (Herbert Jenkins, London, 1968), include lists of the firm's figures, and also accounts and copies of letters sent from the factory. From the mid-1820s and through the 1830s, Minton's produced in their white porcelain body a range of over a hundred figures or groups, typical examples of which are shown in Plates 5, 6 and 7.

Many of the models first introduced in the 1830s were reissued in the new Parian body in the 1840s—so one can find Minton models in the cold-white biscuit china body and also in the warmer-looking creamy Parian china. And as late as 1847—that is, some five years after the introduction of Parian —some retailers were apparently still ordering the earlier biscuit-china figures; for in a letter dated 28th December 1847, Minton's replied to one order '. . . if the Ariadne would do in our Parian material instead of bisque china, we could send it immediately, please let me know. The Parian is much preferred for statuary.'

The discovery of Parian is shrouded in mystery. Claims to have been the original inventor were put forward by several different firms and, in one case, by an individual workman who was employed by one of these firms. It seems that Parian was discovered accidentally whilst experiments were being carried out to unravel the secret composition of the biscuit porcelain that had been produced at the Derby factory in the eighteenth century—for this body was much warmer looking than the nineteenth century biscuit figures produced by Minton's and their contemporaries.

The efforts to achieve success were continued for several years. Eventually a claim to have invented an entirely new porcelain was made by a workman named John Mountford (see also page 98), who had taken up employment at the Stoke-on-Trent factory of Messrs. Copeland and Garrett after working for a number of years at the Derby works. The claim that John Mountford first discovered Parian is made by one of his later employers, Sampson Hancock of Derby, in an interview published in the trade journal *The Pottery Gazette* in 1895:

> He [Mountford] was apprenticed at the old works in Derby, but left early in life, and came to Copeland and Garretts' at Stoke-on-Trent to start the figure trade there. While in their employ he brought out the composition known to the trade as Parian . . . the name of this man will be recorded in time to come among those of famous potters . . .

A further mention of John Mountford's contribution to the discovery of Parian was made by John Haslem in *The Old Derby China Factory* (G. Bell

& Sons, 1876). In this book, Haslem gave the credit for the actual discovery of the composition to Mountford; but he noted that it was, in fact, put on the market by Thomas Battam, the art director of Messrs. Copeland and Garrett.

John Mountford was assisted during all his experiments at Copeland and Garrett's by Thomas Battam, and the two worked closely together over a period of many years after Mountford had left the Derby factory. As the art director of the firm, Thomas Battam would probably have been the more intelligent of the two—although if the discovery was, indeed, accidental, the question of intelligence would have had little bearing upon the matter beyond that of the ability to recognise the discovery for what it really was and to foresee its possibilities.

Credit for the discovery was given to Thomas Battam by *The Art-Union* magazine, which stated:

> It is but justice to Mr. Battam, the artistic director of Messrs. Copelands' establishment, to state that the original idea and introduction of this material is wholly attributable to his taste and judgment . . .

John Mountford himself claimed publicly to have been the discoverer of the Parian composition but, as in the aforementioned cases, some years had passed between the time Parian figures appeared on the market and the date of the claim. He stated in *The Staffordshire Advertiser*, 20th September 1851:

> I am prepared to prove that in the latter part of 1845 I discovered that material known as Statuary Porcelain [an early name by which Parian was known], that I gave to Mr. S. Garrett the receipt for its production.

After leaving Copeland's, John Mountford went into partnership with Samuel Keys as a manufacturer of Parian. In 1857, he started in business for himself. A number of Parian figures have been discovered which, bearing the mark 'J. Mountford—Stoke', must date from that time. During the earlier partnership of 1850–57, examples were marked with the joint names 'S. Keys & Mountford' (see page 82).

While Mountford and Battam had been carrying out their experiments at the Copeland works, several other firms had also been trying to discover a substitute for the earlier Derby bisque. In the course of time, some of them succeeded and lodged claims to have been the first with the discovery of Parian.

The firm of Minton was amongst the first to lodge such a claim and was certainly the first to give the new porcelain the name 'Parian', which ousted the other names by which the new material was first known and has persisted until today. Messrs. Minton claimed to have produced the final true Parian by 1845.

Messrs. T. and R. Boote also laid claim to the discovery; and Thomas Boote, a partner in the firm, made what is perhaps the earliest claim of all by stating that he first produced Parian in 1841 '. . . when learning the Art of

Pottery with a Mr. E. Jones'. A significant fact which mitigates against this early claim is that T. and R. Boote did not manufacture Parian for the open market until about 1850.

Finally, it was accepted that the credit should be given to Messrs. Copeland and Garrett, and a statement appeared in a handbook to the official catalogue of the Great Exhibition of 1851 which ran as follows:

> The first idea of imitating marble in ceramic manufacture originated with Mr. Thomas Battam, the artist directing the extensive porcelain manufactory of Mr. Alderman Copeland at Stoke-on-Trent in the commencement of 1842. After a series of experiments he succeeded in producing a very perfect imitation of marble, both in surface and tint. One of the earliest specimens was submitted to His Grace the Duke of Sutherland who expressed his unqualified admiration . . . and became its first patron by purchasing the example submitted. This was on the 3rd of August 1842 . . .

This date seems to be rather early in view of the fact that no mention of Parian-type figures was made in *The Art Union* magazine until the issue of January 1845—and even then, the term 'Stone-china' was used. It does appear improbable that an item of news of such importance to the world of ceramics, and relating particularly to such an illustrious personage as His Grace, would have been entirely overlooked by the editor of the magazine in question for so long a period.

But doubts still lingered in the minds of certain authoritative people in the ceramic world, and in 1851 the jury of the Great Exhibition invited both William Taylor Copeland and Herbert Minton to draft a statement regarding their individual claims to priority concerning the discovery. This request was made because it had been suggested to the jury that it should award a medal to the firm which could substantiate beyond doubt its claim to be the inventor.

Statements were submitted by both men and were duly studied by the jury. It was considered, however, that neither claim was sufficiently substantiated. The report by the jury, which was issued later, said that they

> . . . could not recommend an award of the council medal for the invention of Parian without deciding on the disputed claim of priority . . . we have not felt it our duty to come to any such decision; especially as it would appear from the statement of each party that, whichever may have actually been first in publicly producing articles in this material, both were contemporaneously working with success towards the same result . . .

Enough has been said to make it plain that the true facts relating to the first discoverer of this Victorian porcelain are obscure. The generally accepted opinion is that the strongest claim came from the firm of Copeland and Garrett. Whether John Mountford made the discovery on his own whilst working for them, or whether it was the work of Thomas Battam, or—as is

more than probable—it was the final result of their combined efforts will never be proved. It remains that someone working in the Victorian era did discover an entirely new form of porcelain by means of which it was possible to model figures and busts of much greater intricacy than had been produced before.

Reviewing the subject over a hundred years later, we feel that for all practical purposes the present-day collector can consider that Messrs. Copeland and Garrett were the first to successfully *market* the new Parian body in 1846, and that the initial milestone in its acceptance by the public was the Art Union of London's commission for the reproduction in the new body of John Gibson's statue of Narcissus—a Copeland and Garrett model illustrated on the dust jacket of this book and also shown in the Frontispiece and in Plate 22. We must concede, however, that other firms may well have made experiments resulting in a similar ware and that some few figures or groups might have been manufactured before 1846; but they were not a commercial success and were in the nature of trials.

There were marked differences in the Parian made by the various firms which took part in the experiments to produce the new form of porcelain. Some firms were considerably more successful in their efforts than others. Although many makers took up the manufacture, only a limited number managed to achieve that delicacy of texture which is the outstanding characteristic of the best quality Parian now sought by the discriminating collector.

Each of the successful firms marketed its products under a different name from that used by its competitors. Thus, after a time, it is not really difficult for the collector to recognise the varying features of the work of each firm.

Messrs. Copeland and Garrett at first marketed their discovery under the name 'Statuary Porcelain', probably because it was used mainly for reproducing statuary in miniature—a purpose to which it was eminently suited. Messrs. Wedgwood, who produced some particularly fine pieces in the new material in about 1848, gave it the name 'Carrara' because of its similarity to the white marble cut from the quarries near Carrara, in Northern Italy. These quarries have been worked for more than two thousand years and are almost four hundred in number. The marble obtained from them is of excellent quality.

The firm of Minton called its new porcelain 'Parian', owing to the remarkable likeness it bore to the marble which came from the Isle of Paros. This island is one of a group known as the Cyclades, which belong to Greece and lie on the east of the Aegean Sea. The quality of the marble quarried near the summit of Mount St. Elias on Paros has been recognised for many centuries, and it has been used as the medium for some of the world's finest statues, including the famous Arundel Marbles which are now in the British Museum. Marble from the Isle of Paros is being cut to the present day.

Each firm which marketed the new material noted at once its strong resemblance to one source of marble or another and implied this in the name adopted for the final production. Indeed, Parian was so very much like

marble that it was suggested in some quarters that the original experiments had been carried out in the specific endeavour to discover a type of porcelain which resembled marble rather than to discover the secret of the Sèvres and Derby bisque. That the result of the experiments did resemble marble to such a marked degree was, however, entirely a matter of chance.

But this similarity appealed to the Victorians very much because they were particularly attracted to marble as a material. To them, it suggested opulence and wealth. Marble halls, pillars and floors were considered a sign of great elegance and prosperity, which they were prone to revere. So the likeness of the new material to marble was seized upon quickly; and it played a great part in the adoption of the name by which it is still known. Paros marble was considered by the Victorians to be of the highest quality. It followed, therefore, that the name Parian would have greatest snob-appeal in a period noted for that human failing.

It is rather disappointing to find that some writers and experts on works of art have decried Parian simply because Victorians likened it so emphatically to marble. It is true, perhaps, that one medium should not be made to deliberately imitate the qualities of another already-established medium. But this does not really apply to Parian, which has strong qualities of its own, very distinct from its marble-like characteristics, which make it unique and particularly adaptable to the production of detailed figures and busts. When Parian was first discovered, nearly every contemporary review made a point of stressing its marble-like qualities. This undoubtedly helped to give rise to the idea that that has been the sole object of the experiments. We believe this to be false.

There were many reports published, both by individuals and journals dealing with the arts, all of which praised the uniqueness of the new discovery but referred to its remarkable imitation of marble. One such eminent person during the Victorian period was Mr. John Gibson, R.A., who expressed the opinion that the new material was 'the next best thing to marble' 'that he had ever seen'. In stating that it was 'the next best thing', he surely indicated that Parian had qualities apart from its likeness to marble which were certainly virtues of its own.

It is still quite a common experience to find a degree of confusion existing amongst antique dealers in the recognition of the difference between a normal bisque figure and one which is essentially Parian. The reason for the variation in colour and texture between the bisque and Parian made by the different Victorian firms is due entirely to the constituents used during the making of the body or liquid slip (see page 20).

The visible difference between Parian and the earlier biscuit or unglazed porcelain is more difficult to detect in the productions of some firms than in those of others; but the ivory creaminess which is most indicative of the examples made by Messrs. Copeland and Garrett and the other leading manufacturers of Parian, combined with the outstanding silkiness of the texture, makes the distinction fairly obvious. The biscuit porcelain is a dead white and has a chalk-like appearance.

The firms which produced the first Parian used a soft-paste type of composition. It was not until several years later, and after many further experiments, that a harder type of Parian was evolved. This hard type was considerably cheaper to produce as well as being easier to handle. It was much coarser in final texture and easier to mould, and it encouraged many lesser known manufacturers to cater for a cheaper market—which was soon flooded with indifferent imitations of the soft-paste variety.

It was John Mountford who eventually made a claim to have evolved the hard-paste variety. As in the previous instance, there were other claimants. One of these was the firm of T. J. & J. Mayer, who made a claim in 1847. A later claim was lodged by Charles Meigh of Hanley.

It is highly probable that, in continuing his experiments, Mountford's efforts were directed towards the improving of what had already been achieved in the manufacture of Parian, and that he did not carry on with the sole purpose of producing a cheaper article. But that is exactly what did happen; and the new form of Parian he evolved was considerably inferior in quality to the soft-paste variety. It soon became known as non-frit or hard-paste Parian. The composition used previously was adulterated with ball clay, and even flint glass was introduced into the making. It was also fired by a process entirely different from that to which the first composition had been subjected.

The resulting product was much coarser in texture, and the beautiful sheen which had been such a delightful feature of the earlier article was missing. It is only fair to say that the quality did improve greatly, after a time; but it never equalled the first frit Parian—and it should not take long for a new collector to learn to detect the difference at a glance.

In spite of the inferiority of the non-frit Parian, what immediately attracted the less important manufacturers was not only that it was easier to make but also—and this was the really vital factor—it was very much cheaper to produce. It was not long before many firms were flooding the market with inferior examples of what had been an exquisite porcelain—indifferently modelled articles such as jugs, vases and various ornaments. Pieces of this kind were turned out in an endless variety and sent all over the world.

Fortunately, the better class of ceramic makers continued to produce their fine examples in soft-paste, or frit, Parian as before, and the middle-class Victorians who admired the original Parian because of its unique qualities paid little or no attention to the productions of the cheaper firms. A feature of the hard-paste Parian was its rougher and coarser surface, which was much more difficult to keep clean since dust and dirt could adhere to it quite easily.

The composition of non-frit Parian was sixty-seven parts of felspar to thirty-three parts of china clay. It was capable of standing much more fierce and sudden applications of heat, not to mention fluctuations and variations of temperature, when undergoing firing. These variations did not give rise to the danger of cracking and splitting, as had been the case before. Losses during manufacture, which were often serious in the production of soft-paste

work, were reduced to a minimum and this, again, was a factor which recommended itself to the makers of the cheaper ceramics.

Furthermore, the slip, when prepared, was of a considerably thicker variety than the earlier type and much more suitable for rapid casting—which proved to be a great attraction to firms prepared to put quantity of production before quality of work. It was so much stiffer, in fact, that it became possible to make completely hollow figures from it by the simple method of pressing the semi-hard mixture into the moulds with the fingers instead of having to pour it in from a bulk container and then wait for it to partly solidify. The waiting time was thus entirely avoided.

This method was satisfactory, up to a point, and it enabled figures to be made much more quickly than by the original procedure. But the results were inferior because the pressure of the workers' fingers could not give anything like the clarity of cutting which was a feature of frit Parian. The cheese-like mixture could not be manually forced into the tiny crevices with the ease of the natural settling achieved by the thinner consistency.

Apart from the composition of the slip, the main difference in the production of non-frit Parian as opposed to the method employed with frit work lay mostly in the kiln. In the case of frit Parian, air was allowed in full measure into the kiln, whereas with non-frit work air was deliberately excluded and then the exact amount necessary to promote combustion was allowed to enter.

Many experiments were carried out with the non-frit formula to try to achieve the beautiful smooth texture which had been lost, but none of these experiments proved to be successful. It was not until later that an Irish firm, trading under the name of 'Belleek', utilised an entirely new idea and made an advance in this direction. Before that, however, one experiment which was tried for a considerable time was that of dipping finished articles into a glaze. This only had the effect of clogging up even more the already degraded cutting, and very little sharpness of modelling could be achieved.

Another attempt was known as smear-glazing. This was not done to the finished figure but was carried out at the time when the work was introduced into the sagger—a fireproof box, used to protect models from the smoke and fumes in the kiln which would stain the white body. The glaze, which was put into the sagger on the same principle as that employed with salt-glaze work, melted as the heat of the second firing rose to a sufficient degree and then settled on to the non-frit Parian in a fine, misty coat.

Although this was more successful than the dipping process, it was still far from a satisfactory solution to the problem, and the results could in no way be compared with the earlier soft-paste work. A good deal of time and money must have been spent in the various experiments, but success remained elusive.

Owing to the cheapness of the method of production, non-frit Parian continued to be manufactured by many small firms, and the market remained inundated with poor work which was not worth buying then and is still not worth buying unless one is prepared to collect it purely as an example of

Victoriana rather than for its intrinsic beauty. At least, it can be said that it is no worse, from an artistic point of view, than a good many other quaint objects which are collected nowadays.

There is little doubt that the neglect of fine quality frit Parian porcelain by the present-day collector of Victoriana has been influenced by these cheap products, which have delayed the emergence of the former as one of the best productions of Victorian times. But that realisation has now come about and, as the fact is being recognised more and more, the owner of good quality Parian will find the value of his collection rising sharply.

Chapter II

The Art Unions and Exhibitions

In spite of the praise showered upon it from all sides when it was first intro-
duced, Parian Statuary, as it was then called, showed every sign of being
a complete failure as a marketable proposition. The first manufacturers to
make efforts to secure a general sale for the new figures were Messrs. Cope-
land and Garrett. They issued two figures, of which one was called 'The
Shepherd Boy' and the other was a delicate portrait-bust of a young woman.
'The Shepherd Boy' was after a work by Richard Wyatt, a London-born
sculptor who had studied in Rome under Canova, and it might have been
expected that his work would have had a great attraction for the public.
But the sales of both pieces were extremely discouraging, and for a con-
siderable time it was doubtful whether any further works in the new medium
would be produced. Had it not been for the intervention of the art unions,
which were beginning to flourish at that time, it is indeed probable that no
other works in Parian would have been issued.

The first 'Art Union' was formed in 1836, prior to the discovery of Parian,
and was called the Art Union of London. Its object was to foster sales of
works of art and its first move was to organise a scheme under which those
who paid the membership subscription were entitled to participate in a
yearly lottery with the prospect of winning one of many financially attractive
prizes.

To keep within the letter of the law, the prizes offered as an inducement
to membership were not in the form of money but were generally current
works of art, with particular emphasis upon Royal Academy pictures which
were being exhibited at the time of the draw. The fact that the prizes were
not issued in the form of money did not truly legalise the various art unions
at all; but as far as is known, no direct action was taken against them and they
were definitely encouraged by Prince Albert.

Art union draws were legalised in 1846 and were then brought within the
framework of the Victorian law relating to lotteries. This enabled them to
extend their activities and increase the variety of prizes given away, which is
how they came to play such a definite part in the popularising of Parian figures.

From their inception, the art unions were a great success with the public; and although the first union was linked to London, they began to spring up all over the country and even across the Irish Channel, where the Royal Irish Art Union also did good work in helping to bring Parian ware to the notice of the public.

Before long, some of the more important unions became quite wealthy organisations as a result of their direct appeal to the middle-class Victorian public which, although living in affluent circumstances for the times, could not afford the hundreds of guineas which was often the value of the individual prizes distributed by the unions.

Besides paintings and other valuable works of art offered to members, hundreds of smaller prizes were issued—and it was among these that works in Parian eventually found their place. Apart from the chance of winning one of the bigger prizes, the acquisition of a good piece of soft-paste Parian manufactured by a firm of the standing of Messrs. Copeland or Minton, or any other well-known ceramic firm, was sufficient to make the lucky recipients the envy of their friends.

As the cost of a good Parian figure bought directly from the makers might have been in the region of three guineas or more, according to its size and intricacy, its equivalent value today would be approximately £25.

After the disappointing reception by the public of the first two figures issued by Messrs. Copeland and Garrett, the interest of their Mr. Battam in the new process had been kept alive solely by a group of sculptors and artists who maintained a firm belief in the artistic value of Parian as a material of the future.

This enthusiastic group arranged a meeting at the Copeland and Garrett works where Mr. Battam received the Royal Academician John Gibson and others including representatives of the Art Union of London. Mr. Gibson reaffirmed his confidence in Parian as a medium for the production of works of high artistic value and together they examined and re-examined the material and the commercial opportunities for its exploitation. The outcome was a determination on the part of all to continue their efforts to establish Parian on the middle-class market.

The Art Union representatives were very impressed and very enthusiastic and, after hurried consultation with their committee, decided to commission the manufacture of some Parian figures. These were to be specially made for the Art Union of London and were to appear in their prize lists at the first opportunity. This was the decision which saved Parian from a very real threat of total extinction so soon after its discovery. Its place as a viable alternative to the earlier bisque for the modelling of figures and many other articles was now assured.

The Art Union of London had now to decide upon the models to be issued. After due deliberation, it was agreed in 1846 to commission fifty copies of a figure by John Gibson entitled 'Narcissus'. The original statue had already been exhibited at the Royal Academy and had been awarded a diploma of honour. When adapted for reproduction in Parian by E. R. Stephens, its

height was 11⅞ inches. A copy can be seen in the Victoria and Albert Museum (see Frontispiece, Plate 22).

Some difficulties arose in obtaining the sanction of the authorities of the Royal Academy although Mr. Gibson had already given his consent and had notified the committee of his approval of the scheme, but after prolonged consultations, the misgivings were overcome and work upon fifty copies for eventual distribution as prizes was begun at the works of Messrs. Copeland and Garrett at Stoke-on-Trent.

The work was treated urgently and the fifty copies were completed and issued as prizes in the same year of 1846. Their special printed mark is reproduced here. The price paid to Messrs. Copeland and Garrett for the pro-

duction of the copies was £3 each. This figure makes it clear that such Parian figures would have been well outside the purchasing power of the average family and would have appealed only to the better-class household. They were not made to decorate the ordinary cottage mantelshelf, as were the cruder Staffordshire earthenware figures which were being turned out in vast numbers by the manufacturers of the period.

Parian figures could not be turned out cheaply, and the high price charged for them probably had a good deal to do with the initial difficulties experienced in launching them on the market. It may also explain why good class Parian is not easy to come across nowadays. Apart from the figures which could be won in the art union lotteries, the number of which would be limited, Parian would be found only in the homes of relatively prosperous families who, following the custom of the time, would undoubtedly entrust their dusting to servants. Parian figures, usually standing on pedestals in the hall or in window niches were particularly vulnerable to breakage in careless hands—far more so than the more modestly priced ornaments which stood on cottage mantelpieces and were looked after by their more prudent and careful housewife owners.

Another cause of scarcity is the revulsion against all things Victorian— whether of good taste or not—which swept through Britain shortly after the First World War; many fine Parian figures would have been looked upon as 'Victorian junk' and discarded by families who could afford to replace them with what was considered more up-to-date and fashionable work.

In November of 1846—the year of the inclusion of 'Narcissus' in the prizes

distributed by the Art Union of London—it was stated that the venture had been a complete success, and a further figure was at once commissioned for use the following year. It was reported:

> Those already finished are extremely beautiful and so satisfactory that a further commission from the Society has resulted . . . the committee of the Art Union of London have awarded to Mr. Foley one hundred guineas for a reduced copy of his beautiful statue of 'Innocence' also to be executed in 'Statuary Porcelain'. (See Plate 23.)

The success of the Parian figures commissioned and issued by the first art union encouraged other unions in different parts of the country to emulate its example. In this way, the new form of porcelain was taken up by the Victorian public and a general demand for Parian was created—not only to be won as prizes in the various lotteries but also to be bought directly from the firms, which were by this time beginning to manufacture the figures and busts in large quantities.

The new medium had become established as attractive and very fashionable, and few Victorian families of means failed to display splendid Parian figures which occupied places of honour in their vestibules, halls and drawing rooms.

Figures were included in the prize lists of practically every art union in existence, and the foremost manufacturers of ceramics vied against each other to secure the services of the leading sculptors and modellers of the day— either to grant permission for their previously carved works in marble to be used or to model figures and busts for the special purpose of reproduction in Parian. Many of the stately families of the day were approached for permission to make copies of the statues which graced their parks and gardens. The first figures issued by the Art Union of London continued so popular that they remained in its list of prizes for years afterwards, and many more were added as time went on. (An interesting article, 'The Victorian Art Union Movement' by Geoffrey A. Godden, is contained in *Apollo* magazine of September 1961, and a further one by Elizabeth Aslin is contained in *Apollo* magazine of January 1967.)

In 1846, Henry Cole, under the pseudonym of 'Felix Summerly', won a Society of Arts prize for the design of a tea-service. The design was manufactured by Messrs. Minton in Parian as well as in porcelain. This breakaway from the figures and busts to which Parian had previously been devoted proved to be an equal success.

A year later, in 1847, Henry Cole launched a firm under the title of 'Summerly's Art Manufactures' and engaged the services of numerous well known artists to model special designs, some of which were issued in the Parian body. The work he turned out was well done and he was encouraged in his new venture by comment in *The Art-Union* magazine of June 1847, which reported:

> . . . we cordially rejoice if the gentleman [Henry Cole] to whom we refer and who in experience, taste and judgement is second to none, can

succeed in wedding to 'High Art' the art that has been in this country considered and treated as 'Low Art' so as to commence a new era for both . . .

Later in the same year, the magazine again reported:

. . . we rejoice that Felix Summerly has succeeded in inducing such men as Horsley, Townsend, Bell [each a well known sculptor of the day] and others to aid a project pregnant with immensely beneficial results to British manufactured art . . . we understand that arrangements are making to carry out this project upon a very extensive scale, and that ere long, there will be few of the manufacturers of England who will not contribute to it in one form or another . . .

Queen Victoria expressed great personal interest in Summerly's Art Manufactures and purchased a number of the works of art which the firm produced, not a few of these being made in Parian. In spite of such august patronage and praise, Summerly's Art Manufactures did not meet with the success it deserved. At the end of three years, serious financial troubles overtook it and the scheme closed down completely. During the time it existed, however, there is no reason to doubt that Henry Cole did a lot to popularise the process of Parian manufacture and that he was the instigator of some really fine work being done in this medium.

One of the most successful of his productions in Parian was the model statuette called 'Dorothea', from Cervantes' *Don Quixote*, which had been modelled for the purpose by John Bell in 1847. 'Dorothea' proved to be very popular and sold in great numbers at the time. This figure, which is shown in Plate 86, was a registered design (see page 115) and bears a diamond-shaped registration mark, signifying that the model was entered in the official records on 4th October 1847.

During its three years of existence, the work produced by Summerly's Art Manufactures was not reserved entirely to Parian ware, and it is quite possible that the venture might have proved to be a greater success if Mr. Cole had concentrated upon more work of the quality of 'Dorothea'—especially as the Parian work he did issue was of such a fine texture. We have never found a Parian figure issued by him which was not made by Messrs. Minton and carrying the special mark shown on page 87. An interesting article, 'Felix Summerly's Art Manufactures' by Shirley Bury, is contained in *Apollo* magazine of January, 1967.

With the help of the patronage and publicity of the art unions and Henry Cole's Summerly's Art Manufactures, the new Parian body was now a fully established favourite of the Victorians and was being made in many forms —such as jugs, decorative vases, tea-services, brooches and many other articles of utilitarian value—quite apart from the figures which had captivated the public taste.

The popularity of Parian was also due in no small measure to the several exhibitions held from the 1840s onwards. The Victorians were fond of osten-

tatious display in general, and any excuse which led to the gathering together of the fashionable people of the time was seized upon eagerly and organised as often as possible. Exhibitions of the arts and crafts of the day were held in London and other large towns, culminating in the Great Exhibition of 1851 in Hyde Park, London, which reached a peak of display more flamboyant than attempted on previous occasions.

Before that exhibition was conceived, however, smaller ones were held; and from the first appearance of Parian on the market, the new statuary porcelain, as it was called at that time, took its place amongst the best ceramics on show at these exhibitions. Its marble-like qualities, and the accurate reproduction of the original pieces, fascinated the Victorian public wherever it was put on display.

Messrs. Copeland and Garrett were, as we have said, among the first to exhibit Parian figures and articles of all kinds made from the new materials, and they continued to do so at all the major exhibitions for many years. They even held exhibitions of their own productions in their own galleries. Some of these were quite elaborate displays and contained many fine examples of Parian.

The first exhibition to create a stir amongst the art unions in general and permit Parian to make a strong impression upon them was the one held in Manchester in 1846—the same year that the Art Union of London commissioned the figure of 'Narcissus' to be made for them. In January of that year, *The Art-Union* magazine gives particular praise to the stand of Messrs. Copeland and Garrett in referring to this exhibition, and illustrated the stand in the magazine with definite emphasis upon the new product, Parian. The engraving is reproduced below.

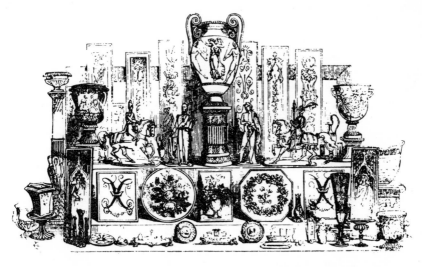

Amongst the pieces picked out for special mention were the equestrian copy of the statue by Philibert and the model of 'The Shepherd Boy'. Other pieces referred to included articles of decorative and utility value, which

shows that at that early stage Messrs. Copeland and Garrett had developed the use of Parian beyond the manufacture of figures and busts.

Special mention was made of a Parian copy of a marble vase, the original of which was displayed in the British Museum. The Parian copy was thirty inches high and, for the purposes of making it useful in the parlour, it had been adapted to some degree so that it could be used for holding flowers. This was an example of Parian work being lead-glazed inside to enable it to hold water.

Several other firms displaying work at this exhibition were also very successful, and praise for their exhibits was showered upon them by both the public and the journals of the day. Many other minor exhibitions were being held up and down the country at that time, and Parian was allocated special display sections at nearly all of them. The Society of Arts arranged exhibitions in London during 1847, 1848 and 1849, and so great had become the appeal of Parian that it was said to have entirely dominated the stands of ceramics at these exhibitions.

The section of the public which was beginning to find that it had money to spare, thanks to the industrial success of the country at that time, discovered to its delight that the exhibitions were offering it the possibility to possess excellent copies of the world's finest statues of its own and previous times. Copeland, Minton, Wedgwood, Worcester and many other great firms were all providing this new opportunity, and the market for Parian developed rapidly towards its peak period of the 1860s.

Before the peak was finally reached, many more exhibitions were held. They were extremely popular with the Victorians—more so than they would be with the public of today. In those days, they were events of social significance which grew increasingly ambitious—eventually leading to the Great Exhibition of 1851, which was specially designed to entrance the imagination of not only the British but also the rest of the world. The Great Exhibition was sited in Hyde Park, London, and was a culmination of ostentatious display which attracted visitors from all parts of the globe. The nobility and general public alike flocked to see it.

This exhibition, which achieved royal patronage, gave to Parian an importance its manufacturers had never before been offered, and they were not slow to take advantage of such a splendid opportunity. The following firms were amongst those that exhibited Parian work: Messrs. G. Grainger & Co. of Worcester; J. Rose & Co. of Coalport; Messrs. Copeland, Minton, Wedgwood, Keys and Mountford, Charles Meigh, Samuel Alcock, T. & R. Boote, J. Edwards & Sons, all from Staffordshire; and Bell & Co. of Glasgow. The last-named firm was one of only two ceramic firms situated in Scotland which turned their attentions to the making of Parian figures. Most of their work was marked in a distinctive way with the illustration of a bell. Further details about these and other manufacturers are given in Chapter VIII.

The Parian work put on view during the Great Exhibition was, without doubt, both in quality of porcelain and in artistic character, amongst the finest Parian ever made, and it is a matter of great difficulty to pick out

for special attention the work of any one firm. One of the most outstanding pieces, specially designed for the exhibition, was a delightful dessert-service made by Messrs. Minton & Co. This was made in a combination of Parian and normal porcelain. Parts of the service were coloured turquoise, with further gold embellishment. The Parian figures which it featured were left in their natural bisque tone, and the entire service was an object of exquisite beauty.

When Queen Victoria visited the exhibition, this dessert-service captivated her at once, and she did Messrs. Minton the honour of purchasing it from them. Duplicate pieces, now in the Victoria and Albert Museum, London, are shown in Plate 79. Minton also had on show a particularly fine ewer and basin, a copy of which can be seen in the Victoria and Albert Museum.

An unusual exhibit was a large chimneypiece, made entirely of Parian. The modelling of this spectacular work was very involved and would be considered extremely ornate by present-day standards. But it presented a display of craftsmanship which it would be difficult to emulate today.

As Messrs. Copeland and Garrett had claimed the credit for being the first to introduce Parian to the world—although it must be remembered that it was the jury of this very exhibition which so adroitly refused to commit itself upon this question—their successors, Messrs. W. T. Copeland, went out of their way to put on a really dazzling show of Parian in 1851 although they exhibited a good deal of work in other materials as well.

It was said in an official publication:

> . . . this exhibition is remarkable . . . especially for the great beauty of its Parian groups and figures, several of which are eminently successful and show complete mastery over the material in its best and most legitimate application.

Despite the exaggerated prudery of the Victorians, typified by the shock expressed if a lady dared to show her ankle in public, they displayed a great interest in the classical figures made in Parian, of which many examples of male and female nudes were on show. These were accepted without question, and no less than a hundred different figures of this type were issued.

In 1859, Messrs. Copeland organised another exhibition of their work in their own premises in Bond Street, London. The figures were arranged along each side of the main aisle, and great interest was shown in them. The work shown ranged from small models to ones which were the same size as the marbles from which they had been copied. Many of the smaller ones were scaled down by the use of a machine which had been invented by Benjamin Cheverton (see page 24).

One of the busts on show at this private exhibition was called 'Clytie' (see Plate 31), and this was picked out for special reference by the current *Art Journal*. It was described by the journal as '. . . with the hair brought down so low on the forehead and the figure represented as if rising from a bud of the lotus'.

C

The legend from Greek mythology relating to this bust is the well known one of Clytie, an ordinary nymph who fell in love with the great Apollo (see Plate 30), god of poetry, love, music, the sun, and all things beautiful. He could not stoop to love so lowly a being as a nymph, and yet he felt for Clytie a deep compassion. This he expressed by turning her into a sunflower, so that she could always turn towards him in adoration. And that is how she is depicted in this very charming Parian bust by Messrs. Copeland.

The cost of the bust was three guineas a copy. Therefore, at a time when the wage of an average workman was not more than a pound or so for an arduous week's work, such busts as 'Clytie', with its superb craftmanship, did not find their way on to the cottage mantelshelf along with the earthenware dogs and other crude ornaments. Almost a hundred years later, we prize our copies of 'Clytie' and 'Apollo' and handle them with the same thrill that must have been experienced by a Victorian 'papa' when, surrounded by his admiring family, he placed his copies on their plinths in the parlour.

Two other important busts were on display at this exhibition: one of Queen Victoria, and the other of Prince Albert. The originals of these were carved by Joseph Durham at Osborne House. Busts of 'Ariadne' and 'Juno' were reproduced in Parian in their original size. Amongst the reduced busts, the *Art Journal* of December 1859 mentioned the one of 'Miranda' by Calder Marshall as being particularly charming. Busts of Lord Nelson and the Duke of Wellington were also remarked upon as pieces of work of great merit.

The exhibition was separated into two sections. One was for busts and figures reduced from already famous statues and the other was for works by well known modellers for the special purpose of production in Parian.

The reaction of the public left Messrs. Copeland in no doubt that their venture was a huge success, and it must have done a great deal to increase the popularity and sale of their work.

Exhibitions were also held in Ireland. At the Dublin Exhibition of 1853, the Royal Worcester Company showed a remarkably fine dessert service intended for the use of twenty people and made of a combination of Parian and china in a manner which was a speciality of the firm under the management of Messrs. Kerr and Binns. This service was known as the 'Shakespeare' service, and the modelling of the figures from which the moulds were made was by W. B. Kirk, who was the son of a very famous Irish sculptor (see Plates 55, 56 and 57).

Chapter III

The Manufacture of Parian

Accepting the general opinion that Parian originated in the works of Messrs. Copeland and Garrett and that Thomas Battam had a good deal to do with the first experiments, it is interesting to consider first of all Battam's description of the method of manufacture, including the composition and constituents of Parian and the method of figure construction.

In its finished state, Parian is a very highly vitrified form of bisque porcelain which is very smooth and satisfying to the touch. If it is not smooth and silky in texture, then it is the later and less expensive hard type of Parian.

Parian is semi-transparent; and even through the thickest parts of a piece, light can be seen shining if its source is bright enough for the purpose. It has a delicate ivory tone, although this slight colour can vary to a certain extent according to the constituents used in the manufacture. Some good Parian produced by one manufacturer will be considerably whiter than that displayed by others due to changes in the mixture. The pieces made by Messrs. Minton and the Belleek firm are examples of this difference.

Parian is capable of rendering the most intricate detail in modelling, and we have in our collection several pieces which illustrate this unique feature to perfection. One model of 'Richard Coeur-de-Lion' shows the most remarkable detail in its imitation of chain-mail (see Plate 114), and the small brooches shown in Plate 109 are also striking in this respect. This ability to render detail so sharply is far more pronounced than with normal porcelain.

The first process in the manufacture of a Parian figure was the preparation of the master model from which moulds would be made and the figure finally cast. The commissioned artist would make a copy in miniature of the selected statue, or would model a figure specially for the purpose, either in wax or alabaster. Alabaster was used more frequently than wax, although it was more costly, probably because the resultant model was a good deal tougher and stronger. The reduced model had to stand up to some rough albeit very skilful handling, and alabaster served this purpose better.

When the modeller was entirely satisfied that his work was an exact copy of the original, it was handed over to a workman called a block-cutter. It

was the duty of this highly skilled man to cut the model up into the sections from which the moulds were to be made. After this came the making of the very many moulds required for the production of a figure. The amount of time this work took was very great: but time then was not the important factor in business that it is today. The task would, of course, take much longer if the figure or group was in any way involved and intricate—such as the one in our collection which was made by Messrs. Copeland and Garrett from an original bronze entitled 'Chasse au Lapin', by the famous French sculptor, P. J. Mêne. This is a really fine group of dogs hunting (see Plate 45).

It has been said that for one Parian group, 'The Return from the Vintage', which consisted of seven separate figures, the number of moulds used in the manufacture exceeded fifty. The piece was so elaborate that it is doubtful whether a copy remains in existence since few would have been made—and it is even more doubtful whether such a copy would be in an unbroken condition. A copy may still exist in a museum not known to us, or might even be giving elegance to someone's home. We hope so; and we would give a great deal to be able to say that a copy of this exquisite piece of workmanship graced our own collection. Maybe the gods will be kind one day and we shall come upon a copy for sale, dusty and neglected at the back of a quaint little shop, at a price which we shall be able to afford.

To return to the mode of manufacture, the block-cutter separated the figure or group by carefully cutting it into the many pieces required for moulds. The head—not necessarily all in one piece—arms, body, legs and sections of the clothing or drapery, and any other objects such as urns, animals or whatever went to make up the whole work, had to be taken into consideration and a decision made as to the number of moulds that would be required. After the exacting dissection had been carried out, the mould-maker would start constructing the moulds, which were usually made from plaster of Paris or some similar substance.

The composition of the Parian itself was then started—really a form of porcelain made from a mixture which was a glassy, vitreous composition of silica and alkali which was known in the trade as 'frit'. The compound was ground together and then thoroughly mixed with white clay to which a certain amount of lime had been added.

Thomas Battam said the colour of the resultant Parian was governed by the amount of iron silicate present in the composition, and this applied particularly to the amount present in the felspar that was used. Some felspar is entirely free from iron silicate, such as the Swedish variety used by certain firms. With this type of felspar, an almost entirely white Parian was the result—certainly much whiter than that made from other felspars.

A contradiction to Thomas Battam's reason for the varying colour of Parian in the final stage was made by Léon Arnoux, Messrs. Minton's art director (see page 52). Not being chemists, we cannot venture an opinion as to who was right or who was wrong. We can only give the facts as our researches have presented them to us.

The formula used by Messrs. Copeland and Garrett for the manufacture

of Parian was forty parts of felspar, thirty-six parts of china clay and twenty-four parts of frit. The frit had been made from fifty-seven parts of white sand, eleven parts of Cornish stone and eight pounds of potash.

The slip having been made up according to the formula of the particular firm, it was worked to about the consistency of cream and then poured into the various moulds of plaster of Paris, where the moisture contained in the slip was quickly absorbed by the porous plaster. The slip became coated upon the interior of the mould, and this build-up of the body was allowed to continue until a certain thickness had formed as a kind of shell.

The judging of the correct thickness was a matter of experience inherent in the skill of the craftsman, only to be gained after a considerable amount of training and experimenting. When the correct thickness had been decided upon, the remaining liquid slip in the mould was poured back into the bulk container. The slip which had been allowed to accumulate in the mould remained there until the drying had proceeded far enough for the cast of slip to bear its own weight and slightly contract away from the mould. It was then removed. The various casts were then passed to another workman known as the repairer, who built them into a whole unit around a basic plaster stick, or prop. By these means, he formed a copy of the original figure.

As the repairer assembled the different casts, he trimmed them carefully to ensure that an exact fusion took place. Great difficulty was often encountered at this point. To fix the casts together with accuracy, it required an extremely delicate touch, much skill and a good deal of experience. If the slightest fault or discrepancy developed at this point, liquid slip from the bulk was used to repair it. This jointing was executed with the greatest of care and, finally, any trace of surplus slip was removed with a soft brush or some other convenient refining tool—which often turned out to be the skilful finger of the worker concerned.

It was not uncommon at this stage of production for part of a figure to develop a tendency towards a sliding movement from its correct situation within the model as a whole. If this did happen, the warping or collapsing part was at once supported by a prop or some other form of correction. An important factor, in this eventuality, was that the prop should be constructed from the same material as that used for the original casts. This was essential because of a very distinctive occurrence during the manufacture of Parian—namely, the unusual shrinkage with took place once the piece was placed in the kiln. We refer to this later, when discussing the extremely fine modelling which was of such great advantage to Parian figures. If slip prepared for other work was used, the eventual shrinkage could not be guaranteed to take place at the same rate as that of the original material and could well result in serious cracking of the figure or even total destruction.

Whenever it was necessary to resort to such a prop, the end which touched the model had to be prevented from sticking to the part of the figure which was being supported. To this purpose, that end of the prop was covered with a coating of powdered flint.

After the propping was completed, the figure had reached the stage

where it could be left alone in a warm temperature for about a week or so. It had to be very carefully watched all this time by the craftsmen engaged upon the work, in order to be certain that it did not show any further signs of slipping or warping. This involved workmanship and time which would make the labour costs of such work almost prohibitive today and would certainly result in the figures being tremendously costly.

If the critical period was safely overcome and no further corrections were necessary, the figure was then sufficiently prepared and dried out for its introduction to the firing kiln. If it was placed into the kiln too soon, cracking was sure to take place when the heat was applied, as this rose to a temperature of about 1,100 degrees centigrade. The firing continued for a matter of sixty hours, and sometimes slightly longer. During it, the figure would contract considerably, and it was this contraction which accentuated the sharp, clear modelling to which we have already referred.

After the necessary firing time had elapsed, the heat was slowly reduced until the Parian was sufficiently cool to allow further important work to be carried out. When the figure had been removed from the firing oven, the first task was to disconnect it from the supporting props which had been used during the earlier stages—and it will now be understood why it was necessary, by the use of flint, to prevent the prop from adhering to the finished work. If this had not been done, considerable skill and a lot more difficult work would have been required to remove the props at this stage, bringing the added danger that the figure itself might have been damaged irreparably and all the previous work wasted.

At this point, unsightly scars were removed and the figure was brought within sight of its perfected state. Then, when the craftsman was satisfied that all corrective work had been done, the figure was fired again but at a much greater temperature than before. It was this second firing that brought about the vitrifaction. To enable this to happen and still avoid cracking the figure, the process was carried out by placing the figure in a sagger filled with sand.

During this secondary firing, the figure continued to contract. But no further props were used, because the sand in which the figure was embedded provided a sufficient support. This was the time during the manufacture when Parian took on its smooth marble surface texture—a texture almost impossible to describe. It has no obvious glaze, as is the case with normal porcelain, and yet it does carry a certain low gloss which can only be defined as the smoothness of rich old ivory.

It was not uncommon for Parian to be fired more than twice, at a higher temperature each time, in order to achieve a sufficient degree of vitrifaction and, consequently, an even greater beauty of surface.

Contraction of the figure continued with each successive firing. The amount of contraction under normal firing was approximately one sixteenth the first time it was placed in the kiln, and about one eighth during the first process of vitrifaction. Because of this diminution, the average total shrinkage was about one third during the entire process of manufacture.

In about 1862, however, Messrs. Copeland's introduced a new body which contracted to a markedly lesser degree. We find the following recorded in J. B. Waring's *Masterpieces of Industrial Art and Sculpture at the International Exhibition, 1862* (Day & Son 1863):

> This year the specimens are remarkable, not only for their high artistic character and general excellence, but also for the introduction of a new body, by Mr. Battam, F.S.A., the special recommendation of which is, that it allows of the smallest amount of contraction yet known in a clay body, being, as we are informed, about one-thirteenth of the model. This is a great recommendation . . . How important the consideration of contraction in reference to Parian figures must be, will be appreciated by the fact, that in the old material a figure, say of four feet in height, after coming from the oven, would be only three feet high, with proportionate shrinkage throughout all its parts . . .

When Parian first became a popular and marketable proposition, Léon Arnoux, the art director for Messrs. Minton, did not agree with those other craftsmen who had said that the ivory tone of Parian was due to the composition of the frit. Arnoux, a practical potter, believed that it was a result of the particular treatment given to the material during the firing procedure. In his official report on the 1871 exhibition, he noted:

> This body corresponds to the hard porcelain biscuit made by the Germans, and other Continental nations . . . the mixture is about the same in all countries . . .
>
> A striking difference of colour is to be noticed when the English and foreign statuary biscuits are placed side by side; the English have a yellowish tint particularly pleasing; the foreign, a bluish white colour. From this contrast it might be inferred that in one of them some colouring material has been introduced, whereas the difference is entirely owing to the process of firing. In the French and German ovens great care is taken that no air should be admitted, except that which is strictly necessary to effect the combustion of the fuel; consequently the ware is fired in a reducing atmosphere with an excess of oxide of carbon, the small quantity of iron existing in the clays, combining . . . with the silicic acid, forms a silicate protoxide of iron which has a bluish or greenish colour. In the English parian ovens, air is abundantly introduced, the ware is fired in contact with an excess of carbonic acid, and as iron oxidises when heated in this gas, the result is the formation of a silicate of peroxide of iron . . . it is this which spread in small quantity in the mass of the biscuit produces the pleasing creamy colour already mentioned . . .

We have in our collection a bust of Beethoven which certainly does show the bluish-green cast remarked upon by Léon Arnoux; and in our opinion this greenish tinge is not as attractive as the usual beautiful tone of Parian. Whether the cause of the definite off-colour is due to some carelessness during

one of the periods of firing or due to some detail in the original mixing of the slip, we are not in a position to say. This bust of Beethoven is not marked, apart from having the number 332 impressed on the back and the name of the composer impressed on the front, and we have not been able to discover the name of the firm which made it. It might even be of Continental manufacture.

The original model from which plaster casts were made, and hence the reduced replica in Parian, was often especially designed by the talented modellers employed by the leading manufacturers. Some figures or groups were commissioned from leading sculptures of the period; and many more were reduced copies of already famous full-size marble sculpture. The original working model for these small copies of large works was often acquired by means of Benjamin Cheverton's reducing apparatus.

Benjamin Cheverton was born in 1794 and died in 1876. He was a sculptor in his own right, but he is better remembered as an inventor of machines which were considered to be revolutionary in their day. As he was interested in art in all its forms, the machines he invented were mostly directed towards the improvement of the arts in one way or another.

The Victoria and Albert Museum records that, as a sculptor, Benjamin Cheverton exhibited several pieces of work at various exhibitions held by the Royal Society of British Artists between 1835 and 1849, and he is known to have modelled a bust of Andrew Duncan, Senior, who was a well known Scottish medical man. A copy of this bust is now in the National Gallery of Scotland, in Edinburgh. Other works by Cheverton are preserved in various galleries and museums in different parts of Britain.

But the outstanding achievement of Benjamin Cheverton in connection with the development of Parian was that he invented a machine which allowed accurate reduction to scale of any bust or figure, no matter of what material the original was made. The reductions were made in the round, and the efficiency of his machine was not affected in any way by the size of the original it was set to copy. This successful machine was an enormous step forward in the production of Parian figures and of great value to the manufacturers. It enabled a great deal of what had previously been very laborious work, necessitating a high degree of skill for its execution, to be avoided completely.

Records in H.M. Patent Office state that Benjamin Cheverton applied for and was granted a patent for the machine under the title of 'Machinery for cutting wood and other materials'. The patent number was 10,015, and it was granted to Cheverton on 16th January 1844. According to information from the same source, the machine was actually first invented in 1828. In another patent—number 13,137 of June 1850—Cheverton protected 'Methods of imitating ivory and bone'.

Cheverton did not work alone on the creation of the machine, although the credit for persistent effort and final development goes to him. He was assisted to some extent by a Mr. John Isaac Hawkins, of whom very little seems to be known other than that he was a civil engineer.

The minutes of a select committee of the House of Commons referred to the invention by Benjamin Cheverton in 1836; and Cheverton himself wrote the following words to a Mr. Cowper on 26th June 1836:

> . . . Mr. Watt [presumably the inventor of the steam engine] as far back as the year 1800 was engaged in the application of machinery to the production of modelling and he was occupied in these and more extended analogous pursuits down to the close of his active life. They formed the favourite amusement of his declining years, and during that time he succeeded in producing the round figure by mechanical means, both of a size similar to and reduced from that of the original. Mr. John Hawkins, unacquainted with Mr. Watt's proceedings, succeeded also in accomplishing the same objects in the years 1814 and 1815. Subsequently, he was joined by Mr. Cheverton and an entirely and greatly improved machine was prepared by them in the year 1828, by which the specimens of ivory sculpture now before the committee were executed.

This machine—which looks like a cross between a guillotine and a gibbet—is now in the Museum of Science at South Kensington, London (see Plate 8).

As far as can be ascertained, the first practical use to which the machine was put was the reduction to scale of a bust of the Duke of Wellington in October 1828. The copy was made from an original by Nollekens—an eighteenth century sculptor who was born in London and whose forté was busts, of which he did a great many.

There was no limit to the amount of reduction to which the machine could be set. It was reported in a letter dated 21st January 1848: '. . . Benjamin has just finished the fourth size of the little busts of Cupid. They are no longer than the finger nail. He declares that he will do no more as it is so trying to the sight'.

When making reductions for use in Parian production, Cheverton usually made the model in alabaster—the same material which had been used when the models were made by hand—and the reductions were nearly always done in his own studios. The master models were then handed over to the manufacturers, who made the necessary moulds from them. There is no evidence suggesting that Cheverton ever granted the use of his machine to any other person, and his helper, Mr. John Isaac Hawkins, seems to have disappeared completely from the scene after a very short time.

The machine made in 1828 adopted an entirely new principle of working as opposed to the earlier models, which had been normally based upon a system of turning lathes. The Science Museum records:

> . . . The statue or bust to be reduced and the block of alabaster or other material which was to be used for the purpose, were mounted upon vertical spindles connected together by a system of gears which could be rotated by hand through equal angles whenever required. The tracing point and the cutting tool were mounted upon a carriage which slid

along a bar pivoting on a ball joint. These were connected together by a system of linking which allowed them to move together longitudinally, in respect to the bar, and this, in turn allowed the carving of the recesses which it would not otherwise have been possible to reach. It is this movement which distinguished the machine from others and rendered it so suitable for the reproduction of sculpture. The ratio of reduction could be adjusted by a movement of the tracing point and cutting tool towards, or further away from, the fulcrum of the ball joint.

Cheverton used his machine quite frequently for the purposes of making reduced copies of famous statues and busts owned by the nobility which were destined to be issued in Parian. In this way, his new invention gave an entirely fresh impetus to the production of good Parian copies of statuary which was already well known. In almost every case when Cheverton made a reduction of an original for production in Parian, he signed the reduced model by engraving the alabaster figure with his name when it was completed.

At the Great Exhibition of 1851, Benjamin Cheverton's machine was sited in a prominent place and was seen in operation by the visitors. The jury of the exhibition was so impressed that an award of a gold medal was made to Cheverton for his reduced alabaster equestrian figure of 'Theseus', one of the Elgin Marbles now in the British Museum. It was said in the Report of the Juries that the figure had been reduced 'for the purpose of casting with an accuracy which leaves the most fastidious critic with nothing to desire'.

The 'Theseus' figure was eventually reproduced in Parian by Messrs. Minton, and each copy bears the inscription 'Cheverton, Sc.'—the initials being one of several abbreviations for 'sculpsit', the standard Latin word used by sculptors after their name and meaning 'he carved'.

Another early reduction undertaken by Benjamin Cheverton was that of 'Ino and the Infant Bacchus', from the original by sculptor J. H. Foley. The Parian figure, in this case, was manufactured by Messrs. Copeland, and it was featured in the illustrated catalogue of the Great Exhibition of 1851. A good example on a special base is shown in Plate 26.

Before Cheverton died, in 1876, there was hardly a sculptor of the period whose work he had not reduced by the use of his machine. The accuracy of the work he achieved has to be examined in conjunction with the actual statues to be fully appreciated. It can be said that the copies made by the use of his machine were remarkable examples of flawlessness. Apart from the reductions made for the potters, Cheverton also produced and marketed most attractive busts and such like in ivory; and some fine medal-like plaques were also made.

The majority of soft-paste Parian work was left its natural colour and was untouched by embellishment, particularly in the case of figures. Its delicate tonal value, combined with the clarity of moulding, produced an article which it was agreed needed no further development.

But in spite of this, some manufacturing firms did endeavour to improve

Parian, and they carried out experiments with this end in view. The chief object of their efforts was to enlarge the market and meet the ever-growing demand for novelties. More and more prosperous families had money to spare, enabling them to add to the decoration of their already overcrowded drawing rooms.

Once Parian had been firmly established and a big market for it had been created, many of the makers turned to the consideration of what they believed would be an obvious advancement in the form of colour Parian. There was also a need to meet the competition of the colourful Continental biscuit figures.

The gilding of frit Parian had been done by many manufacturers for some time, but this had been restricted to a form of lining or for emphasising certain parts of figures—such as defining objects held in the hands of a character, and the like. It had been done to only a very limited degree and could be particularly attractive (see Plate 25). But the figures were, more often than not, better left entirely in their natural colour. Some firms realised this and made no efforts to introduce colour in any form.

One good firm which made experiments in the surface colouring of Parian was Messrs. Minton; and the particular type of Parian which they had developed certainly lent itself to the successful application of colour when done by such fine manufacturers of ceramics. They were careful to employ only the very best artists, and the dignity and translucence of their coloured work resulted in figures of great charm. The coloured Parian made by Messrs. Minton was very much admired in Victorian days and it sold very well. The pieces which have survived are sought by collectors and are not cheap to buy. We were offered a coloured figure in an antique shop in Newcastle not long ago. The figure was slightly broken, although not seriously, and the price we were asked was £27. It was a beautiful figure of a man dressed in a gay but controlled coloured costume, and we did not consider the price to be unreasonable. We might have been tempted to buy it if the figure had not been broken—but in that case, the price would have been higher.

In about 1851, possibly for their stand at the Great Exhibition, Messrs. Minton produced a pair of coloured figures entitled 'The New Shepherd' and 'The New Shepherdess' which proved to be among their most successful issues. They were not very large figures, being only $6\frac{3}{4}$ inches high, but they were acclaimed on all sides as extremely attractive and many copies were sold. A pair from the Godden collection is shown in Plate 75, and one can be seen in Colour Plate I.

The colours employed by Messrs. Minton for their Parian were delicate subdued blues, pinks, greys and browns; and the varied combination of these colours when applied to the figures often enhanced them to a considerable degree. Minton was one of the firms which was fond of applying gilding or actual gold leaf to its figures, but this was not always an improvement—although it may have seemed so in Victorian eyes. If the gold was applied to any extent, it was inclined to impart to the figure a crudity which was not in keeping with the delicate colouring and good quality of the Parian.

Very little coloured Parian appeared before the Great Exhibition, and it did not really begin to filter on to the general market until about 1853.

The Royal Worcester Porcelain Company also carried out a good deal of experimenting with colour allied to Parian, and was as successful as Minton in producing quality work. This firm, which had already reached a high degree of fame for its beautifully executed colour work in other media, was fully experienced when it came to applying it to Parian and, as could be expected, the results were very fine indeed. The colours mostly used by the Worcester Company were browns, greens and a delightful plum-purple which gave the Parian a deep richness and tonal quality that can be recognised at once. The more we think of that plum-purple colour the more sure we are that the slightly-broken figure we had refused in Newcastle was a piece of Royal Worcester work—and we begin to wonder whether we were quite as wise as we thought we were.

Some firms toned the entire slip of their frit Parian, and the result was an article of one special colour—such as brown or green—which, in the case of utilitarian objects, was quite pleasing. Sometimes the slip was stained red and the finished tone was known as porphyry, which it was intended to resemble. Or it was stained a greenish colour to represent malachite, which it was called. We have seen pieces of Parian which had been made a light fawn colour by this staining process, but we have not been able to discover the name by which it was known.

Not a great deal of frit Parian was coloured, in relation to the amount put on the market, and it was not until the advent of the cheaper non-frit type that coloured work really came into its own. Numberless small firms again seized the opportunity to flood the market with crude work which was garish and had modelling which was distinctly poor. A collector will not find it difficult to detect this type of work and avoid it. It was manufactured with the intention of appealing to the poorer and uneducated masses of the public, and to compete with the highly profitable market of cottage ornaments being made in ordinary pottery.

The result was a deluge of rubbish, and much of it is still with us today. Unless one has some particular reason for specialising in this branch of Victorian manufacture, it is hardly worth buying. It is surprising to discover the exaggerated prices sometimes asked for this low-grade work. If the amount of money you have to spare for your collection is limited, do resist buying copies of this cheap Parian and reserve your resources for the scarcer but infinitely more beautiful work, plain or coloured, of good craftsmanship. The thrill experienced when one does discover a really worthwhile Parian figure or bust—impressed, perhaps, with the name of an art union long forgotten—is well worth waiting for.

Besides adding colour to Parian, some Birmingham firms developed the idea of combining it with other materials. One firm, Messrs. Potts & Co. of Birmingham, acquired Parian figures and groups from the Staffordshire manufacturers which it then combined with its own designs in brass, bronze and even silver-gilt. The efforts to do this were not very successful. But the

idea must have possessed some merit because one such piece, made by another Birmingham firm, Messrs. R. W. Winfield, was sold to Queen Victoria for use at Osborne House.

Most firms were content to restrict Parian to a combination with other forms of porcelain, although one or two attempts were made to ally it to coloured glass and some of these experiments were quite successful.

When other forms of porcelain were used, it was common for the parts which were not Parian to be enamelled in turquoise, green and gold. Some of these pieces were really magnificent. Elaborate openwork baskets bedecked with floral designs in coloured enamels, apart from the Parian parts, were also made—but these, because of their original fragility, are very rare.

The beauty of the best coloured Parian set off a craze for amateur colouring of plain Parian between 1870 and 1880. This explains why some of the examples of coloured hard-paste Parian found in curio shops today are so crudely coloured. The majority of the amateur artists were dilettante dabblers who managed to do little more than mutilate otherwise good figures.

It must not be thought that the Parian body was employed solely for the manufacture of decorative figures and groups. On the contrary, it was largely used for utilitarian articles—countless thousands of decoratively moulded jugs; vases; butter dishes; and even tea services. In these cases, the inside surface of the article was glazed. Parian is slightly porous, and the added glaze was both a hygienic necessity and an aid to cleaning. This explains a point which often puzzles collectors of Parian in the early days, when they are becoming acquainted with the material. We have sometimes been told, even by the owners of antique shops, that a certain article could not possibly be made of Parian because the interior carried a highly glazed surface. But this is not the case. As we have said, the purpose of the application of lead-glaze to some non-frit Parian was merely to ensure that the article was entirely non-porous and so served the purpose for which it had been made.

The Parian body could be readily tinted, and many coloured vases and similar objects are really of tinted Parian although they are often not recognised as such. For example, the splendid and expensive Minton Pâte-sur-Pâte ware, such as those pieces shown in Plates 82 and 83, 86, and 88 to 92 in Geoffrey Godden's *Victorian Porcelain* (Herbert Jenkins, 1961), are made from coloured Parian.

The 1871 exhibition included much glazed Parian and Minton's art director, Léon Arnoux, noted in his official report:

> Messrs. Minton, and the proprietors of the Porcelain Works of Worcester, in order to obviate the difficulty of cleaning Parian when soiled, have found the advisability of glazing it, and this we think an improvement when it is applied to the decoration of our tables in the shape of comports, baskets, or centre-pieces . . .

Arnoux, in the same 1871 report, mentioned:

> It is not unlikely that the reader has noticed, in the course of the last few years, large quantities of glazed Parian covered all over with a high

lustre, possessing the various iridescent hues peculiar to mother-of-pearl . . . The Royal Porcelain Works of Worcester, and the Belleek Company in Ireland, have produced the largest quantity of goods of that class . . .

Arnoux also noted:

The Exhibition contains a good selection of glazed Parian ornaments in celadon and white. This pottery had a great success in the Paris exhibition of 1867, when produced for the first time by Messrs. Minton.

The graceful two-colour Minton figure shown in Plate 81 is a rare example of this type.

The Principal Manufacturers

The Parian figures turned out by Copeland and Garrett, and by Messrs. Copeland after 1847, did not deteriorate at all during the entire period that they were engaged in the manufacture of Parian ware. Whether figures, busts, articles intended for decorative reasons, or those solely for utilitarian purposes, their work remained of the finest possible quality.

Jewett wrote in 1878, when discussing the work of Messrs. Copeland:

> . . . in this ware it is a literal truism to say, perfection can no further go . . . the vases and other decorative articles . . . take rank with the finest productions of any age or any country.

This may sound like fulsome praise, but it is not undeserved. It is our opinion that this rather neglected aspect of Victorian craftsmanship is rapidly approaching the stage where it will take its place amongst the best porcelain production of all times.

There is no doubt that some of the best work of the leading ceramic manufacturers was copied directly by a few unscrupulous firms who made Parian figures and busts by using their rivals' high-quality copies as original models and cutting them up to make the moulds for their own cheaper products. We strongly suspected this had been done with an inferior piece of Parian we once saw. It was smaller than, but in all other ways identical to, the Copeland bust of 'Clytie' (see Plate 31), and we felt certain it had been so copied.

In every such case, the result was but a poor imitation of the original piece—but it sold on the cheaper market, and that was all that interested firms which had no pride in the quality of the work they produced. This copying of work made by the better firms came to its height after 1855. Due to the shrinkage which always occurred at the firing stage, these plagiarisms can often be detected—apart from their lack of quality—by the fact that they are considerably smaller than the originals they imitate.

There is no doubt that Messrs. Copeland were subjected to a certain amount of this copying of their work, and it is hardly necessary to warn the

new collector to keep a sharp look out for such falsifications. A person who has seen and handled a fine piece of Copeland Parian will not be easy to deceive in this way. No collector will be satisfied with work which is so much lower in quality.

Some very delicate and intricate trinkets and bric-à-brac were made by Copeland in the Parian medium. It is said that Queen Victoria was very partial to the neat tracery of the flowers and jewellery they made and that she purchased many pieces. It must be stated here, however, that other firms also produced delicate pieces of Parian jewellery (see page 66).

Messrs. Copeland impressed their name upon most of the Parian work they issued, and it has been said that they did not allow their better figures more than about three years in production before taking it off the market. But this is certainly not true of a figure called 'Innocence', which continued in steady production for about ten years. The firm, which was started in the first place at Stoke by the Spode family, is one of the best known manufacturers of ceramics still in existence. Its Victorian art director, Thomas Battam, who had been so closely connected with the original discovery and launching of Parian porcelain, died at the height of its popularity on 28th October 1864.

Another famous firm which still exists and also took great care not to reduce the quality of its Parian work was that of Messrs. Minton. The new collector can consider himself lucky to come across a Minton figure such as the well known 'Dorothea' (Plate 86) or 'Miranda' (Plate 70)—simple, but charming models.

Although it is of equally good quality, the Parian made by Messrs. Minton is quite distinguishable by an experienced collector from that of Messrs. Copeland. It is not as deep in tone, and it has a certain appearance of fragility which is very pleasing. It is not, in fact, any more fragile than the work of any other firm but it does possess this air of daintiness which we find quite entrancing. We pride ourselves that we can recognise a piece of Minton Parian on sight by this feature alone.

Herbert Minton (Plate 82) was in charge of the firm in 1845. His nephew, Michael Dainty Hollins, joined him as a partner in that year, when the firm started to manufacture Parian ware. By the time Herbert Minton died, in 1858, the firm had grown and flourished to such an extent that it employed 1,500 hands. It was the largest ceramic manufacturing company of the Victorian period.

Another nephew of Herbert Minton, Colin Minton Campbell, who was born in 1827 and died in 1885, was a partner in the firm from 1849. He was a High Sheriff of Staffordshire. A large statue of him was carved by Sir Thomas Brock, R.A., and was erected outside the factory.

The Minton firm started a new vogue in the use of Parian by combining it with other forms of ceramics, such as glazed porcelain. This soon became a speciality of the firm, and some extremely beautiful pieces were made in this manner from about 1851 onwards. The technique was used to manufacture such things as dessert and tea services, a number of which were exhibited on the Minton stand at the Great Exhibition of 1851, where the new application

of Parian in combination with other materials was well received. Indeed, it was said by the jury in control of the exhibition that the work was '. . . of great and exquisite beauty' (see Colour Plate II and Plates 72 and 79).

Minton's put Parian to use in the manufacture of tableware more than any other firm of the period. A good many of these articles, such as the butter dish shown in Plate 69, were objects of real charm quite apart from their utilitarian purpose. The company also made a feature of gold decoration on its Parian ware, and this was applied to tableware as well as to figures. Other firms also employed tasteful gilt borders or other enrichments on their matt-white porcelain.

Minton made a point of employing well known artists and modellers, a number of whom came from France to work for them. Many of these artists are considered by name and achievement in Chapter VII.

Apart from the successful combination of Parian with other materials and the fine figures they made, Minton produced some really outstanding equestrian statuary which brought them instant recognition as being in the top rank of Parian makers. One such figure was that of 'Amazon' by Fauchère. They continued to manufacture Parian until late in the 1890s, by which time the market had become flooded with cheaper work by lesser firms.

The majority of the Parian work turned out by Messrs. Minton after 1862 carries the impressed name mark of the firm, and in many cases also their own impressed year mark as reproduced on page 87. Earlier examples bear the arrow-like mark shown on page 87. This makes it easy to identify and date their work with considerable accuracy, although sometimes care has to be taken owing to the rather poor depth of the impressions. We possess a jug in which this is the case: but the ability to recognise Minton work, and the sixth sense which is developed in the collector, leaves no doubt that the jug is a Minton piece. A list of Minton models is given on page 88.

Parian was a discovery which essentially belonged to Britain. Apart from a not very successful effort to establish it in America, its manufacture was mostly confined to Staffordshire and Worcester; and it heralded the commencement of a firm which became famous at Fermanagh, in Ireland. This was the Belleek company, which must certainly be included in the front rank of Parian makers.

The Parian work of the Belleek factory possessed its own marked qualities which, in the better examples, were very fine indeed. An outstanding feature was a sparkling effect which reminds one of frost glistening on a hard surface. This effect is very attractive, and it is not difficult to recognise. It was achieved by the use of a particular kind of felspar in the manufacture, although the overall method remained much the same as that used by the other firms we have discussed.

Charles Locke Eastlake, in *Hints on Household Taste*, published in 1878, refers to this lustre or frost-like appearance of Belleek Parian by stating it '. . . glistens like barley sugar'. This is a very apt phrase which will bring to the minds of older people the glistening texture on the sugar watches and animals which they used to find decorating Christmas trees.

D

The idea which led to the establishment of the Belleek factory was born in 1851 when a Mr. John Bloomfield, who was a landowner in County Fermanagh, Ireland, visited the Great Exhibition in London. Whilst on this visit, Mr. Bloomfield discovered that felspar was an important ingredient of the Parian work which had captured his attention. He was aware that on his own land in Ireland there were considerable deposits of felspar. But he knew nothing of the quality or type of his felspar, and this was something he determined to discover as soon as possible. He did know, however, that another ingredient of Parian—china clay—existed beneath the grass of his fields, and it did not take him long to realise what this combination could mean to him in terms of money.

In due course, he contacted Messrs. Kerr and Binns of Worcester, who were turning out a type of Parian he had greatly admired in London, and it was agreed that tests should be made of the Irish felspar. It was soon discovered to be much purer than any English felspar so far in use. Further details were discussed and settled, and by the early part of 1853 Kerr and Binns were using the felspar from Fermanagh exclusively. The resultant Parian figures were put on the English market under the name of 'Irish Statuary Porcelain'.

These figures were much whiter in tone than previous Parian, but they were of a specially beautiful quality. This would suggest that the colour of Parian was indeed governed by the quality of the felspar rather than the effects of the firing, as had been previously declared by Léon Arnoux (see page 23).

Using this felspar, the Worcester company made a wonderful dessert service in Parian for display at the Dublin Exhibition in 1853. This service had gilded decoration, and the larger pieces were supported by Parian figures modelled on characters from Shakespeare's *A Midsummer Night's Dream* (see Plates 55, 56 and 57). It was a tremendous success, and an immediate demand for Irish felspar was created amongst the English manufacturers. Soon, Mr. John Bloomfield was a much richer man.

He was also a very astute man who appreciated the enormous market for and possible development of Parian. Accordingly, he decided not to leave the use of his own natural resources entirely in the hands of other people. He made up his mind to open his own works. For apart from the necessary felspar and china clay for the manufacture of Parian, there was also plenty of fuel available for the kilns in Fermanagh.

After abortive consultations with London financiers, Mr. Bloomfield approached Mr. David McBirney, a wealthy man who was the owner of a large store in Dublin. And Mr. McBirney, after a series of conferences decided to finance the establishing of the proposed works. Soon after that, kilns were built at Belleek on the River Erne. This was within easy reach of the sea—a great advantage from the point of view of trading with England and America. The river was to be used as the source of power for the works and to this end a water-wheel was built. It was quite a large wheel for the times, capable of providing one hundred horse-power.

In 1857, the firm started up in business under the name of McBirney and Armstrong. Why the name of Bloomfield did not appear is not clear. It has been asserted by some authorities in Ireland that the factory did not really begin work until 1863, but there seems to be a good deal of doubt about this.

At its commencement, the firm employed about seventy hands; but success fully deserved by the good quality of its work, soon brought the number of employees to two hundred.

R. W. Armstrong, who was with the firm from the start in conjunction with Mr. McBirney, acted as the art director. He had been one of the men who had taken a large part in the early experiments and trials with the Fermanagh felspar. He was a very capable man and there is no question that a good deal of the success of the firm was due to his efforts.

Belleek produced pieces both in soft-paste and hard Parian, and from the beginning there were distinctive differences between its work and that of other firms. It is said that it was the only firm which managed to turn out work which was not entirely composed of soft-paste or hard-paste but was a combination of the two. Such a technique called for an even higher degree of skill for its manufacture than was necessary with single-paste work. This meant that the men employed by Belleek were craftsmen of the highest standard. The pieces produced by this method were accordingly expensive in relation to the prices ruling at the time, and they did not create a very strong market. (From the collectors' point of view, this was rather unfortunate because it has made early Belleek ware something of a rarity.)

It was not long before the name of the firm was changed to McBirney & Co.; and in the early 1860s, it concentrated on the making of utilitarian goods rather than decorative pieces. Many articles such as vases, jugs and tea sets were designed, and the tendency was towards a naturalistic treatment which showed a distinctive incorporation of marine motifs such as sea-shells, etc.

Soon, other beautiful features began to show in Belleek work. The firm tried out a new adaptation of hard-paste, which was pressed into an extremely thin egg-shell quality; and it was discovered that a thin glaze laid over this very thin Parian produced a result which was strong, attractive and startlingly light in weight.

This extremely delicate work was a success with the public as soon as it was placed on the market—and this can be fully appreciated by collectors who have the good fortune to handle any of this exquisite Irish production. As far as we know, the Belleek effect of delicacy was never emulated by any other maker of Parian.

A great disadvantage with hard-paste Parian was the difficulty experienced in keeping its rather coarse surface free from dust and dirt. This problem was tackled and completely overcome by the Belleek firm. It carried out experiments with a new form of lustre glaze which had been invented by a Frenchman, Jules Brianchon, in 1857, and discovered that when it was applied in a certain manner to Parian it prevented the adherence of dust and dirt, other than what would be considered normal, to the finished product. The lustre or glaze was made by mixing together thirty parts of resin, ten

parts of bismuth nitrate and forty parts of lavender oil. The mixture was allowed to cool and then a further quantity of lavender oil was added. A slight variation of the mixture was used to obtain a delicate mother-of-pearl effect which, once seen, is quite unmistakable. Perhaps it was the mother-of-pearl appearance that turned the minds of the Belleek designers towards sea-shells and sea-horses. Their designs also included mermaids, fish and other types of marine life.

Much of this work was easily broken, and not a great deal of it has lasted until today. In consequence, even chipped pieces are hard to find and are also expensive. Breakages were made all the more likely by the specialisation of the Belleek factory in the production of openwork Parian baskets.

Queen Victoria, who showed considerable interest in Belleek work and bought many examples, was particularly attracted by the baskets which, besides being in openwork design, were made in the glazed parian.

Baskets had been made in Parian by other firms, but nothing had been manufactured to equal the delicacy of Belleek workmanship. Belleek baskets were often decorated with floral designs, and the individual flowers were made by hand by the girl workers—the hard-paste Parian slip being worked into shape and modelled by the pressure of the thumb into the palm of the hand. Roses, shamrock leaves and thistles were often conjoined in these beautiful designs.

Should a collector wish to specialise in a particular maker's work, it is suggested that Belleek Parian would certainly be a very good choice—although the collection would not grow by leaps and bounds and prices would not be cheap. But when such a collection had reached a reasonable size, it would be one of great beauty and fragility as well as representative of some of the finest Parian made in Victorian times. It would also be a valuable collection.

The Belleek firm is, incidentally, still producing very fine glazed Parian-like ware in its traditional styles.

Numerous other firms took up the manufacture of Parian once it had become popular—so many that it would be quite impossible to include the names of all of them or a description of the variations of their products. We are therefore confining ourselves to a review of the work of those whose output can be considered as the best in artistic quality and of the greatest interest to anyone starting a collection of Parian.

Amongst the firms not too concerned with Parian ware at the outset was that of Messrs. John Rose & Co. of Coalport. This firm did not make a speciality of Parian work; consequently, the figures it did make were limited in quantity. But they were by no means limited in quality. The Parian work was, in fact, of outstanding merit—as one would expect from such good ceramic manufacturers. Although the company made no effort to produce Parian on the same scale as Copeland, Minton or Belleek, the limited number of pieces Coalport did produce are considered to be a great prize when they are discovered today—and they are well worth searching for.

One particularly fine specimen made by them in about 1850 was a figure of the Duke of Wellington, $10\frac{1}{4}$ inches high, modelled by G. Abbott. The

impressed mark includes the wording 'manufactured at Coalbrook Dale'. If you should come across an unbroken copy, buy it at once and consider yourself very lucky.

The Coalport Parian work was excellent in every way. We, sadly, have only come across two specimens. These were discovered in London and, surprisingly enough, were quite reasonably priced. Unfortunately, the person who found them for us did not realise the scarcity of Coalport Parian and therefore did not buy them but waited to consult us. By the time we contacted the owner, a dealer—who realised only too well the rarity of the pieces—had bought them. We could not trace him, and so two lovely examples of Coalport Parian were lost to us. We are, however, able to illustrate two fine examples in Plates 95 and 96.

We still live in hope that one day we shall be able to add a delightful piece of Coalport Parian to our collection. Experience has taught us that, when one is least expecting it, a corner is turned and, suddenly there in a shop window is a copy of a wonderful work in fine Parian—and it could be Coalport.

Although the Coalport works did not make a speciality of Parian, it did include a number of pieces in its display at the Great Exhibition. It had also taken its place amongst the firms which had started to combine Parian with other media.

Just prior to the introduction of Parian ware, during the 1840s, the Worcester porcelain works—then trading as Chamberlain & Co.—was in the doldrums and passing through a very difficult period in its history. But this fine old firm overcame its initial difficulties and managed to carry on until 1852, when a change of management took place which certainly affected the firm to its lasting benefit and laid the foundations of its present-day success. For in 1852 the Worcester porcelain factory came under the direct and complete control of W. H. Kerr and Richard W. Binns. The latter was a well known designer of ceramics who persuaded W. H. Kerr to join him in an effort to revive the fortunes of the struggling Worcester firm.

The two men came to an agreement, and their entry into the business brought a fresh outlook to the depressed firm and instilled a new surge of life into the works, as a result of which the prestige of the firm improved. Mr. Kerr tackled the business problems and Richard Binns took over the artistic directorship, trading under the style 'Kerr & Binns' or, on occasion, 'Kerr & Co.'

The first of Mr. Binns' endeavours was to revive the manufacture of the previously successful Worcester Grecian-styled vases and statuettes. The general methods of production were modernised and a special section of the works was set aside and equipped for the modelling of what was called 'Statuary Porcelain' but was in reality Parian figures.

Under its new management, the company had agreed to experiment with the felspar that had been discovered in County Fermanagh, Ireland, and it was this felspar that they used in the manufacture of their Parian figures in the newly-created department of their works. It was for this reason that the figures were put on the market under the name of 'Irish Statuary Porcelain'.

They exhibited this ware at the Dublin Exhibition in 1853, and many of
the figures were given very high praise. They were whiter than the Parian
shown previously by other English manufacturers—as was the later Belleek
work made from the same felspar—and it was this new departure in Worcester
Parian that contributed to the fascination it exercised over visitors to the
exhibition. It lacked, however, the wonderful lustre later achieved by the
Belleek Company.

The Worcester figures were exhibited under the name of W. H. Kerr &
Co., Royal Porcelain Works, Worcester; and there is no doubt that the
exhibition did create a big demand for them. So much so that the firm opened
special sales depots in Ireland, and even in America, and a good deal of
Parian and other ware was sold in this way. The present Royal Worcester
Company succeeded Kerr & Binns in 1862 and also produced very fine
Parian ware.

Another porcelain manufacturing firm had opened in Worcester in 1801,
started by Thomas Grainger. In time, this firm turned its attention to parian
and specialised in making very delicate pierced vases and dishes in this
material. It also made figures of good quality. Thomas Grainger died in 1839,
to be succeeded by his son, George. The firm was taken over by the Royal
Worcester Company in 1889.

When the famous Staffordshire firm of Wedgwood first started to manu-
facture Parian, it did so under the name of 'Carrara'. As previously men-
tioned, it was a case of choosing a name which denoted that the product
carried a strong likeness to a particular marble. But the name did not persist
for long. It was soon absorbed in the generally adopted one, Parian.

Like other firms of good standing, Wedgwood also engaged the services of
the best modellers of the day for the designing of Parian work, and put on a
show of splendid figures for sale to the public. As in the case of the Worcester
company, Wedgwood did not make a particular feature of turning out Parian
work; but as one would expect from a firm of its reputation, the work it did
produce is well worth making a special effort to find today.

One firm fell so completely under the influence of the manufacture of
Parian that it gave up making any other commodity and turned the entire
works over to its production. But in spite of this absorption in the making
of Parian, the firm did not cheapen its products in any way. We have some
very good examples of its work in our collection. The name of the firm was
Messrs. Robinson & Leadbeater, whose sole partners were Mr. James
Robinson and Mr. Edward James Leadbeater. These two men started the
firm in 1865. Relating to the type of work turned out by them in both frit
and non-frit Parian, it was written in *The Pottery Gazette* of June 1893 that
they '. . . now occupy the unique position of being the only concern who
devote their entire energies to the perfection of that most beautiful ceramic
production, Parian'.

In 1865, Robinson & Leadbeater took over the machinery and moulds
which had been used by Giovanni Meli, who had been employed as a free-
lance modeller by various firms before starting his own works in 1852. It is

known that Robinson & Leadbeater did make use of these moulds; and as Meli marked his work with his initials on many occasions, it is possible that some of the figures which have been attributed to him may, in fact, have been made by Robinson & Leadbeater—although the original modelling would have been the work of Giovanni Meli.

The new partners adopted a speciality, concentrating most of their efforts on the production of portrait busts of famous men and women of the times. These were seldom made above 7 inches in height and were sometimes smaller. The firm did, however, make a certain number of larger busts as well. We came across one not long ago. It was of Beethoven and was 20 inches high. The smaller-sized busts are quite easily recognisable after one has had a little experience of them, as is the quality of the Parian of which they are made.

By the end of the 1860s, when the manufacture of frit Parian had about reached the height of perfection, Messrs. Robinson and Leadbeater were firmly established and then turned exclusively to the manufacture of Parian. They had in their employ a young modeller named Roland Morris, who had succeeded in creating a good reputation for himself in recognition of the work he had accomplished. This young man soon became chief designer for the firm. Perhaps it was because this one person took over the entire designing of the busts that there is a suggestion of sameness about them that tends towards monotony. It becomes quite easy to recognise a Robinson & Leadbeater bust at a glance, without turning it over to check the mark on the back (see Plates 90–4).

A certain amount of coloured work was also made by this firm, but it did not make a speciality of it—probably due to the fact that most coloured Parian was made from non-frit paste and the majority of the Parian made at this factory was of the frit variety. The tint of the Parian turned out by Messrs. Robinson & Leadbeater closely resembled the creamy-ivory tone which was particularly obvious in the work of Messrs. Copeland. From this, it is reasonable to assume that the composition of the frit used by the two firms did not differ to any marked degree.

Robinson & Leadbeater marked almost every model they turned out by impressing their initials, 'R. & L.', on the back of the bust. On their better-class work—not to suggest that any of their work was poor—these initials were enclosed within an impressed oval line. The contraction 'Ltd.' was added to the mark used after 1887, although it was not added to the standard impressed initial mark.

It is generally accepted that Robinson & Leadbeater continued to manufacture Parian longer than any other company, and they certainly did so until the early part of the twentieth century.

An alphabetically arranged list of the many manufacturers of Parian goods, with their working periods and marks, is given in Chapter VIII, on page 59.

Chapter V

Gathering, Recording and Displaying your Collection[1]

Gathering a collection of Parian figures will bring you many hours of pleasure as you hunt amongst the interesting and beautiful antiques in the shops you visit during your search. You will find yourself looking forward to these expeditions, and you will make many friends amongst the antique dealers upon whom you will call. They are friendly people, and they enjoy chatting about the varied articles they have on display.

Even though you do not buy something each time you call, you will always be sure of a welcome and encouragement to browse around. The dealers will soon realise, when once you have made yourself known as a collector of a particular subject that you will have your individual attitude towards your speciality and that you will be inclined to fuss a bit about the articles in which you are interested.

As a dealer once remarked to us: 'We dealers know a little about a lot of things but we cannot be expected to be experts on everything we have in the shop. We find that our customers who specialise in a given subject are the experts on their pet subject, and we are constantly learning from them. The more we chat with them the more we learn.'

During your early days of collecting, don't be timid about entering and browsing around any antique shop you may come across, even though you have never visited it before. You will be welcome, and you won't be pestered to buy something you don't want. If you mention your special subject, you will probably find that the dealer will go out of his way to try to obtain pieces for you and will get in touch with you when he is successful. Besides being a pleasant person, he will also be a businessman.

You might find that the prices of Parian vary considerably in different districts. We were offered two rather nice Parian figures in a certain important town at a price of £75 for the pair. We would have been delighted to have added the figures to our collection if the price had been reasonable because

[1] This and much of the following chapter is primarily addressed to the beginner-collector; the authors, therefore, ask the indulgence of the more experienced readers.

they were very beautiful specimens, but did not buy them because we considered them much too dear.

Do not let this discourage you and make you think that you will always be expected to pay anything like such prices for most Parian figures. You won't. Those two pieces were, in fact, grossly overpriced—splendid though they were. The same shop was asking £32 for a copy of a Minton 'Dorothea' (see Plate 86) which we had already bought from another dealer for only £8.

The point we are making is that prices do vary a great deal in different localities, and even in shops in the same district. We realise that we were very lucky to be able to buy a 'Dorothea' for £8. As it is a very fine unbroken figure by a well-known maker, we would have been prepared to pay more. At the time, £10 would have been reasonable; but since then, prices have climbed higher.

The thing you must do is to hunt around as wide an area as you can and buy your figures whenever you are offered them at what seems a fair price. But remember that the value of good Parian work is on the way up now that it is becoming recognised as a worthwhile specimen of Victorian artistic production—and this applies especially to figures and busts. Provided that you do not overpay to any great extent, you need not fear that you are going to suffer depreciation of your outlay in the future. Indeed, the tendency should be for the value of your collection to rise.

Good bargains are still to be found, and it is up to you to search them out and buy at prices which suit your pocket. But the day is rapidly approaching when bargains will be hard to find. You would therefore be wise to set yourself a standard to which your collection should conform—and we have no hesitation in advising you as to what that standard should be. When you come across a piece of Parian, be it bust or figure, always ask yourself if it makes a definite appeal to you. Do you like it entirely for its own sake, and will it give you pleasure to own it, quite apart from the fact that it is made of Parian? If the answer is yes, and the piece will fit as a unit into your collection, then buy it—always remembering to try to get it on the best terms you can.

If you take this attitude from the beginning, and try not to deviate from it, you will find that you can well agree with Bernard Berenson, the authority on Italian art, when he said, 'Where were my eyes yesterday?' With the passing of each day, you will discover in each piece some fresh aspect of pleasure that you had missed before, and your delight in your collection will become a growing thing in your life.

As your collection grows, you might realise that a particular aspect of Parian ware is starting to impinge upon your consciousness and is creating an interest particularly its own. In other words, you are approaching the final stage of collecting—that of specialisation. This will come as your knowledge of the subject increases, which it cannot fail to do with the constant handling of good specimens.

There are dozens of ways in which the urge to specialise may develop. You may be drawn to the work of one particular firm as opposed to that of others.

You may decide to collect only historical figures, or royal figures, or named figures; or art union issues may appeal to you to the exclusion of other work. But whatever form it takes, you will realise that you have found your own niche in the world of collecting. From that time forward, your interest in your hobby will intensify. Your hunt for specimens will become more direct; and when you make a find, the feeling of elation will be all the more satisfying. Price will not play such an important part in your decisions. When you find a piece that cries out to your specialistic instinct, you will be ready to make a much greater sacrifice to own it. And it is here that we should point out that most antique dealers are only too willing to reserve a specimen against a deposit on the agreed price.

When you find yourself in the grip of specialisation, you will begin to wonder what you are going to do with the pieces you bought in your early days of collecting and which do not now fit into your scheme. You can, of course, always sell such pieces or, perhaps, form them into a separate limited collection to which you will not add.

A specialised collection eventually attains a greater market value than does a general one; but most specialists do not consider this to any degree, their main object being to gather a specialised collection irrespective of basic values. The more they concentrate upon one aspect of their hobby the more absorbing they find it becomes and the less they are concerned with the financial angle.

After you have given yourself over to specified collecting, however, you will still find it quite difficult to resist the temptation to buy an available fine specimen although it by no means falls within your chosen range. We speak from experience in this matter and we know there is only one way out of the difficulty, and that is the exercise of strong personal discipline. Unless you are in the happy position of being able to indulge yourself financially, you must be resolute to a painful degree and force yourself to be content with just admiring the piece and leaving it in the shop.

From the beginning, it is a good idea to keep an accurate record of your collection. We have found the most satisfactory way to do this is to use a small loose-leaf book to which pages can be added as the need arises, devoting a page to each piece. Before making any entries in the book, attach a self-adhesive label—of the type which can be bought at any stationer's—to the base of each model in your collection and number each one consecutively.

Divide the pages of the book into suitable sections and fill in all details relating to each specimen (see sample page), being very careful to remember to number each page with the corresponding number on the Parian figure. You may prefer to use some form of card index system, but that is a matter of personal choice. Whichever method you choose, however, we urge you to keep a record of some kind because memory is an elusive thing, especially with the passing of the years after the purchase of a figure.

Do not neglect to keep the record up to date as you gather additional information relating to a piece in your collection. It is surprising how often one comes across fresh facts months after buying a figure—which should be

DATE	20th. OCT./67.	PAGE 39
FROM	ANTIQUE STALL: PORTOBELLO Rd. LONDON	
PRICE	£12-10-0	
OBJECT	PARIAN BUST	
TITLE	"APOLLO"	
MAKER	PROBABLY COPELAND	
MARKS	C. DELPECH (REDI) ART UNION OF LONDON 1861 ❋	

REMARKS

❋ PLINTH MARKED:-PUBLISHED FEB. 1st. 1861

GREEK MYTHOLOGICAL GOD OF SUN: LIFE:
POETRY. ART AND ALL THINGS FORTUNATE.

SEE PAGE 40 "CLYTIE."

ORIGINAL MARBLE IN BELVEDERE GALLERY:
VATICAN: DISCOVERED BY FRASCATI: 1455:

COPIED FROM GREEK STATUE 3rd. CENT. B.C.
PROBABLY FROM REIGN OF NERO:

P.T.O.

recorded in your book immediately. The information you could come across a long time after buying might include the name of the original sculptor, the date of his birth and death, or details of his training, and perhaps where the original statue is situated and the name of the present owner. But don't expect all of this to come your way fortuitously. An odd hour spent in the reference room at your local library can bring a good deal to light.

If any of your Parian figures are from a manufactory which is still a going concern, you may be able to obtain most of the information you desire by writing to the current art director; but do not forget to enclose a stamped addressed envelope. Remember that you are asking a busy man to give you some of his time, which may even involve a certain amount of research into the early history of his company. Some of the larger firms have their own museums which contain many examples of their early work, of which the curator may be able to oblige with information.

As time passes, you will appreciate your records and will not regret the work that went into the compiling of them. A check against the number on the base of a figure in your collection will lead you to a wealth of information concerning that piece—facts which you would almost certainly have forgotten if it had not been for your records.

An aspect of your collection which at first you might consider of greater importance than recording it will be the displaying of the figures in your home. You will soon become aware that odd figures standing apart from each other in various places is not a really satisfactory way of displaying them and does not present the idea of a collection. The odd figure here or there in a suitable niche can be quite attractive, in certain instances; and there might be a case where a figure appears to have been made specially for a particular spot. But the important thing to remember is that they are a collection and should be displayed as such. Apart from that, there is no doubt that the figures gain an indefinable quality by being grouped together as a unit.

If the room in which you have decided to display your collection is already fitted with a built-in alcove, you have no problem. Such an alcove will serve as an ideal focal point for the display. It will probably need some adjustment in the form of added shelves, but that should not prove too great a difficulty. But do ensure that the walls are firmly plugged where the ends of the shelves are to come to rest, as a large Parian bust or figure is a weighty thing. And remember that the shelves will not necessarily have to be arranged an equal distance apart. The pieces of Parian which go to make up your collection will be of various sizes.

We have figures which range in height from a 22-inch 'Lady Godiva' by Monti (see Plate 37) to a four-inch bust of Shakespeare by W. H. Goss (see Plate 52). This large divergence in size was overcome by displaying the smaller figures and busts on shelves built into a corner of the room on the principle of an open corner cupboard, and leaving the larger models in a section of their own on the opposite side of the room.

Shelves made of wood are more satisfactory than glass ones for Parian, again due to the weight of some figures.

The question of a suitable background for figures is also very important. We suggest an attractive plain wallpaper, or an emulsion paint specially mixed to a colour which tones with the general scheme of the room. We settled for the latter method and did consider painting the shelves the same colour, but after some experimenting we decided to paint them white.

A good deal of time can be spent in arranging figures upon shelves and forming different compositions in an effort to decide which has the most pleasing effect. We have devoted many happy hours to doing this, arranging and rearranging—and if we are allowed to form a judgment of the result from the admiration of our collection shown by visitors, then we have been quite successful.

It is best to avoid cramming too many specimens on to the shelves. Just because you have forty pieces, it does not mean that they all have to be displayed at the same time. It is a very good plan to show only a third of your collection at a time. The display will be much more tasteful, and you can change the selection at intervals by bringing other pieces out of reserve.

The question of lighting the collection is governed to a great extent by the general lighting of the room; but judiciously arranged lights do give a dramatic and effective finish to a collection upon which time and care has been lavished. A special electrical installation is hardly a thing to be tackled by an amateur, however, and is best delegated to a professional electrician.

Buying, Cleaning and Repairing Parian

One day, when we were out on a 'hunting tour', we were delighted to see a particularly fine Parian group in the window of an antique shop. We had bought work from the dealer on previous occasions and knew him to be a very fair man. What added to our already whetted appetites was the fact that the piece was marked with a low sale price. In great glee, we entered the shop. But we should have guessed the truth before entering. The lovely Parian group was broken—and rather seriously, at that—although it had not been obvious from the window.

The dealer appeared to be generally affected by our disappointment and, during our ensuing conversation, he told us that, on average, four out of every six good pieces of Parian that came into his hands were broken or chipped to some extent, although often not really seriously.

You will find this to be true as you go around collecting; but don't think that you will never come across a perfect figure. You will undoubtedly discover a number of pieces which are quite sound and reasonably priced during the course of your hunting.

With damaged pieces, however, it is noticeable that breakages seem to have occurred considerably less frequently with busts than with full-length figures. This would be because the busts have far fewer projections and sharp features to suffer careless handling.

The point is that you will often find yourself wondering whether to spend your money on a piece which is not too badly broken. In such a case, you will probably be strongly tempted to buy because of the low price at which the item is offered. But a decision should be made only after careful consideration, even if time is short. In your early days of collecting, you might be reasonably well advised to buy such a piece, provided that it is of good quality and made by a reputable manufacturer such as Copeland or Minton —assuming that the damage is not too great or the price too high.

Effective results can be achieved in the way of repairs if they are tackled in an unhurried and careful manner, and if the correct approach and materials are used. But we must impress upon you strongly not to spend money on a

piece which has been severely damaged. There is a great difference between attempting the repair of an example which has been only slightly chipped or cracked or even has a small part missing entirely—such as one finger from a figure, or a feather from a hat—and tackling a major repair. It is comparatively easy to repair minor faults; but in the case of a figure with a leg or an arm, or part of the head missing, you have no chance at all of successfully replacing the part and you should therefore refuse to buy.

Assuming that you have discovered an attractive figure or bust which has suffered only some minor damage that can be repaired, it is worth buying—unless you have arrived at the stage where your collection is of such a size that you can afford to ignore anything except really perfect pieces. Most dealers are very reasonable when it comes to damaged articles and are usually prepared to reduce the price accordingly.

Having brought your newly purchased figure home, you are now ready to tackle the necessary cleaning and repairs. Let us assume that you have bought a figure which is slightly chipped and also has a finger missing from one hand. We have chosen this example because we did once buy a figure damaged in this way which can be seen, both before and after we tackled it, in Plates 44 and 46.

The first thing to do, whether it needs repairing or not, is to give the piece a thorough wash all over in tepid water to which has been added mild soap or washing-up liquid. It is best not to totally immerse a Parian figure but to stand it upright in the water to a depth of two or three inches. The reason for this is that, owing to the shrinkage that occurred during firing, there are several small holes or vents in most figures. They were left there to allow the hot air to escape and so prevent the figure from exploding, as it certainly would have done when the shrinkage took place and the air in the figure became sufficiently heated.

These small holes were cunningly left where they would not be seen in the finished work. They are often located in the folds in drapery or similar convenient places, and it is sometimes quite difficult to detect them; but they are there just the same, and a careful search will reveal them.

If a figure is fully immersed, water will find its way into the model through the holes. Water can get inside quite easily, but it is really surprising how difficult it is to get it out again. It cannot be drained away without great patience, and it has an annoying habit of dripping slowly out of the figure on to your shelves for weeks, or until it has evaporated completely. These small holes will not, of course, be found in figures which were moulded in one piece. Such figures are completely hollow, and the problem does not arise.

Another good reason against total immersion is that Parian can become very slippery when covered with soapy water and a model might be dropped, even though the greatest care is taken with it. To lessen the impact in the event of such an unfortunate happening, it is advisable to wash Parian in a plastic bowl rather than in one of a hard material.

Many pieces of Parian are of a very intricate design and, during the washing procedure, parts of a model might be difficult to reach. The best way to

overcome this is to use a soft brush; an old shaving-brush is ideal. It proves most effective for poking into the crevices which could not otherwise be reached. Alternatively, a worn toothbrush that has become soft can be extremely useful.

After a good going-over with soapy water, it may be found that there are still spots of dirt left on the specimen which even the soft brush has failed to reach. To remove these, use a matchstick which has been slightly frayed at the end; but on no account use any hard object or you may find yourself with more trouble than you started with.

When the figure has received a thorough washing, rinse it in several flushings of clean water and then dry it carefully with a soft towel. Even at this early stage, you may be amazed at the great improvement: often figures will have been standing uncared for in a dusty and even smoky atmosphere for upwards of a century, with no effort having been made to remove the accumulated dirt.

After the piece is thoroughly dry, examine it minutely. You may be lucky enough to find that it is quite unblemished, apart from the damage of which you knew in the first place. Good class Parian does not stain easily and it may have remained untouched by the years but for the accumulation of dust and dirt.

During this first examination after washing, you might notice an odd black mark here and there—particularly in the crevices of drapery or similar places. It will be easy to see that these are not dirt marks but have the appearance of faults in the Parian itself; and that, in fact, is exactly what they are. They are flaws perpetuated in the process of manufacture, caused whilst the piece was undergoing the firing. Don't worry about them. They occur at times in even the best of work and are not considered a disfigurement in a true sense. It is rarely that they are very large in size.

You might find other defects after the washing, and these will probably show as areas of yellowish stain. Should this be the case, there is no need for despair. There are ways by which you can achieve their removal, one being the application of water to which a small amount of ammonia has been added. Do not use too much ammonia at first, and apply the solution by a gentle dabbing action with a wad of cotton-wool or some other soft material which has been soaked in the liquid. Do this directly on to the stain. If it does not remove the stain after a short time, add a little more ammonia and try again. This method is nearly always effective if sufficient persistence is used.

We have discovered that certain of the new enzymic cleansers are extremely useful in removing stains from Parian ware, whether of the earlier frit or the later non-frit type. The particular one which we have found very efficient is sold under the trade name of 'Big S'. In the case of an obstinate stain, try it. You will find it quite gentle in its action. The best way to apply it is to leave the stained part of the Parian soaking in the solution overnight. In the morning, it is highly probable that you will find the stain has disappeared completely.

It is not generally known that human saliva has distinct cleansing proper-

ties; but do not apply it direct from the tongue if you have first been using another method. Moisten a cloth with saliva and rub the stain vigorously with it and you will be surprised to find that it has powers far greater than one would expect.

If the methods so far suggested fail—although we are fairly certain that one of them will succeed in removing any ordinary stain—you can try the effect of a diluted bleach or detergent without fear of damage. A good bleach for the purpose is 'Peroxide of Hydrogen'.

Do not, except in extreme circumstances, use an abrasive of any kind. If you do, you run a grave risk of injuring the beauty of the sheen on the surface of the Parian. If the stain is really obstinate and an abrasive does seem to be necessary, however, it is not impossible to restore the silkiness of the surface. But do try every other method of stain removing first.

When reduced to the use of an abrasive, be sure that you use only a very mild one—and even then, pause and consider whether the chance of dulling the surface will be preferable to leaving the stain and accepting it as no more than an example of patina. We would prefer that to the chance of spoiling the surface of good soft-paste Parian. But if the stain occurs somewhere on the model where it is impossible to leave it, you must get to work with your abrasive.

Never use anything as hard as sandpaper or emery cloth. We would suggest nothing more fierce than the 'wet-and-dry' used for the rubbing down of the surface of a car during repairs to the body-work. Ordinary metal polish is a mild abrasive, and you might do worse than try that.

Whatever abrasive is used, it is more than likely that the part where it is applied will lose its surface sheen and you will have to do something about putting the damage right. To this end, wash the area again very thoroughly to remove all traces of the abrasive and then apply a good white wax. Purified beeswax mixed with turpentine, to enable it to be applied easily, makes a very good polish and often proves quite effective if the damage caused by the abrasive has not been too great.

It will be helpful to slightly warm the part of the figure to be treated with the wax before you apply it, but be careful not to make it too hot. The object of warming the surface is to enable the wax to penetrate to the greatest degree possible after the Parian has been roughened. It will also result in a smoother application of the wax, which will restore the original surface more accurately.

The Parian figure should now be clean and without a stain, But, remembering our example, it is still minus a finger from one hand. This can be replaced quite successfully—and on completion, the repair should be almost if not totally impossible to detect with the naked eye. It can be done as well as that if you take sufficient time and care over the work. And this applies to many minor repairs. But no major repairs should be attempted unless you have already had a good deal of experience. Such operations are best entrusted to the hands of a skilled professional, assuming the quality or rarity of the figure justifies a reasonable outlay.

The **first** requisite is absolute cleanliness of the part to be mended or

E

remodelled. This applies to both edges if two broken parts are to be joined together again and to the one edge if a new part is to be modelled and added at a later stage. There must be no dirt, grease or dust adhering to the parts which are to be joined together or perfect cohesion will be difficult from the start. Dust and grit are easily dealt with by washing; but if grease is present, it must be removed by the application of a solvent. Methylated spirits will serve the purpose quite well.

To stray a little from our original assumption, if the broken finger has been badly replaced in the first place and is still attached to the hand, the first thing to do is to remove it again in order to clean the surfaces to be rejoined. It can usually be taken for granted that the original repair was done many years ago, in which case it will be a certainty that the adhesive used was made from an animal basis of some kind. This will be soluble if sufficient water—and patience—is used. Persistence may be necessary because even old-fashioned glues hardened considerably over the years. The join will probably be very obvious because a ring of dust will have accumulated around it during its years of exposure to the atmosphere.

To remove the broken part from the main figure, rather warm water is the first line of attack. The simplest methods are often the most efficient and should always be tried first. If the glue used for the first repair was of an animal basis then warm water, or even hot water, applied for a sufficient length of time will generally do the trick and soften it enough to enable the required part to be removed. Do not be too quick to assume that the join is not going to break down with the application of water alone. Sufficient application may prove you to be wrong.

To take the worst view and assume that water is not effective, no matter how long you persist and even though it has been applied at quite a high temperature, it will then be reasonable to conclude that the original adhesive was not animal glue but a form of shellac—one of the first advancements made in adhesives. Use methylated spirits, and a generous saturation will usually result in the join giving way in a short time.

When the join has been broken down, both surfaces must be treated to remove all traces of the original adhesive. Further applications of hot water or spirits—according to whether or not the basis was an animal one—should soon attend to this. A sharp knife will prove useful at this stage to ensure that all traces of the glue are finally removed and to help make a good 'seat' between the parts to be rejoined. It may well take several days to reach this part of the proceedings.

Modern adhesives are a quite different proposition from those that were in use at the turn of the century. The best thing you can do at this point is to visit a shop which specialises in equipment for making models. Such a shop will carry a wide range of adhesives to meet the needs of amateur model-makers. Select one which is quite transparent and colourless; and enquire about its rate of setting. This is necessary because you will need to know how long you can spend over the job. Some modern glues set very quickly.

Another important thing is to discover whether or not the adhesive you

have chosen is soluble. If it is not and you fail to make a completely successful join the first time and allow it to set, then you will be in real trouble. So be careful to make full enquiries about the adhesive you decide to buy

At the same shop, you can purchase the pastes or compounds from which to model a finger. An exact colour match may not be possible. If it is not, you will have to colour the added finger afterwards. Some modern modelling materials set fairly hard and others set like a stone. It is the latter kind you require if other details such as pliability and colour coincide.

If a new finger is not necessary, it should be fairly easy for you to make the join with your adhesive. You might, of course, have to add a touch of colour to the join to give the job a proper finish.

The successful modelling of a new finger does not call for an excessive amount of skill. It can be done very well indeed with patience and careful attention to what you are doing. If you can secure a photograph of a similar model, it will help you very much. A useful point about the modelling of a finger or a small piece of drapery is that you can make it quite separately from the figure to which it has to be attached. You will therefore be able to make as many attempts as you wish and discard those which you consider to be unsuitable.

Having prepared a satisfactory new part, do not forget to allow it to harden thoroughly before joining it to the figure.

Once you have repaired the figure, leave it alone for the prescribed time to allow it to set. Do not be tempted to meddle with it. Prodding it about is the most certain way of making sure that it does not settle down properly. When it has set, however, the next step is to colour the added piece so that your work is as impossible to detect as you can make it.

The first materials which come to mind are the oil paints used by artists, but they are not very successful on Parian. Egg-tempera colours are much more effective and you can buy them already made up from any art dealers. When the right colour has been found, it will be found quite easy to apply and will cover the join very successfully.

After the egg-tempera colour has been applied, it may be that the original sheen of the Parian is not fully represented. To bring back the original appearance, use a soft brush and paint over the area you have coloured with a thin coating of almond oil. This will restore the sheen—but do leave it alone until it has quite hardened. You will then have achieved about as much as you can do in the way of repairing a piece of good quality Parian.

These really worthwhile methods will often convert a moderately damaged figure into one which you will consider quite satisfactory enough to enhance your collection.

Chapter VII

Sculptors, Modellers and Parian Models

Many of the modellers and sculptors whose work was produced in Parian were eminent Victorian artists. Parian copies were also made—particularly after the advent of the Cheverton reducing machine (see Plate 8 and page 24) —from statues which preceded the work of the contemporary sculptors. A complete list of those whose work was used, directly or otherwise, would therefore be quite beyond the scope of a single volume.

In view of this, we list here those whose work, whether by direct modelling or by reduction from existing statues, received the greatest attention.

Arnoux, Léon (1816–1902)

Born in Toulouse, Léon Arnoux came to England in 1848. This was a loss to the ceramic manufacturers of France because he is reputed to have been better versed in the techniques of porcelain making than any other man in France. He was also a born experimenter and was always striving to improve any production with which he was connected.

He took over the position of art director at the Minton factory and continued with his experiments. There was scarcely a type of ceramic in which he did not work, and he showed considerable interest in the newly discovered Parian.

Arnoux continued his association with Messrs. Minton until his death, on 25th August 1902, although he did officially retire in 1892. A good deal of the work for which he was directly responsible was shown at the Great Exhibition in 1851.

Baily, Edward Hodges (1788–1867)

Bristol-born Edward Hodges Baily became a pupil of Flaxman, under whose direction he worked from 1807. Baily gained the gold medal of the Royal Academy in 1811 and continued to exhibit regularly. He was elected an academician in 1821. Many of his works brought him recognition, one of the

best known being the figure of Lord Nelson which overlooks Trafalgar Square. He also produced the bas-reliefs on the south side of Marble Arch. Many specimens of his work were produced in Parian by various firms.

A list of his full-size sculpture is given in Rupert Gunnis's excellent book *Dictionary of British Sculptors, 1660–1861* (Odhams Press, 1953)—a work which every Parian collector should possess.

Beattie, William

This sculptor exhibited a good deal of work at the Royal Academy, mostly between 1829 and 1864. His work was shown at other major exhibitions, such as the British Institution. While living in Stoke, he did much modelling which was destined for production in Parian. He modelled work for Wedgwood from c. 1850 to 1864. Other firms for which he did modelling were Bates, Brown-Westhead, Moore & Co., from 1859 to 1861; W. Adams & Sons; and Sir James Duke & Nephews.

Bell, John (1812–95)

This artist, who was born in Norfolk, modelled a considerable amount of work for Parian production by Minton from 1845 to 1860. He also produced designs for Henry Cole's Summerly's Art Manufactures scheme (see page 106 and Plates 65, 70 and 86). As a sculptor, his best known works are the Wellington Memorial in the Guildhall and his statues of Sir Robert Walpole, Isaac Newton and Oliver Cromwell. He was also included in the group of sculptors commissioned to do work on the Guards Memorial in Waterloo Place and the memorial to the Prince Consort in Hyde Park.

Apart from his successful work as a sculptor and modeller, he also wrote a drama, entitled *Ivan*, and a number of professional treatises. Parian figures taken from Bell's originals normally bear his signature.

Canova, Antonio (1757–1822)

One of the greatest and most interesting of Italian sculptors, Antonio Canova was born in Venetia. It is considered that his greatest work of art was the statue 'Perseus with the head of Medusa', but before that he had established himself with great fame by the creation of 'Theseus and the Minotaur' and 'Cupid and Psyche'.

Canova was a prolific worker and he amassed a large fortune, but he was of a philanthropic nature and he used his wealth to good purpose. He was also generous in imparting his skill, and he put many young sculptors on the road to success by his tuition and help. Minton's reduced copies of Canova's originals have his name on the front of the plinth (see Plates 71 and 81).

Carrier, de Belleuse (Albert E. Carrier, 1824–87)

This French modeller worked mostly as a freelance and established an international reputation for himself. His models were commissioned or bought as

freelance work by many famous ceramic firms which were specialising in Parian figure work, particularly Minton; but Copeland, Wedgwood, Brownfield and Mayer all used his services at some time or other. His work was very distinctive in technique and can be recognised with little difficulty.

Cocker, George (1790–1868)

This figure modeller is mainly known for his pre-Parian white biscuit-porcelain figures or groups, which sometimes bear his signature. Cocker was apprenticed to the Derby factory but left in about 1817. He subsequently worked at Coalport and at Worcester, returning to Derby in 1821. In 1825, he left the Derby factory and produced figures on his own account, first in Derby and, after 1840, in London. In 1853, he moved from London to Stoke-on-Trent, where he was engaged by Minton and then by John Mountford and other manufacturers of Parian figures.

Cumberworth, Charles (1811–52)

Although having an English-sounding name, Cumberworth was born at Verdun in France and joined the art school of the Beaux Arts in 1829. From 1833 until 1848, he exhibited regularly at the Paris Salon. One of his most successful works was the statue of Marie-Amélie, Queen of France. Another outstanding work was the statue of the Duke of Montpensier. He also created a bust in bronze of Paul Féval.

Specimens of his work can be seen in the Museum of La Rochelle, including his statute of a 'Young Girl with a Dove'. An obituary notice in the *Art Journal* of October 1852 read: 'We announce with much regret the recent death in Paris, of a young and promising sculptor, M. Cumberworth, a pupil of Pradier. He was known here by statuette groups of "Paul and Virginia", "Young Indians" and several graceful figures moulded and cast by Alderman Copeland in statuary porcelain . . . his works indicate pure taste and true talent combined with originality.'

D'Orsay, Count (1801–52)

Count D'Orsay was another interesting character of divers abilities. He was both a portrait painter and a sculptor. Born in Paris, he was the son of an army officer, became an army officer himself and established a reputation as a man-about-town. He married the daughter of Lord and Lady Blessington and came to live in England. He was a prodigious worker, exhibiting work at the Royal Academy from 1843 onwards. He exhibited both paintings and sculpture. Much of his work was reproduced in Parian (see Plate 24).

He remained a man of fashion in England, and his house was always open to the artistic and literary people of London. A follower of Bonaparte, he returned to France in 1849 to join Prince Louis Napoleon in Paris, the two remained life-long friends.

Durham, Joseph, R.A. (1814–77)

An English sculptor who did work for the various firms which manufactured Parian figures, Durham studied under E. H. Baily and first exhibited at the Royal Academy in 1848. He was made a member of the Academy in 1867 after consistent exhibition. He was commissioned specially by Queen Victoria to model a bust of herself and one of the Prince Consort. These busts were modelled at Osborne House and were issued in Parian form.

Foley, John Henry, A.R.A. (1818–74)

Born in Dublin, Foley trained at the art school of the Royal Dublin Society and then came to England to become a student at the Royal Academy school. He exhibited his work at the Royal Academy from 1839, and in 1859 he was elected an Associate of the Royal Academy. He modelled directly for Parian work as well as allowing much of his original carving to be reproduced in the medium, mainly by Messrs. Copeland (see Plate 26).

Gibson, John, R.A. (1791–1866)

One of the most famous of English sculptors of the mid-nineteenth century, John Gibson was born near Conway. His father was a landscape gardener, and the family moved around the country a good deal due to this. When John was nine years of age, the family moved to Liverpool; and at the age of fourteen, he was apprenticed to a local woodcarver. But he was dissatisfied with this work and wanted to become a sculptor. After several abortive attempts, the determined young man managed to arrange for his apprenticeship to be transferred to a Samuel Francis, who owned a marble works.

John Gibson first attracted attention to his work with a wax figure symbolising 'Time', which he exhibited when he was eighteen years of age. This figure was particularly admired by the historian William Roscoe, who gave Gibson the freedom of his house and access to his valuable books. In this way, Gibson studied anatomy and developed a passion for the works of the Grecian sculptors.

His first work of real importance was 'Psyche', which he exhibited at Liverpool; and in 1816, some specimens of his work were exhibited at the Royal Academy. In 1817, he went to London and from there to Rome to study under Canova. When Canova died, five years later, John Gibson entered the studio of Thorwaldson. By that time, he was widely known and his work was in great demand. He was elected a member of the Royal Academy in 1836 but did not return to England. He made Rome his home until his death. He was greatly influenced by the work of Thorwaldson and, in this respect, a good deal of his work was taken from classical mythology.

As related on page 11, Gibson was responsible in great measure for the taking up of Parian sculpture by the Art Union of London, whose subsequent orders did much to popularise the new ware. His famous work 'Narcissus' was the first Art Union Parian figure (see page 11, and Plate 22).

Jeannest, Emile (1813–57)

This talented French sculptor produced several models for Minton between 1848 and 1852. Minton's Parian figures 'The Rose of England' and 'The Lily of France' are examples of Jeannest's work, both being first modelled in 1849.

Keys, Edward

This ceramic modeller was apprenticed at the Derby factory and progressed to become foreman of the figure department. He left Derby for Staffordshire in 1826 and was employed first by Daniel's and then, from at least 1831, by Minton's. Between 1831 and 1842, he modelled some of this firm's tasteful biscuit figures. In 1842, he started on his own account—a venture that failed—and from 1845 to 1853 he was employed at Wedgwood's, where he probably designed some of their Carrara, or Parian, figures and groups.

Keys, Samuel

This brother of Edward Keys (see previous entry) was also trained at the Derby factory and worked there before moving to the Staffordshire Potteries. He was with Minton by at least June 1833, as the factory wages books then record: 'Samuel Keys for Figures £5. 12. o.' He modelled many of Minton's figures up to about 1849, when he joined John Mountford—a partnership which produced good (but now rare) Parian ware up to 1857. They were exhibitors at the 1851 Exhibition (see page 82).

Macbride, John P. (1819–90)

Born in Liverpool, MacBride first exhibited at the Royal Academy in 1848 and continued to do so until 1853. The Glasgow Museum possesses a portrait bust of Colonel Peter Thompson by MacBride. A good deal of his work was reproduced in Parian but he did not do much direct modelling for this purpose.

Marochetti, Baron (1805–67)

Baron Marochetti was born in Turin, but the greater part of his life was spent in France and he became a naturalised Frenchman. He studied at the School of Beaux-Arts. Two of his most outstanding works were the equestrian statue of 'Richard Cour-de-Lion', which stands in the courtyard of the Palace of Westminster, and the equestrian statue of Queen Victoria, in Glasgow. A good deal of his work was reproduced in Parian.

Meli, Giovanni (c. 1815)

Sculptor and freelance modeller, Meli was born in Palermo. He made a number of models for Copeland & Garrett, Copeland's and other firms in the 1840s

and the early 1850s. He then established his own factory at Stoke for the production of Parian in about 1858. During the early 1860s, he did a certain amount of modelling for the firm of Sir James Duke & Nephews. His factory was taken over by Robinson & Leadbeater in 1865, after which he returned to Italy. But eventually he went to America, where he started a terra cotta factory in Chicago.

Monti, Rafaelle (1818–81)

Born in Iseo, in Italy, Rafaelle Monti was the son of Gaetano Monti, a sculptor of note. Rafaelle studied under his father and became successful early in life. While still young, he was awarded a gold medal in Milan for his group 'Alexandre-complant-Bucephale'. He worked in Vienna from 1838 to 1842.

After coming to London, in 1848, he exhibited a number of works at the Royal Academy and gained considerable fame for his figure 'Statue Voilée', which he executed for the Duke of Devonshire. The head of this figure was reproduced in Parian and was one of the most controversial pieces ever made in the medium (see Plate 29). By some experts it was declared to be a splendid work of art, but others described it as 'a mere work of technical trickery'. Certainly, no other sculptor succeeded as well as Monti in depicting the human form covered by a veil with the same exquisite sense of delicacy and accuracy.

Monti remained in England and died in London.

Powers, Hiram (1805–73)

An American sculptor, born at Woodstock, Hiram Powers started his career in Washington by modelling busts. In 1837, he emigrated to Italy and lived in Florence for the remainder of his life. He sent his work to the most important exhibitions all over the world, and it appeared at the Royal Academy in London regularly from 1841 until 1867. His famous statue 'The Greek Slave' was shown at the Great Exhibition in 1851. This figure was a great success and was one of many of his works which were reproduced in Parian.

Protat, Hughues

Protat was one of several talented Continental modellers employed by Minton at the Stoke-on-Trent factory. Several Cupid subjects were his work up to 1858, when he left Minton for Wedgwood. Protat moved to London in about 1864, but he continued to undertake modelling for the Staffordshire potters.

Steell, Sir John (1804–91)

Born in Aberdeen, Steell went to study in Edinburgh. Later he went to Rome, where he won his first notable success with his statue, 'Alexander and

Bucephalus'. He soon ranked as one of the greatest sculptors of the times. When he returned to Scotland, he was appointed sculptor to Queen Victoria. One of his most successful works was his equestrian statue of the Prince Consort. At the time of the unveiling, he was awarded a knighthood.

Toft, Charles (1831–1909)

Born at Hanley, Charles Toft studied at Stoke-on-Trent School of Design. He moved to Worcester and joined Kerr & Binns. Early in his career, he modelled some fine Parian busts for them (Plate 53). Toft left Worcester to become an instructor at Birmingham Art School in the early 1860s. He joined the Minton's in 1871 and became one of their most talented modellers. They reproduced much of his work, which was mostly figures, in Parian and many of the pieces were signed copies. Later, he went to work for Wedgwood as chief modeller but left in 1889 to start a small factory of his own.

Townshend, Henry James (1810–66)

This well known painter modelled jugs and figures for Minton in the 1840s, several of which were made in the Parian body. The 'Infant Neptune' included in the 1851 Exhibition was one of Townshend's models.

Westmacott, Sir Richard (1775–1856)

Born in London, Westmacott was another of the many young sculptors who went to Rome to study under Canova. He became very well known and returned to work in England in succession to Flaxman as Professor of Sculpture at the Royal Academy. He did much portrait work and made busts of Pitt, Addison and many other celebrities of the times. A number of monuments by him are in Westminster Abbey and St. Paul's Cathedral.

Whitaker, John (c. 1807–74)

This Derby figure modeller was employed at the Derby factory from 1818 until its closure in 1848. At this period, he joined Minton's staff. A John Whitaker also modelled for John Mountford and for several other firms.

Wyatt, Richard (1795–1850)

Wyatt was born in London. He was trained in Rome by Canova at the same time as John Gibson, R.A. He specialised in female figures, which were frequently reproduced in Parian.

Wyon, Edward William (1811–85)

This famous Victorian sculptor is, to Parian collectors, mostly associated with his models and bust-portraits which were reproduced by Wedgwood. Such specimens normally bear Wyon's name as the original sculptor.

Alphabetical List of Makers, their Marks and Models

The following pages contain a checklist of the many British manufacturers of Parian wares . . . giving the working period of each firm or partnership as well as details of any marks used on Parian. Cross-references are also given to other references to the same potters in this work, so that all relevant facts on any manufacturer are given in concise form in this chapter.

It must be noted that much Parian does not bear a maker's mark or name. As a rule, the leading firms with an established reputation to trade upon and uphold did mark their products; but the smaller firms, producing ware down to a price rather than up to a quality, did not mark their general ware.

Reference to the place-names Burslem, Cobridge, Fenton, Hanley, Longton, Stoke and Tunstall relate to the once separate townships which now make up the present city of Stoke-on-Trent—a district known as the 'Staffordshire Potteries'.

Adams & Bromley
(Working period 1873–86)

Adams & Bromley, of the Victoria Works, Hanley, succeeded John Adams & Co. (c. 1866–73). Jewitt, writing in 1878, noted in his *The Ceramic Art of Great Britain*, 'Parian portrait busts (among which were those of the Poet Laureate, Lord Derby, and Mr. Gladstone) were formerly produced, and were remarkable for their truthfulness and artistic treatment.' The firm was, however, mainly concerned with jasper and majolica ware rather than Parian. The marks 'A & B' and 'Adams & Bromley' were employed.

Adams, William, & Co.
(Working period c. 1769 to present day)

Messrs. Adams traded under several different styles from the 1760s to the present day, during which time a fine range of earthenware, jasper ware and porcelain has been produced. In the late 1840s and early 1850s, some fine

Parian groups and figures, now rare, were produced at the Stoke factory. One example from the Godden collection is shown in Plate 9 and this, like other recorded specimens, bears the impressed mark 'ADAMS'.

The standard work on the Adams potteries is *William Adams, An Old English Potter* by W. Turner (Chapman & Hall, London, 1904). William Turner noted:

> The firm of Adams & Sons were fortunate in obtaining the services of two first-class modellers—an Italian named Giovanni Meli [see page 56], and another named Beattie, a Scotsman. Some of the pieces which were modelled by Meli are the statuettes of Jacob and Joseph; Abraham offering up Isaac; Italian Fruit Girl; Spanish Flower Girl; Shepherd and Musician with Flute; and many others; but his earliest specimen was the Spanish Brigand.
>
> Beattie modelled the statuettes of Coriolanus; Virginia; Venus; some Grecian subjects; groups of stags; Death of the Stags; Pointer and Setter; Cupid in Captivity; also copies of many Mexican ornaments and statuettes in silver which Mr. Thomas Adams had brought from Mexico. . . . The Parian was shipped to America and many of the principal towns of England and Scotland. . . . Many of the larger subjects were sold for not less than £10, and sometimes as high as £15. . . .

Alcock, Samuel, & Co.
(Working period c. 1828–59)

The porcelain of Messrs. Samuel Alcock & Co. is seldom marked, consequently their products are little-known and often pass for Rockingham or the work of other fashionable factories.

In the late 1820s and 1830s Alcock produced a charming series of little bust portraits in a matt-white Parian-type biscuit body. Two typical examples are shown in Plate 12 of Geoffrey Godden's *Illustrated Encyclopaedia of British Pottery and Porcelain* (Herbert Jenkins, London, 1966). Doubtless, other objects were also made in Alcock's biscuit-porcelain.

Samuel Alcock (born c. 1800) had two factories—one at Cobridge, during the period 1828 to 1853, and the famous Hill Pottery at Burslem from about 1830 to 1859—both of which passed to Sir James Duke & Nephews.

The catalogue to the 1851 Exhibition does not, in the case of Samuel Alcock & Co., differentiate between the porcelain, the earthenware and the Parian objects; but we can assume that the following articles were, in fact, made of Parian or, perhaps, the earlier white biscuit porcelain.

> Fanny Ellsler (a fine standing figure of this famous dancer)
> Beneficence
> Blind beggar, male
> Blind beggar, female
> Greyhounds, chained
> (The above five items were modelled by S. W. Arnold)

Centre for flowers
Chamois hunt
Brigand on watch
Brigand chief
Brigand with deer.

Other ware, such as the 'Apsley vase', 'Burgundy vase', 'Bacchanalian vase' and a series of ornamental cups, may also have been in Parian. The report of the official jury certainly mentions Parian:

> . . . Fancy articles in Parian, or biscuit, of most delicate execution, are shown in this stall, and the Jury may mention as remarkable for fancy and freshness of effect a number of vases and jugs of various forms and colours, in particular some with white figures on a blue ground and some with green ornaments on the same ground.

The jury awarded Samuel Alcock & Co. a prize medal.

Some rare Alcock white biscuit porcelain busts and figures bear a printed mark incorporating the name 'Sam[l] Alcock & Co' with a Cobridge or Burslem address and a representation of a beehive with bees swarming around. This beehive was the Alcock trade mark. It occurs in relief on a raised pad under a superb biscuit figure of Fanny Ellsler in the Godden collection. Other Alcock pieces of the late 1840s may bear this relief mark but most Alcock Parian appears to be unmarked. Certainly one finds very fine groups of chained greyhounds (matching the 1851 Exhibition description previously quoted) which do not bear a factory mark. However, some figures have been recorded with the initials 'S A & Co'. Name marks also occur,

as the example shown. Some rare post-1850 Alcock Parian bears printed name and address marks. Such a marked example is shown in Plate 10, depicting the Duke of Wellington.

Ash, George
(Working period c. 1861–82)

Jewitt in the first (1878) edition of his *Ceramic Art of Great Britain* (Virtue & Co., London) noted:

> The small works occupied by Mr. Ash, as a Parian and majolica manufactory, are of old establishment.

But in the revised edition of 1883, this simple statement is amended to the past tense, with the addition that Messrs. Grove and Cope carried on the

Broad Street Works at Hanley for the production of fancy china ornaments. It would appear that Ash pieces were not marked, although several jugs and small ornaments bear the diamond-shaped registration mark. The small ornament in the form of a child's hand (Plate 11) is such an unmarked example, but in this case it bears a registration mark relating to 21st September 1868 (see page 115), when the design was registered in the name of George Ash.

Baggeley, George
(Working period c. 1850–4)

George Baggeley (the name is variously spelt) produced Parian ware at his Upper High Street Works at Hanley from about 1850 to 1854; but his ware appears to be unmarked.

Bailey, John, & Co.
(Working period c. 1860–5)

John Bailey was born in Hanley in about 1836. By about 1860, he had established a small Parian manufactory at 96 Bryan Street, Hanley, and here he traded under his own name for three or four years. From c. 1864 to 1866, he traded as John Bailey & Co. or as Bailey, Murrells & Co., and during this period the address was the Elm Street Works, Hanley. No mark has, as yet, been recorded.

Bamford, John
(Working period 1850–83)

John Bamford produced a variety of Parian figures and ordinary stoneware at his Nelson Place Works at Hanley. His goods appear to have been unmarked, and this potter is typical of the many small-scale manufacturers of Parian. At the time of the 1861 census, he employed four men, four women, seven boys and eight girls. Bamford was then aged thirty-nine.

Bates, Brown-Westhead, Moore & Co.
(Working period 1859–61)

This short-lived partnership succeeded J. Ridgway, Bates & Co. at the famous Cauldon Place Works at Shelton, in the Staffordshire Potteries.

The *Art Journal* magazine, in 1859, reported on one Bates, Brown-Westhead, Moore & Co., bust portrait of Handel—a model prepared by W. Theed from the original by Roubilliac. This bust was made in three sizes to the order of Mr. Hawkins of the Crystal Palace China Court. The original *Art Journal* review, however, incorrectly recorded the maker's name as 'Bates, Westhead & Co'.

Imposing Parian models were produced, as is evidenced by the example shown in Plate 12 which was made for the Crystal Palace Art Union. Many other pieces were made, as well as the normal range of porcelain and earthenware articles. The mark was the full name of the firm.

Bates, Walker & Co.
(Working period 1875-8)

Parian figures have been reported with the impressed initial mark 'B W & Co', which could relate to this partnership. Bates, Walker & Co. worked the Dale Hall Works, at Burslem, in succession to Bates, Elliot & Co.

Beech, William
(Working period c. 1834-64, continued by Mrs. Beech to c. 1874)

William Beech was born in Hanley in about 1805. From the mid-1830s, he produced large quantities of typical Staffordshire earthenware figures at the Bell Works in Queen Street, Burslem. A James Beech is also listed at the same address in directories of the period, and there is some confusion over these entries. However, William Beech's wife, Jane, continued the Bell Works after the death of her husband in 1864 until the mid-1870s. Contemporary accounts show that at least Jane Beech produced Parian ware as well as the standard earthenware figures, and it is likely that her husband, too, made Parian goods.

In 1875, the partnership of Beech & Podmore is recorded at the Bell Works; but in the following year, this firm moved to the Bleak Hill Works, Burslem. This partnership was soon succeeded by John Podmore (see page 99).

Belleek Pottery Ltd.
(Working period c. 1863 to present day)

Although the mark used on Irish Belleek porcelain has always consisted of the simple name 'Belleek', the original trading name of the firm was D. McBirney & Co.—the partners being David McBirney (d. 1882) and R. W. Armstrong (1824-84). The latter was art director. As such, he designed the many marine and other forms.

Typical Belleek ware is coated with a lustrous glaze, but the underlying body is really a form of Parian. Some fine figures and groups were produced combining happily the matt-Parian body with glazed portions. 'The Prisoner of Love' and 'Erin awakens from her Slumbers' are ornate pieces, but other useful ware and busts were also made (see Plates 13-18).

Belleek Parian ware sometimes bears the impressed mark 'BELLEEK. CO FERMANAGH'; but some pieces, particularly the useful ware, bear the

printed crest trade mark as reproduced here. It should be remembered that the Belleek factory is still producing some of the traditional designs first introduced in the nineteenth century.

Bell, J. & M. P., & Co.
(Working period c. 1842–1928)

Bell & Co. of Glasgow produced a wide range of earthenware, including terra-cotta and Parian ware. At the 1851 Exhibition, no Parian figures were shown, but vases and jugs were exhibited:

> Small vases, with figures in bas-relief, the body and handles modelled after a vase found in Pompeii.
> Antique vase with upright handles.
> Jugs modelled after the antique, with bas-reliefs from the Elgin marbles
> . . .
> Jugs, same shape but plain, with same subject enamelled.
> Bas-reliefs from the Elgin marbles.

Two years later, at the 1853 Dublin Exhibition, Bell & Co. did show figures and bust portraits such as 'Dante', 'Kilmery' and 'Petrarch' and a bust of Jenny Lind. This firm also included Parian in its display at the 1862 exhibition.

Details of this Scottish firm are given in J. Arnold Fleming's *Scottish Pottery* (Maclehose, Jackson & Co., Glasgow, 1923) in which a Parian figure of Diana is illustrated in Plate IV.

While most Bell ware was apparently unmarked, the impressed bell device is recorded, sometimes with the initials 'J B' added. The initials 'J & M.P.B & Co' occur incorporated in several printed marks, normally on earthenware. Sample marks are reproduced here.

Bevington, John
(Working period c. 1872–92)

John Bevington succeeded several Parian manufacturers (Wilkinson & Richuss, page 113; Wilkinson & Sons; Bailey & Bevington) at the Kensington Works, Hanley.

Although John Bevington is mainly known for his decorative glazed-porcelain Dresden-style goods, some Parian was produced between 1872 and specimens should bear his initials.

Bevington, James & Thomas
(Working period 1865–78)

James and Thomas Bevington, the sons of Samuel Bevington, started on their own account in Marsh Street, Hanley, in 1865. From 1867 to 1878, they were at the Burton Street Works, where good earthenware and porcelain was produced. Parian figures were produced up to the mid-1870s, when the works were confined to the production of porcelain. These rare Parian pieces bear the impressed initial mark 'J. & T.B'. A good example from the Godden collection is shown in Plate 19.

Bevington, Samuel, & Son
(Working period c. 1855–66)

Samuel Bevington made Parian goods at the Swan Works, Hanley. This small factory was continued by Samuel's son John until 1866, when Messrs. W. L. Evans & Co. took the works. 'Messrs. Bevington & Son' displayed Parian goods at the 1862 Exhibition, and this catalogue entry probably relates to Samuel Bevington & Son.

Bromley, Turner & Co. (See Turner, Hassalls & Bromley)

Boote, T. & R.
(Working period 1842 to the present day)

T. & R. Boote were established in 1842. They worked several different potteries in Burslem, but the main one was the Waterloo Pottery. A good range of various types of earthenware was produced. In Parian, this firm exhibited in 1851:

Vases, groups of flowers and statuettes
Parian bust of Sir Robert Peel, after Sir T. Laurence.
Set of three Parian vases, ornamented with raised vine, drab ground, the largest three feet tall.
Another set, with groups of flowers, raised.
Parian allegorical group of figures.
Rustic group.
Pierced Parian case.

F

Statuettes, in Parian, about 20 inches high, Shakespeare, Milton, Venus, etc.

Small Parian vase, flowered.

Boote Parian ware is now very rarely found. The production of this body had apparently ceased by the time Jewitt came to write his *Ceramic Art of Great Britain*. Writing at a period before publication in 1878, he noted:

> . . . Parian was also formerly produced both in vases, jugs, groups and other objects. One of the most effective groups was that of 'Repentance, Faith, and Resignation', modelled by Mr. Gillard. Among the Parian vases some, the body of which was buff and the raised flowers white, had a pleasing and softened effect. All these decorative classes of goods have been discontinued by Messrs. Boote . . .

Boote ware bears marks incorporating the full name or the initials 'T. & R.B.'

Brewer, Francis, & Son
(Working period c. 1861–4)

Francis Brewer was born in Derby in about 1814. In the early 1860s, Francis Brewer and his son, Herbert James, produced at Longton a range of porcelain and Parian goods. The works gave employment to forty workmen. The wares appear to have been unmarked.

Brougham, Mrs. M.
(Working period c. 1850)

Little is now known of Mrs. Brougham of Burslem. William White's 1851 Staffordshire Directory recorded that:

> The elegant Parian brooches, Bracelets, etc., manufactured by Mrs. M. Brougham, of Burslem, have most deservedly received the patronage of Her Majesty, the Duchess of Sutherland, Jenny Lind, and many other distinguished ladies.

This floral jewellery is also mentioned in the *Journal of Design* (Vol. IV of 1850–1), but so small are the objects that no maker's marks can be expected to be found on these now rare examples of Parian at its finest (see Plate 109).

Brownfield, William, & Son
(Working period c. 1850–91)

William Brownfield (& Son) produced a good and varied range of earthenware and porcelain from 1871. Llewellynn Jewitt, in his *Ceramic Art of Great Britain* noted:

> In Parian, too, a large percentage of figures, groups, busts, vases, and all the usual, and many unusual, elegancies of home life are made.

The most common examples of William Brownfield's wares now found are his relief moulded jugs (see Plate 20), of which thousands must originally have been made. Several different forms of marks will be found with the name 'BROWNFIELD' or the initials 'W.B.' Between 1871 and 1876, the addition '& SON' or '& S' occurred; but after 1876, the plural form '& SONS' was used. From 1891 to 1900, the firm was retitled 'Brownfields Guild Pottery Society Ltd.'

Brown-Westhead, Moore & Co.
(Working period 1862–1904)

This celebrated firm succeeded Bates, Brown-Westhead Moore & Co (see page 62) and, previously, the Ridgway Company. Superb porcelain was made, as well as a variety of various earthenware. As Jewitt noted in 1878, 'The highest class of Parian is also extensively produced'—although this firm connot be said to be famous for its Parian statuary but rather for tasteful centrepieces and comports.

The Brown-Westhead, Moore & Co. products are marked either with the name in full or with the initials 'B.W.M. & Co'. Each form of mark can also occur without the '& Co'

Coalbrookdale (See **Rose, John & Co.**)

Coalport (See **Rose, John, & Co.**)

Cook, Robert
(Working period c. 1871–9)

Robert Cook (or Cooke) occupied the Brewery Works in Hope Street, Hanley. Jewitt, in his first edition of *Ceramic Art of Great Britain*, 1878, reported:

> Robert Cook makes ordinary Parian goods in large quantities; principally for shipment to America.

Although no factory mark has hitherto been recorded, the charming group shown in Plate 21 bears the impressed initials 'R.C' with the model number 298. This initial mark probably relates to Robert Cook.

Cooper, Mrs. M.
(Working period c. 1860)

Mrs. Cooper is listed in the Post Office Directory of 1860 as a manufacturer of china and Parian figures. The address was given as Etruria Road, Hanley, but no other details appear to have been recorded.

Copeland and Garrett
(Working period 1833–47)

This partnership succeeded the famous Spode firm, at Stoke-on-Trent, in 1833. As related on page 4, Copeland and Garrett were the first to market true Parian under the name 'Statuary Porcelain' in the 1840s. The first sales were slow, and it was not until the 1846 order from the Art Union of London for the figure of 'Narcissus' (Plate 22) that the new body caught on. As this partnership ceased in 1847 (to be succeeded by Messrs. W. T. Copeland), it is not surprising that marked Copeland & Garrett examples are now very rarely found.

The standard mark was the impressed names 'COPELAND & GARRETT', but printed marks incorporating these names were rarely used. That on the first issue of 'Narcissus' is reproduced on page 12.

MODELS

Approximate year	*Name or title, and notes*
1842	*Apollo as the Shepherd Boy of Admetus.* Modelled by R. J. Wyatt after the marble owned by the Duke of Sutherland and situated in Trentham Park. The Duke expressed great appreciation of the parian copy. This figure was engraved in *The Art-Union* magazine of November 1846 and is reproduced opposite.
1844	*Bust of a young girl.* Neither this nor the previous figure proved to be a commercial success (see page 10).
1844	An equestrian figure of *Emmanuel Philibert, Duke of Savoy.* This was copied in Parian from the original by Baron Marochetti.
1845	A model, reduced by Benjamin Cheverton, of the *Lady Clementina Villiers* from a work by Mac. Donald.
1845	*Psyche* (see engraving from *The Art-Union* magazine of November 1846).
1845	*Paul and Virginia*, after Cumberworth. A later issue of the same subject is shown in Plate 41. In the same year, they produced a beautiful vase featuring semi-nude children. It is possible this was one of the first cases of the use of Parian for utility and decorative reasons. This example is here reproduced in the Art Union engraving shown on page 118.
1846	*Narcissus* from the work of John Gibson, R.A. The first Parian figure to be issued as a prize by the Art Union of London (see Frontispiece, Plate 22, page 11 and engraving on page 118).

porcelain We select, for example, " The Shepherd Boy," copied from the original by **Wyatt**.

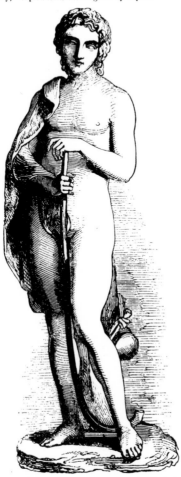

The figure of Apollo, when, as a shepherd, he tended the flocks of Admetus, may be taken as a satisfactory specimen of the artistic perfection to which figures can be brought in the statuary porcelain. This statue is eighteen inches high.*

* This was modelled from a statue by Wyatt for the Duke of Sutherland, who also possesses the original marble. The equestrian statue of Emanuel Phillibert, in the production of which the greatest mechanical difficulties have been most successfully overcome, was also copied for his Grace.

1846 *Shakespeare*

1846 *The Emperor Nicholas of Russia*—a bust from a work by Count D'Orsay.

Apart from these early pre-1847 Parian figures, Copeland & Garrett also produced some decorative vases in the classical style in this then new porcelain. The single example reproduced overleaf is copied from *The Art-Union*

magazine of November 1846. The original stood 28 inches high and was copied from an example in the British Museum.

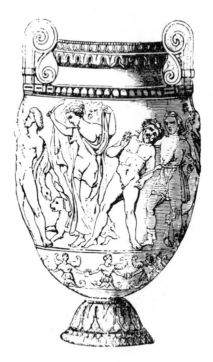

Copeland
(Messrs. W. T. Copeland. Working period 1847 to the present day)

This firm succeeded the partnership of Copeland and Garrett at the Spode works, Stoke-on-Trent, in 1847. For the rest of the nineteenth century, Copeland produced some of the finest Parian ware—figures, groups, vases and a host of tastefully designed useful objects such as jugs, butter dishes and the like.

This Parian normally bears the simple impressed name mark COPELAND. After about 1870, figures often bear month-and-year potting marks expressed in fractional form, i.e. $\frac{J}{80}$ for January 1880. Many models also bear the name of the original sculptor.

MODELS

(N.B. This and subsequent lists of models cannot be considered to be complete)

1847 *Innocence*, $16\frac{1}{2}$ inches high, by J. H. Foley.
Commissioned by the Art Union of London (Plate 23).

1847	*Flora.* Bust.
1847	*Jenny Lind* by Joseph Durham. This bust sold very well in Canada. Jenny Lind made her first appearance on the stage in London in 1847.
1847	*Ondine*
1847	*Eve*, from a work by P. MacDowell.
1847	*Cupid Chained*
1848	*Spring; Summer; Autumn;* and *Winter*, posed for respectively by Princess Alice; the Princess Royal; Prince Albert; and the Prince of Wales. The originals were done by Mrs. Mary Thorneycroft and directly commissioned by Queen Victoria.
1848	*Lord Charles Bentinck.* Bust, after the work of Count D'Orsay (Plate 24).
1849	*Her Majesty Queen Victoria.* Bust, from an original work by Francis.
1849	*Boy with Shell*
1849	*Venus*, after an original by John Gibson, R.A.
1849	*The Last Drop* and *Sabrina*, after the work of Calder Marshall. The two originals were exhibited at the Royal Academy the previous year.
1849	*The Indian Fruit Girl* and *Water Bearer.* A pair of figures after Calder Marshall.
1849	*Ino and The Infant Bacchus.* A group which was 20 inches long, from a work by J. H. Foley (Plate 26).
1849	*The Return From The Vintage.* This was one of the most elaborate groups made, consisting of seven youths carrying on their shoulders a girl in a vine-decked basket.
1850	*Lady Godiva.* An equestrian figure after McBride, this Parian figure was commissioned by the Art Union of Liverpool for inclusion in their prize list.
1850	*Sir Robert Peel.* A bust, after James S. Westmacott.
1850	*The Prodigals Return.* A fine group, after W. Theed.
1850	*Head of Juno.* This Parian bust was produced life-size.
1850	*The Duke of Sutherland.* Original by Francis.
1850	*The Prince Consort*, from the original by W. Theed. This work is a bust.
1850	*Virginia*
1851	*Sappho*, after W. Theed.
1851	*Rebecca*, after W. Theed.

1851	*The Astragali Players*
1851	*Girl With Scorpion*
1851	*Sir Walter Scott.* The original statue was executed for the Edinburgh Association For The Promotion Of The Fine Arts by John Steell, R.S.A.
1851	*Group of Graces*
1851	*Group of Cupids as Kanephoroi*
1851	*The Sea Nymph*
1851	*Princess Helena*, from an original by Mrs. Mary Thorneycroft.
1851	*Modesty*
1851	*The Portland Vase.* A Parian copy of the famous Roman glass vase now in the British Museum.
1851	*The Bather*, from an original by Calder Marshall.
1851	*Christina Linnaeus*, 23 inches high, after G. Halse.
1851	*Samuel Cooper.* Bust. Original by T. Butler.
1852	*The Greek Slave.* A very successful Parian figure, from the original marble by Hiram Powers, which was exhibited at the 1851 Exhibition. This model had earlier been produced by Minton and was copied by several other manufacturers.
1852	*The Duke of Wellington.* Original by Count D'Orsay.
1854	*Lord John Russell.* Bust.
1855	*Queen Victoria.* Bust by J. Durham.
1855	*The Prince Consort.* Bust by J. Durham.
1855	*Boy with Rabbit.*
1855	*Little Nell.* Figure of Dickensian character.
1855	*Clytie.* Bust by C. Delpech, after the Greco-Roman marble in the British Museum (Plate 31). Commissioned by the Art Union of London.
1855	*General Havelock.* Bust.
1856	*Miranda.* 10 inches high. Original by Calder Marshall.
1856	*Ophelia.* 10 inches high. Original by Calder Marshall.
1857	*Ruth*, 18½ inches high, after W. Theed (Plate 36).
1857	*Mother and Child*
1857	*Musidora*, after W. Theed.
1857	*Fox and Terrier*
1858	*Venus and Cupid.* Original by John Gibson, R.A. Commissioned by the Art Union of London.

1858	*The Dancing Girl Reposing.* Original by John Gibson, R.A. Commissioned by the Art Union of London.
1858	*Ariadne.* Bust.
1858	*Donald O'Connell*, after J. E. Jones.
1858	*Lord Nelson.* Bust.
1861	*Caractacus.* Sculptor, J. H. Foley. The original marble was carved for the Egyptian Hall at the Mansion House. The Parian copy was chosen by the Crystal Palace Art Union.
1861	*The Veiled Bride.* 15 inches high. This Parian bust was copied from the original marble 'The Veiled Vestal' by Rafaelle Monti. The marble was shown at the Great Exhibition and was bought by the Duke of Devonshire. It represents a kneeling girl with her face veiled. The jury reported 'extraordinary skill is shown in the execution of this veiled figure . . .' The *Art Journal* described it as 'a work of great beauty'. The Parian bust was commissioned by the Crystal Palace Art Union and was one of its most successful issues.
1861	*The Toilet.* 16 inches high. A Parian group after a work by Calder Marshall. The price of Parian copies was £5. 5. 0. each.
1861	*Bust of Peace*, after Joseph Durham. *Bust of War*, after Joseph Durham.
1861	*Bust of Oenone.* Original by Calder Marshall.
1861	*Bust of Enid the Fair and Good* by Felix Miller, from 'The Idylls of the King'. This and the three preceding busts cost £1. 1. 0., or £2. 2. 0. coloured and on a pedestal. The *Art Journal* said of the colouring 'it was executed with a cautious delicacy that commands admiration even if it fails to establish a recognition of the legitimacy of colour in sculpture'. All four busts were commissioned as prizes by the Crystal Palace Art Union.
1861	*Apollo*, by C. Delpech. Commissioned by the Art Union of London. The Parian bust (Plate 30) was copied from the statue called 'Apollo Belvedere' in the Belvedere Gallery in the Vatican at Rome. It was discovered in 1455.
1861	*Night* (Plate 43) and *Morning.* Two works in Parian by Rafaelle Monti. They were later illustrated in the catalogue of the 1862 exhibition. The rectangular plinths are ostentatiously decorated with classical figures.

1862 *Emily with the White Doe of Rylstone*, after Felix Miller.

1862 *Go to Sleep.* 19 inches high.

1863 *H.R.H. Prince of Wales*, after Marshall Wood, published
 on 1st February 1863 and commissioned by the Crystal
 Palace Art Union. Bust (Plate 32).

1863 *H.R.H. Princess Alexandra*, after Felix Miller, published
 23rd February 1863, prior to her marriage to the Prince
 of Wales. Commissioned by the Crystal Palace Art Union.
 Bust (Plate 33).

1863 *The Goatherd.* The original was by R. J. Wyatt and was
 in the possession of the Duke of Sutherland.

1863 *Bust of Washington* (Plate 39).

Later Copeland figures and busts include:

Infancy of Jupiter by Rafaelle Monti.

Lady Godiva by Rafaelle Monti.

Young England, after G. Halse.

Young England's Sister, after G. Halse.

Wounded Soldier

Sunshine

Master Tom by Joseph Durham.

A Shepherd Boy by L. A. Malampre.

Chastity by Joseph Durham (Plate 35).

Prosperity ⎫ a pair of figures by Owen Hall.
Adversity ⎭

Before the Ball ⎫ a pair of figures by Owen Hall.
After the Ball ⎭

The Trysting Tree. Two separate figures of a girl and a
boy, each with the same title, by G. Halse.

Colin Campbell. Bust. 10 inches high.

Nora Creina by Rafaelle Monti.

On the Sea Shore by Joseph Durham.

Spring by L. A. Malampre.

Summer by L. A. Malampre.

Santa Filomena by Joseph Durham.

Group of Dogs. From the original bronze 'Chasse au Lapin'
by the French sculptor P. J. Mene (Plate 45).

Flute Player by Rafaelle Monti.

Reading Girl by Rafaelle Monti.

A Mother. Bust, by Rafaelle Monti.

Love. Bust, by Rafaelle Monti.

During the years preceding 1860, Copelands made and issued approximately seven figures of Venus, including 'Venus-de-Milo', 'Venus-de-Medici', 'Venus of the Capitol', and 'Venus at the Bath'. They were after Canova, John Gibson and Thorwaldson. The exact year of issue of the various pieces cannot be ascertained.

In 1859, Alderman W. Copeland, M.P. presented to the City of Lichfield, when the museum was opened, ten Parian portrait busts and eight figures or groups. The busts were 'Emperor Nicholas of Russia', 'Lord John Russell', 'Samuel Cooper', 'Donald O'Connell', 'Lord Nelson', 'Lord Charles Bentinck', 'General Havelock', 'The Duke of Wellington', 'Jenny Lind' and 'Sir Robert Peel'. The figures were 'Fox and Terrier', 'Mother and Child', 'The Bather', 'Virginia', 'Boy and Shell', 'Boy and Rabbit', 'Modesty' and 'Little Nell'.

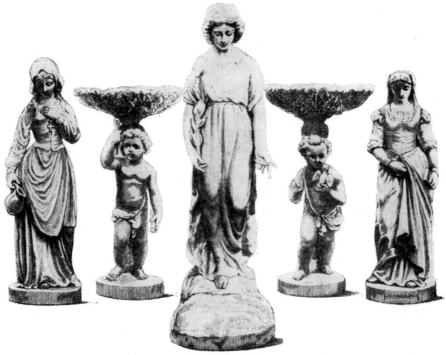

Selection of Copeland Parian Ware, Reproduced from the *Art Journal* Catalogue of the 1871 Exhibition.

Daniel, Thomas
(Working period c. 1851–4)

Thomas Daniel was born in about 1800. He was typical of many small manufacturers of Parian ware, employing four men and some boys at Garden Street, Burslem. Here he produced Parian brooches and figures, but these did not bear a maker's mark.

Derby

As mentioned in Chapter I, the Derby factory produced superb biscuit-china figures and groups in the eighteenth century—examples of which are shown in Plates 1, 2 and 3 and the discovery of the related Parian body was said to be due to the efforts of Victorian manufacturers to copy Derby biscuit-china.

Some of the Derby white figures and groups were continued into the nineteenth century, until about 1810, but were then largely discontinued—perhaps due to the high standard of workmanship and control necessary in the firing processes, which would have made them an uneconomical proposition at a time when the Derby management was turning to the production of less expensive porcelain. Nevertheless, some Derby biscuit was made in the 1820s and 1830s, during the 'Bloor' period. The rare group shown in Plate 233 of Geoffrey Godden's *Illustrated Encyclopaedia of British Pottery and Porcelain* (Herbert Jenkins, London, 1966) shows a rare combination of a matt-white Cupid sleeping in a glazed and coloured arbour.

In 1848, the original Derby factory closed; but some of the former work-people banded together to establish a small factory of their own in King Street, Derby, where they could carry on the tradition of fine Derby porcelain. This King Street firm traded under several different names at various times, but that by which it is commonly known is 'Stevenson & Hancock', and the initials 'S' and 'H' were placed one each side of the old Derby mark as the trade mark of the new company. In the 1848–60 period, some biscuit-china figures were made at the King Street factory in the tradition of the earlier ware. These pieces are now very rare. They are, however, not true Parian but the chalky-white biscuit-china body (Plate 47).

In 1876, a new company was formed with the title 'The Derby Crown Porcelain Co. Ltd.' and a large factory was built in Osmaston Road. The company flourished and, in 1890, was appointed 'Manufacturers of Porcelain to Her Majesty' (Queen Victoria), giving rise to the new title 'The Royal Crown Derby Porcelain Company' and to the well known description of its products as 'Royal Crown Derby'.

The advertisements of the 1880s list Parian amongst the several specialities; but little seems to have been made, for it is now exceedingly scarce.

George Cocker, a modeller at the Derby factory until about 1817, later produced biscuit-china figures on his own account at Derby, and these pieces sometimes bear his signature mark. Cocker later worked at Stoke. Many talented Parian figure modellers and work-people gained their initial training at Derby.

Dudson, James
(Working period c. 1838–82; continued by Dudson Bros. Ltd. to the present day)

James Dudson was born in Shelton in about 1813. He became a celebrated manufacturer of 'Staffordshire figures' in the standard earthenware body. It

is believed that he also made Parian ware but no marked examples have been recorded.

James Dudson died in 1882 but the firm continues, now trading as Dudson Bros. Ltd., at the original address—Hope Street, Hanley. During the past eighty years, a vast range of fine earthenware has been produced, including Wedgwood-type jasper ware.

Duke, Sir James, & Nephews
(Working period c. 1860–3)

Sir James Duke & Nephews succeeded Samuel Alcock & Co (see page 60) at the Hill Pottery, Burslem, in 1860. This firm made a good display at the 1862 exhibition. J. B. Waring, in his three-volume work *Masterpieces of Industrial Art and Sculpture at the International Exhibition 1862*, recorded:

> From among the great variety of works produced by them we have selected a portion of the dessert service executed in porcelain and Parian, very beautifully designed by Mr. George Eyre, the [Parian] figures excellently modelled by Mr. Giovanni Meli . . .
>
> They have been fortunate in obtaining the services of Mr. E. Protat, the wellknown French sculptor and modeller . . . We must not omit to praise also the Parian statuettes, the Cupid Captive, modelled by Mr. Calder Marshall, and Marmion, by Mr. Bailly. The Parian foliage and fruit ornament on vases and ewers by Mr. W. Parker evinced very delicate manipulation and a lively fancy.

The original coloured engraving of Sir James Duke's ware as shown in Waring's book is reproduced in Plate 48. Other Duke Parian ware includes "Lord Elcho" and "Innocence Protected". These and other examples might bear the impressed name 'DUKE' or an impressed hand device.

Edwards & Son
(Working period c. 1887–1900)

Edwards & Son succeeded Stanway, Horne & Adams at the Trent Works at Hanley. Their ware appears to have been unmarked but they probably made articles similar to those of their predecessors (see page 105), and their advertisements mention 'Parian and Majolica Fancy Goods, etc.'

Edwards, James, & Sons
(Working period c. 1842–82)

James Edwards started on his own account in 1842 and subsequently worked several potteries, of which the most famous was the Dale Hall Pottery at

Burslem. In 1851, he took his two sons into partnership. At the 1851 exhibition he showed, under the trading style 'J. Edwards & Sons', a 'Large Parian vase, and a large earthenware tray'. While this simple entry does at least show that at this period the Dale Hall Pottery was making Parian, it does scant justice to the various other products made by this important firm, which was continued by James Edwards' sons until 1882.

Jewitt, in his *Ceramic Art of Great Britain*, writes in glowing terms of Edwards and his ware.

Goss, W. H.
(Working period c. 1858–1944)

William Henry Goss produced good quality Parian ware at his Stoke factory, including several bust-portraits. Llewellynn Jewitt, in *Ceramic Art of Great Britain* (1878 and 1883) remarked on Goss's varied production. Of his Parian, Jewitt noted:

> In Parian, for which Mr. Goss ranks deservedly high, busts, statuary (notably an exquisite group of Lady Godiva), vases, tazzas, scent-jars, bread-platters, and many other ornamental goods, are made. Notable among these are admirable busts of our beloved Queen, of the late Earl of Beaconsfield, of Mr. Gladstone, of Lord Derby, of S. C. Hall, of Charles Swain and that of myself [L. Jewitt] . . . As portrait-busts they rank far above the average, and are, indeed, perfect reproductions of the living originals. It is not often that this can be said of portrait-busts, but it has been a particular study of Mr. Goss, and in it he has succeeded admirably.

Other busts not listed by Jewitt were of Sir Walter Scott, Shakespeare, Byron, General Booth and Robert Burns. The Goss Parians bear the impressed name mark or the printed crest trade mark which incorporated the name. Examples of Goss's work are shown in Plates 49 to 52. Two Goss Parian figures are illustrated in an article by K. G. Howard in *Collectors Guide* magazine of March 1970.

Grainger, George, & Co.
(Working period c. 1839–1902)

George Grainger & Co., of Worcester, succeeded the partnership of Grainger Lee & Co. From the 1830s, rare biscuit-china figures were made; and in the 1840s and 1850s, true Parian figures and groups were produced in limited

quantities. These include a figure of Medusa which bears the name mark 'George Grainger' and the early date '1845'.

At the 1851 exhibition, this Worcester firm exhibited:

Cast of a female hand, 14 years of age, in Parian
Cast of a female hand, 80 years of age
Small jugs in Parian body.

Much late Grainger ware of the 1870s and 1880s is really a glazed Parian body, but it is not generally accepted as such.

In 1889, the Grainger company was taken over by the Worcester Royal Porcelain Co. Ltd., but production continued under the Grainger name until 1902. Several different marks were employed, including the name in full or the initials 'G.G. & Co.' or 'G. & Co.'

Harrop, William, & Co.
(Working period c. 1873–94)

William Harrop succeeded Messrs. Worthington & Harrop (page 114) at the Dresden Works, Hanley, in 1873. Jewitt, writing of the then current (1878) products in *Ceramic Art of Great Britain*, noted:

The productions are the cheaper classes of Parian goods, and fancy jugs in stoneware and ordinary earthenware, of good middle-class quality, all of which are supplied both for the home and American markets. No mark is used.

In about 1880, partners were taken in and the trading style became 'William Harrop & Co.'. As such, the firm continued until 1894. In the 1880s, Parian statuary was still being advertised by this firm.

Hill, Leveson
(Executors of)
(Working period c. 1859–71)

Leveson Hill made Parian and other goods at 40 Wharf Street, Stoke, from about 1859. By October 1861, the works were being managed in the name of 'The Executors of the late Leveson Hill'. Parian statuary was made, as well as jugs and vases, but the ware was probably unmarked.

The works were subsequently taken over by Messrs. Robinson & Leadbeater (see page 100).

Hill Pottery Co., Ltd.
(Working period c. 1862–7)

The Hill Pottery Company of Burslem succeeded that of Sir James Duke & Nephews (page 77). In fact, there may well have been some overlap of the

two trading styles: for while Sir James Duke & Nephews exhibited under
that name at the 1862 exhibition, designs were registered in the name of the
Hill Pottery Co. in May and June of 1861.

The firm's letter-heads described its specialities as . . . Porcelain, Parian
Statuary, Majolica and earthenware in all its varieties'. Apart from the Burs-
lem factory (formerly occupied by Samuel Alcock), the firm had two addresses
in London.

Hodgkinson, E.
(Working period c. 1866–71)

Elijah Hodgkinson established a small works in Mayer Street, Hanley, in
1864. Here, Parian as well as earthenware was produced until 1871, when
W. E. Cartledge took over the works. No marks have been recorded relating
to the Hodgkinson products.

Holdcroft, Joseph
(Working period c. 1870–1906)

Joseph Holdcroft established the Sutherland Pottery at Longton in 1870.
Holdcroft had previously worked for Minton, and he is mainly known for his
good quality Majolica-type glazed earthenware; but some Parian was also
produced. His mark was the initials 'J.H.' arranged as a monogram, the 'J'
within the 'H'.

Hughes, T.
(Working period c. 1851)

We have been unable to discover any facts about Hughes, except that the
last entry in the section relating to china, porcelain and earthenware in the
official catalogue to the 1851 exhibition reads:

Hughes. T. jun. Cobridge. Staffordshire.
Modeller and Designer.
Bust of Rev. John Wesley, in Parian.

Keates, James E., & Co.
(Working period c. 1851–4)

James Edward Keates produced a range of unmarked Parian figures and
brooches at Market Place, Burslem, during the period from 1851 to 1854.

Kerr & Binns
(Working period 1852–62)

This partnership succeeded the well-known Worcester firm of Chamberlain
& Co. in 1852. Parian examples are rare but are of superb quality (see

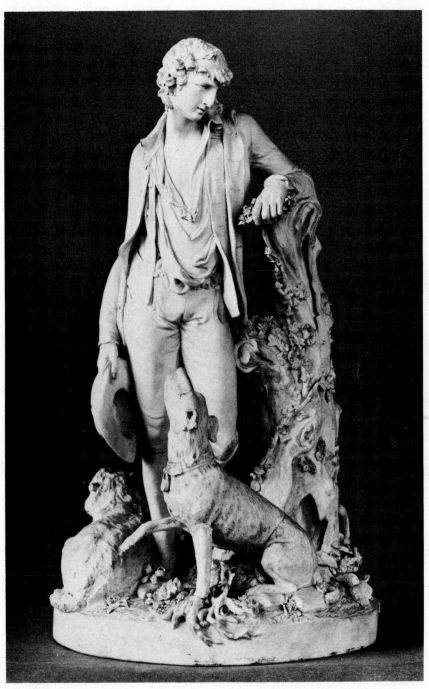

1. A superbly modelled eighteenth-century Derby figure in the un-
glazed biscuit body, which the Victorian potters were trying to re-
discover when they introduced the Parian body in the 1840s. Incised
Derby factory mark of crown, crossed batons and initial 'D'.
c. 1794. $13\frac{3}{4}$ inches high. *Victoria and Albert Museum (Crown
copyright).*

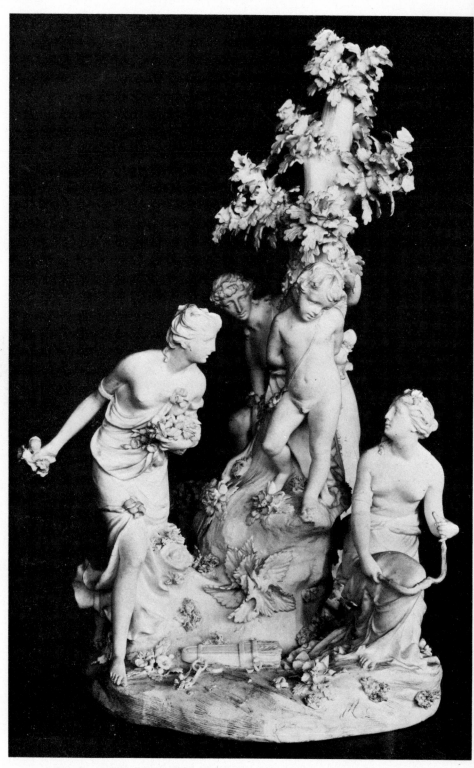

2. A typical eighteenth-century Derby biscuit group: The Three Graces distressing Cupid'—a model which was originally priced at £4. 4. 0d. c. 1795. 14¾ inches high. *Victoria and Albert Museum (Crown copyright).*

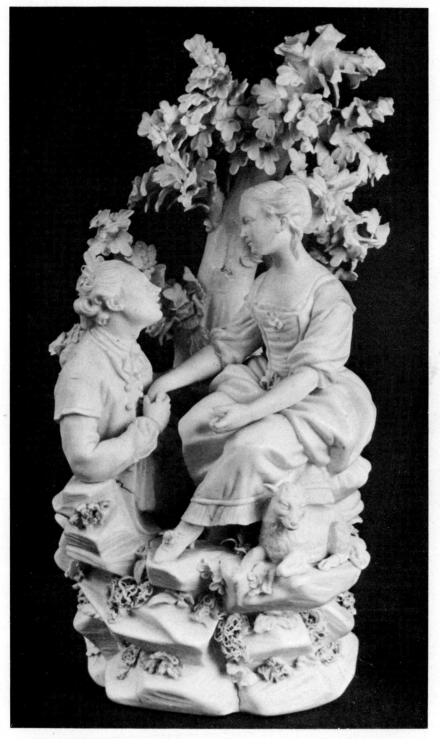

3. A Derby biscuit group copied from a Sèvres example, after designs by Boucher. c. 1800. 10½ inches high. *Derby Works Museum*.

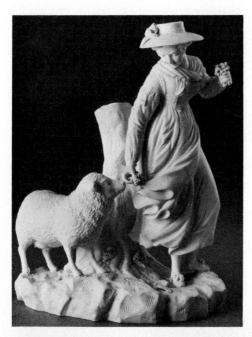

4. A biscuit-china figure from the famous Rockingham factory in Yorkshire. Model number 4. Impressed marked. c. 1830. 6½ inches high. *Godden of Worthing Limited.*

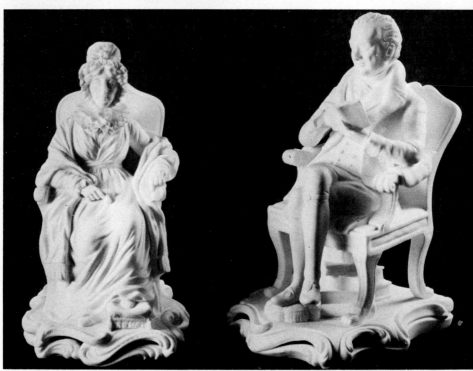

5. A pair of biscuit-china figures of Hannah More and Wilberforce. These Minton models are numbered 60 and 63 in the factory records, but they are often attributed to Derby. c. 1835. 6¾ inches and 7¾ inches high. *Godden of Worthing Limited.*

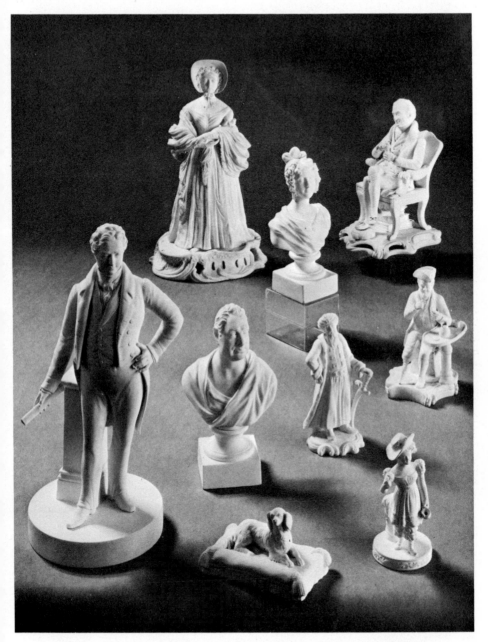

6. A selection of Minton biscuit-china figures, all matching drawings in the factory pattern book. Subjects are: Queen Victoria; bust portrait of Queen Adelaide; seated figure of Wilberforce; Sir Robert Peel; bust portrait of William IV; Grand Turk; Greenwich Pensioner; Spaniel on cushion; and girl 'Peace'. c. 1830–40. Queen Victoria, $10\frac{3}{4}$ inches high. *Godden of Worthing Limited.*

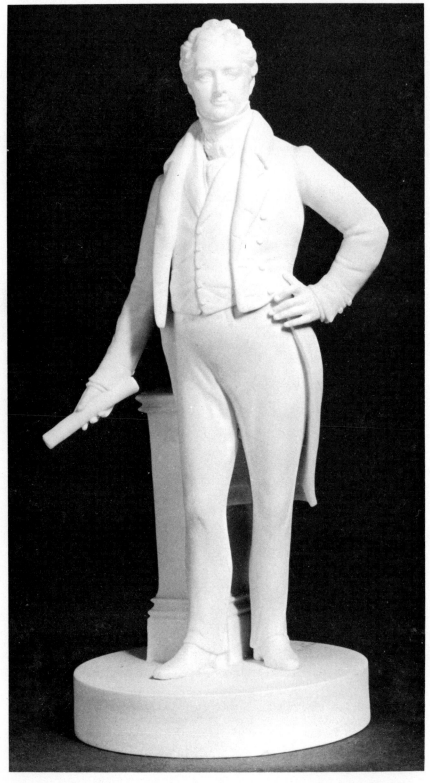

7. A fine Minton biscuit-china figure of Sir Robert Peel. Model number 77 in the factory records. c. 1835. 11¼ inches high. *G. Godden Collection.*

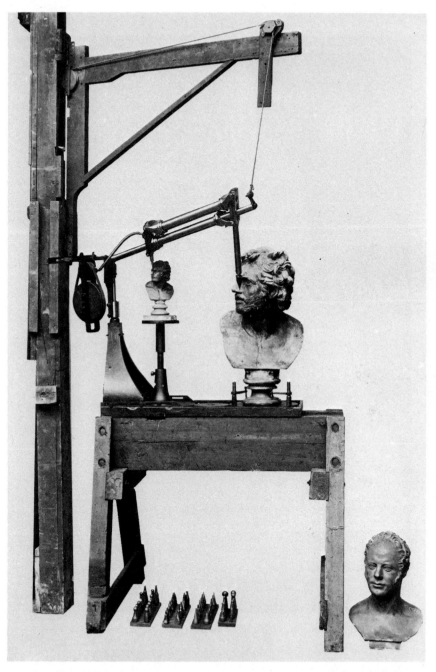

8. The Cheverton reducing machine, by which original figures and busts could be reproduced in reduced size so that moulds could be made for mass production in the Parian body. A bust of Benjamin Cheverton is seen in the lower right-hand corner. *Science Museum, London (Crown copyright).*

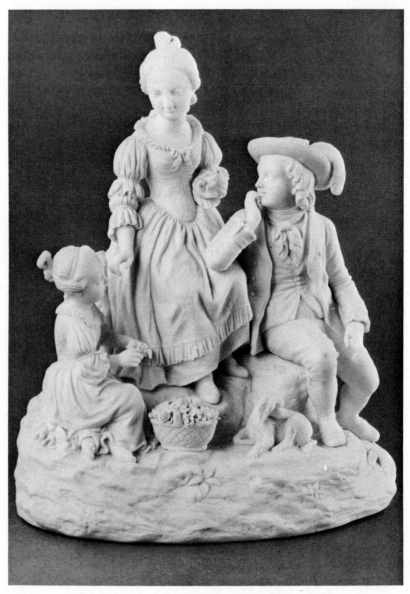

9. A Parian group of superb quality bearing the impressed mark 'ADAMS', relating to the Staffordshire firm of that name (see page 59). c. 1850–60. 12½ inches high. *G. Godden Collection.*

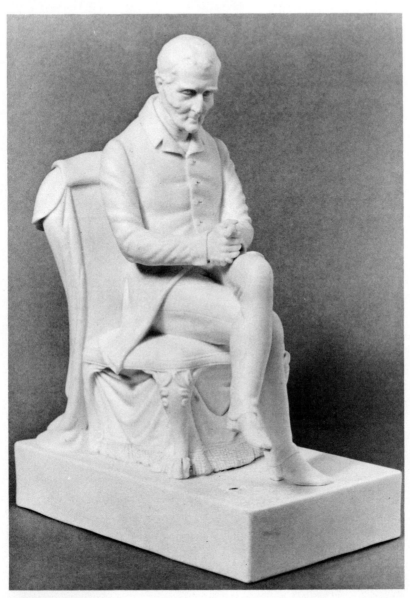

10. A rare portrait-figure of the Duke of Wellington, modelled by G. Abbott and issued by Samuel Alcock & Co. in 1852 (see page 60). The printed mark is reproduced. 11¼ inches high. *G. Godden Collection.*

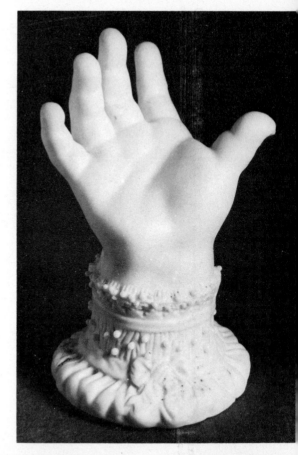

11. An ornamental ring-stand for a lady's dressing table. A design registered on 21st September 1868 by George Ash of Hanley (see page 61). 4 inches high. *G. Godden Collection.*

12. A finely modelled classical figure bearing the impressed mark 'Bates, Brown-Westhead & Moore' (see page 62). This figure was made for the Crystal Palace Art Union. c. 1860. 15 inches long. *Godden of Worthing Limited.*

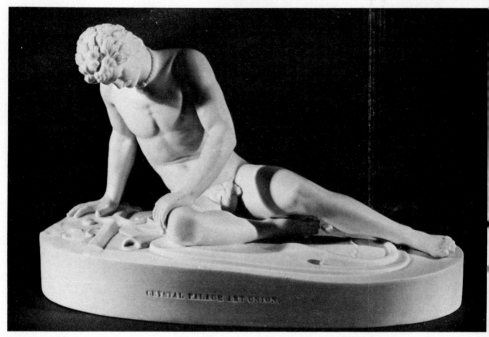

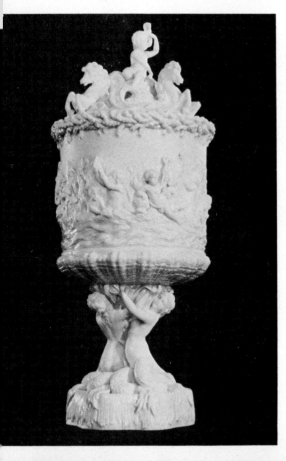

13. An ornately modelled Belleek ice-pail in matt and glazed Parian. The design was registered in 1868 and was by R. W. Armstrong, one of the partners in the first Belleek company. 18 inches high. *G. Godden Collection.*

14. Belleek glazed and matt Parian ware acquired for the Victoria and Albert Museum in 1871 and probably exhibited at the 1871 Exhibition. Centre tazza, $8\frac{1}{2}$ inches high. *Victoria and Albert Museum (Crown copyright).*

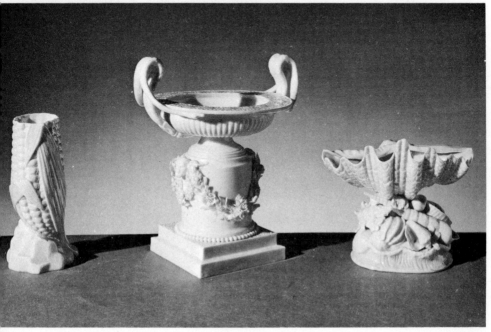

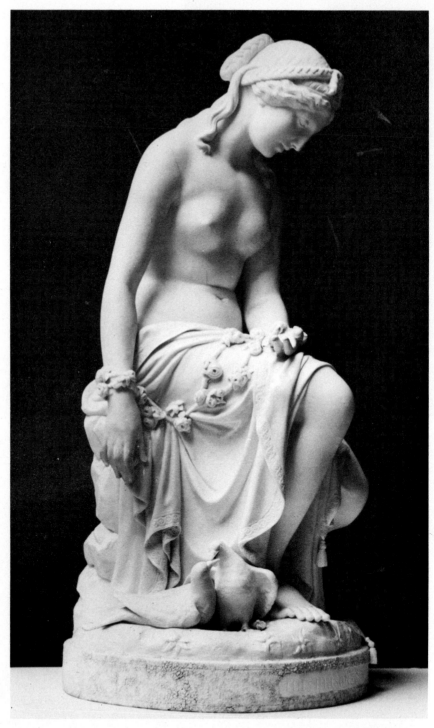

15. Belleek Parian figure 'The Prisoner of Love', an example mentioned in the *Art Journal* of February 1871. 25½ inches high. *Ulster Museum.*

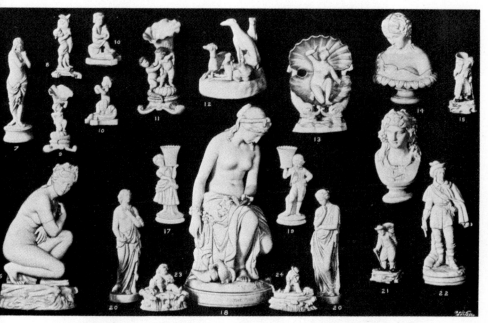

16. A selection of Belleek Parian figures as illustrated in the 1904 catalogue, although most of these models had been produced over the previous thirty years.

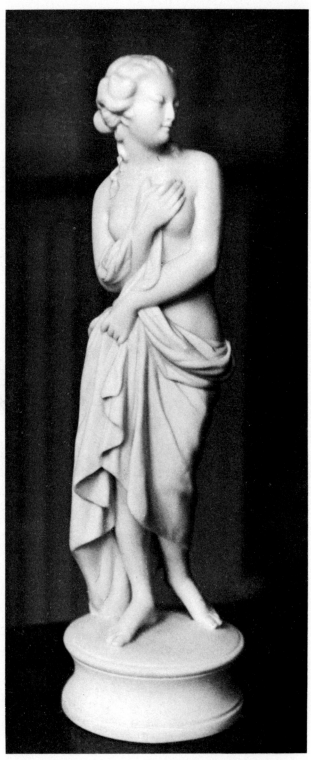

17. An impressed 'Belleek' classical-styled figure.
c. 1875. 12 inches high. *Mrs. Malcolm Scott.*

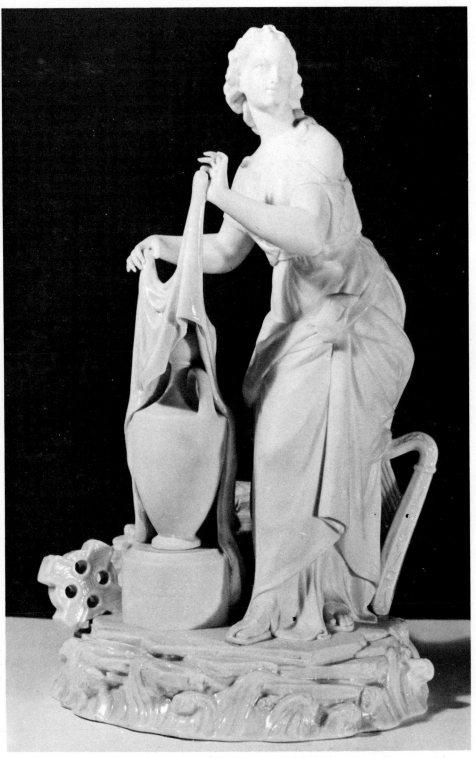

18. A matt and glazed Parian Belleek figure of 'Erin unveiling her
first pot'. c. 1870. 18 inches high. *Ulster Museum.*

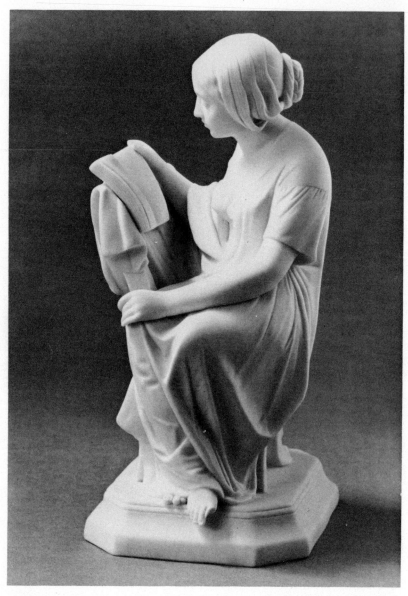

19. A rare Parian figure of the 'Reading Girl'. Impressed initial mark 'J & T B', of James and Thomas Bevington (see page 65). c. 1870. 12¼ inches high. *G. Godden Collection.*

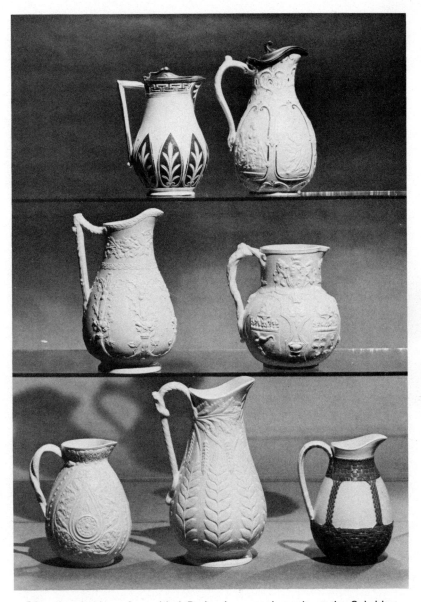

20. A selection of moulded Parian jugs, each made at the Cobridge works of William Brownfield. These designs were registered between 1862 and 1868 and bear the diamond-shaped device (see page 116).
G. Godden Collection.

21. A charming Parian group of the 1870s bearing the impressed initial mark 'R C', attributed to Robert Cook of Hanley (see page 67). c. 1875. 10½ inches high. *G. Godden Collection.*

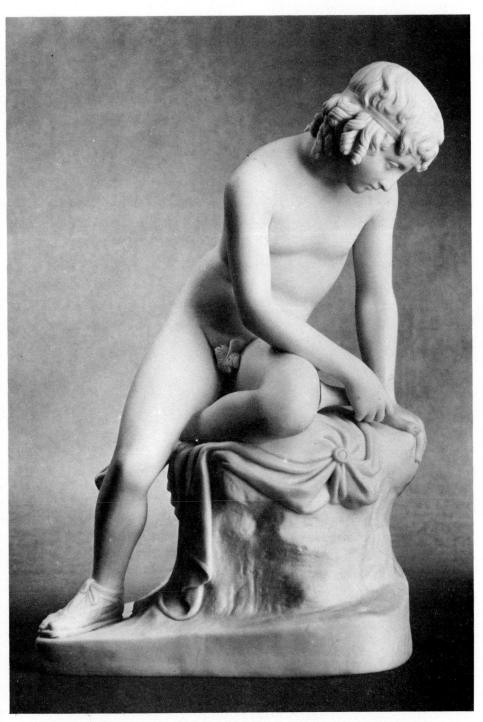

22. 'Narcissus', an early Parian figure by Copeland and Garrett of
Stoke. Made for the Art Union of London in 1846 (see pages 11–12).
Special printed mark as shown on page 12. 1846. $12\frac{1}{4}$ inches high.
G. Godden Collection.

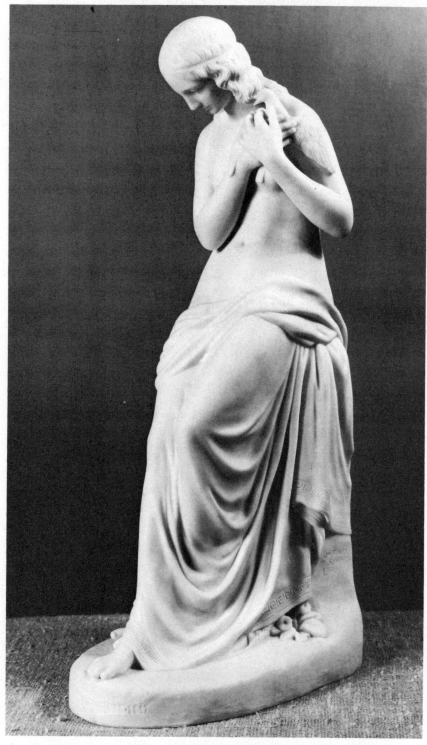

23. An early Copeland figure, 'Innocence' by J. H. Foley. Made for the Art Union of London in 1847. Impressed mark 'Copeland'. $16\frac{1}{2}$ inches high. *Victoria and Albert Museum (Crown copyright).*

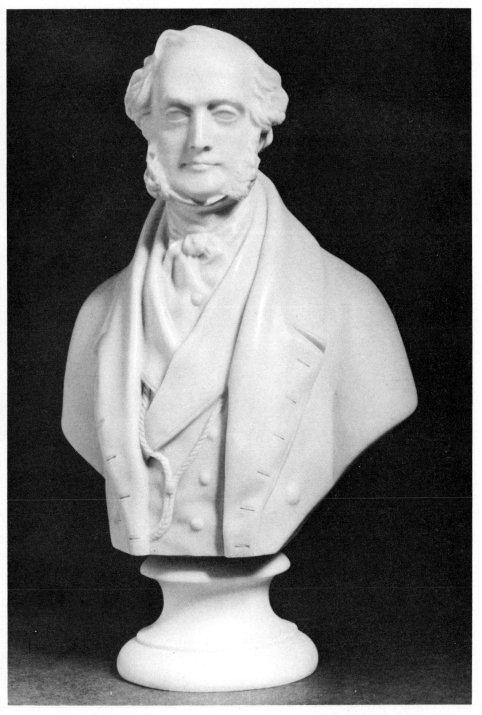

24. A Copeland portrait bust of Lord George Bentinck. Incised mark
'Count D'Orsay Sculpt. 1848' and impressed 'Copeland' mark. $8\frac{1}{4}$
inches high. *Godden of Worthing Limited.*

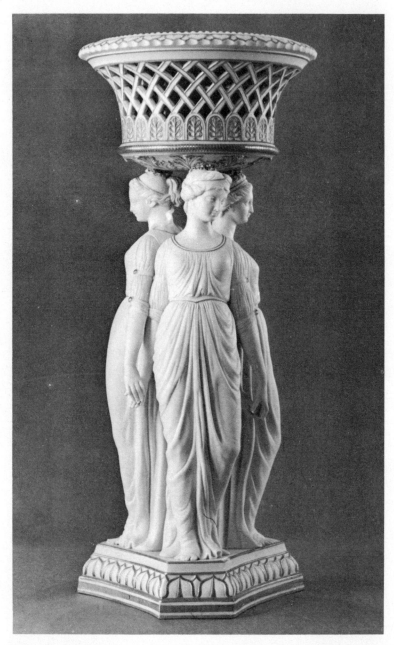

25. An important and superb quality Copeland fruit comport, supported by the Three Graces. Some gilding to base and basket, which tends to accentuate the marble-like appearance of the figure. The openwork bowl still has the red glass inner liner. Impressed mark 'Copeland'. c. 1850. 26 inches high. *G. Godden Collection.*

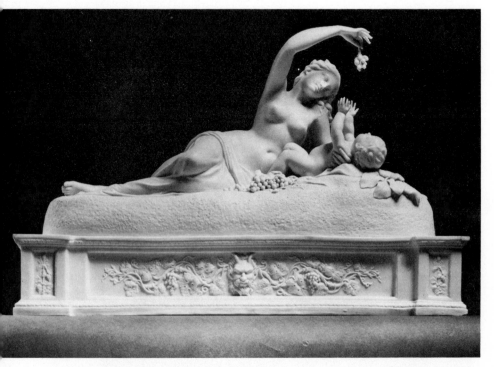

26. Copeland's 'Ino and Bacchus', after the original by J. H. Foley.
In this case, a special ornate plinth is shown. This bears panels at each
end with the relief moulded wording 'Great Exhibition of the Industry
of all nations 1851. Manufactured by W. T. Copeland'. The figure
itself is inscribed 'J. H. Foley, Sculp.' 'Copeland'. c. 1851. Base
23¼ inches long. *G. Godden Collection.*

27. A Copeland moulded
Parian jug of a design registered
on 26th February 1853. Diamond-
shaped registration mark (page
116) with name mark 'Copeland'.
c. 1855. $7\frac{1}{2}$ inches high.
G. Godden Collection.

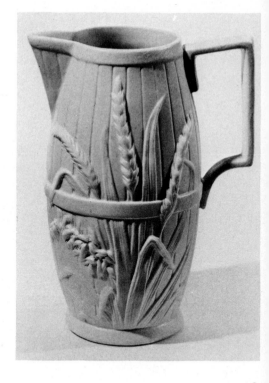

28. A Copeland Parian butter
dish, cover and stand. A design
registered on 14th July 1851.
Diamond-shaped registration
mark (page 116) with 'Copeland'
name mark. c. 1851. $4\frac{1}{2}$ inches
high. *G. Godden Collection.*

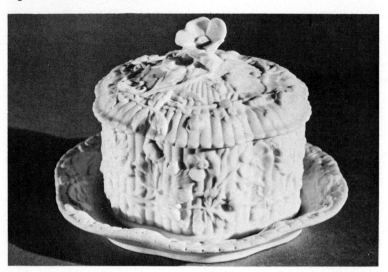

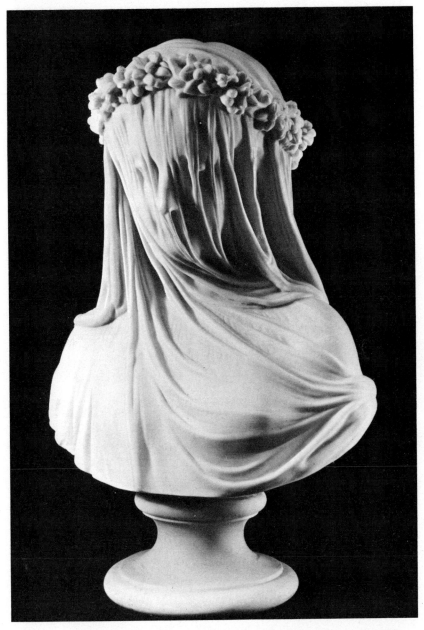

29. A typical Copeland Parian bust, after Rafaelle Monti (page 57). These veiled Monti busts were very popular. Made for the 'Ceramic and Crystal Palace Art Union', impressed with 'Copeland' name mark and date '1861'. 15 inches high. *Harris Museum and Art Gallery, Preston.*

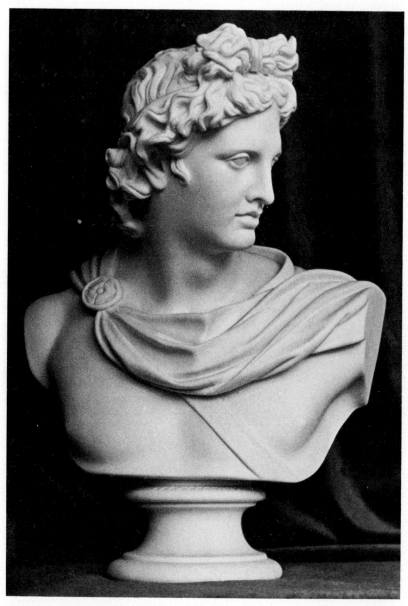

30. Copeland Parian bust of 'Apollo', after C. Delpech. Impressed marked 'Published Feb. 1st, 1861, Art Union of London. 1861'. $13\frac{1}{4}$ inches high. *Authors' Collection.*

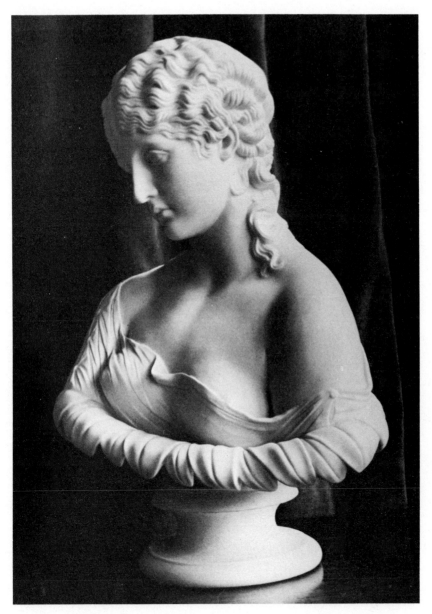

31. Copeland Parian bust of 'Clytie'. Impressed marked 'C. Delpech, Art Union of London, 1855'. 14 inches high. *Authors' Collection.*

32. Copeland bust of the Prince of Wales, after Marshall Wood.
Parian model by F. M. Miller. Marked 'Crystal Palace Art Union.
F. M. Miller, Sculp. Pub^d Feb. 1st, 1863' with 'Copeland' name mark.
$12\frac{1}{2}$ inches high. *Authors' Collection.*

33. Copeland bust of Princess Alexandra by F. M. Miller, Marked 'Crystal Palace Art Union, F. M. Miller, Sculpt. Pubd Feb. 11th, 1863', with 'Copeland' name mark 12 inches high. *Authors' Collection.*

34. Copeland portrait figure of John Wilson, known as 'Christopher North', modelled by John Steell. Marked 'Royal Association Edinburgh, Published August, 1866. Jn Steell R.S.A. Edin Sculptor' with 'Copeland' name mark. 17$\frac{3}{4}$ inches high. *Authors' Collection.*

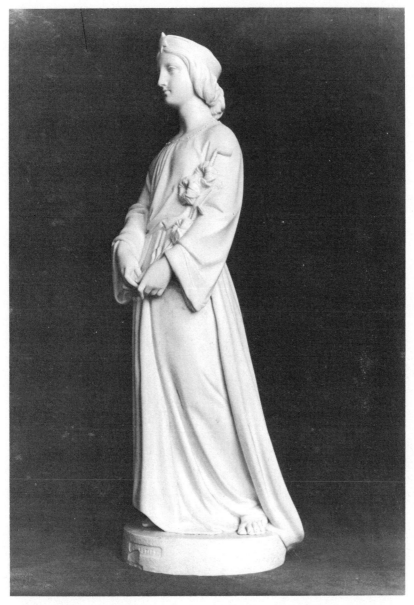

35. Copeland figure, 'Chastity' by Joseph Durham, Marked 'J Durham
Sc. Copeland. Publ Sept 1865'. 24$\frac{3}{4}$ inches high. *Authors' Collection.*

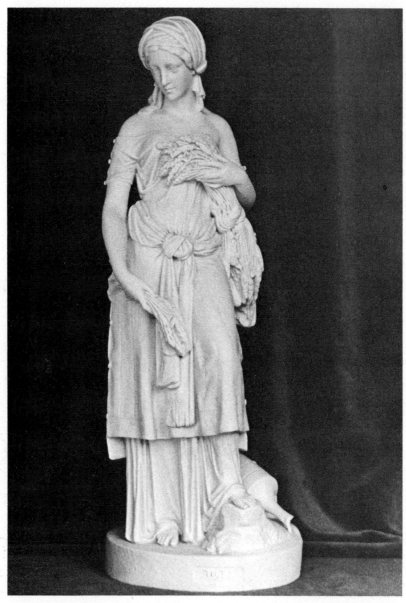

36. Copeland figure of 'Ruth' by W. Theed. Impressed 'Copeland' name mark. c. 1865. 18½ inches high. *Authors' Collection*.

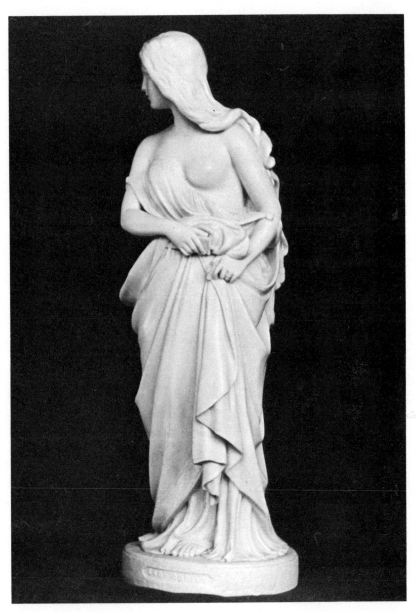

37. Copeland figure, 'Lady Godiva', after Monti (page 57). Impressed
marked 'R Monti, 1871. Copyright reserved Copeland'. 22 inches
high. *Authors' Collection.*

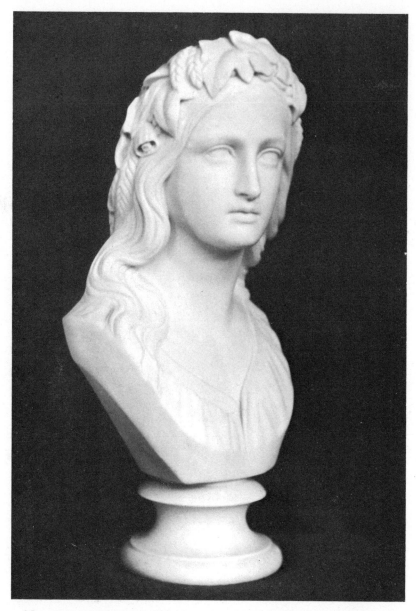

38. Copeland bust of 'Ophelia', after W. C. Marshall, R.A. Made for
the Crystal Palace Art Union, c. 1870. 11$\frac{3}{4}$ inches high. *Authors'*
Collection.

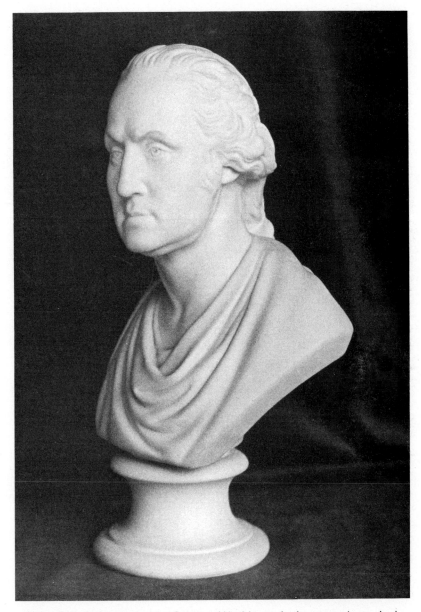

39. Copeland bust of 'George Washington'. Impressed marked 'Copyright reserved, Copeland'. c. 1870. 10¾ inches high. *Authors' Collection.*

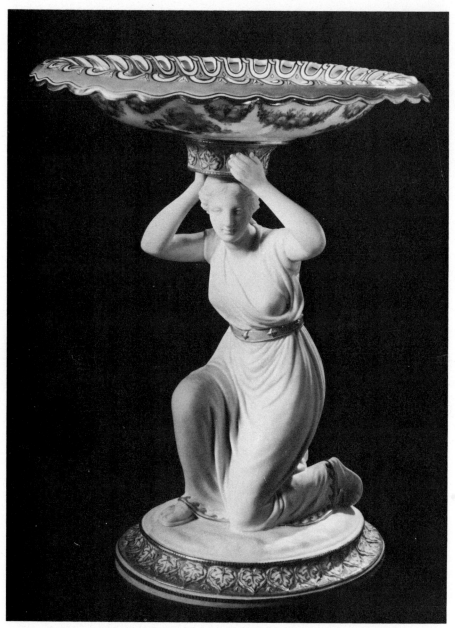

40. A graceful Copeland Parian-supported porcelain fruit comport, from a fine dessert service having several such comports of various designs. c. 1875. 11¾ inches high. *Godden of Worthing Limited.*

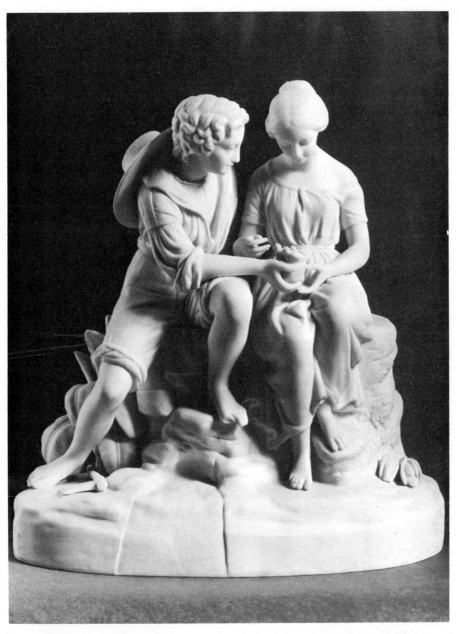

41. A Copeland group, 'Paul and Virginia'—a reissue of an early Copeland and Garrett model introduced in 1845 (see page 118). Impressed mark 'Copeland' with date mark $\frac{D}{76}$ for December 1876.

12 inches high. *Godden of Worthing Limited.*

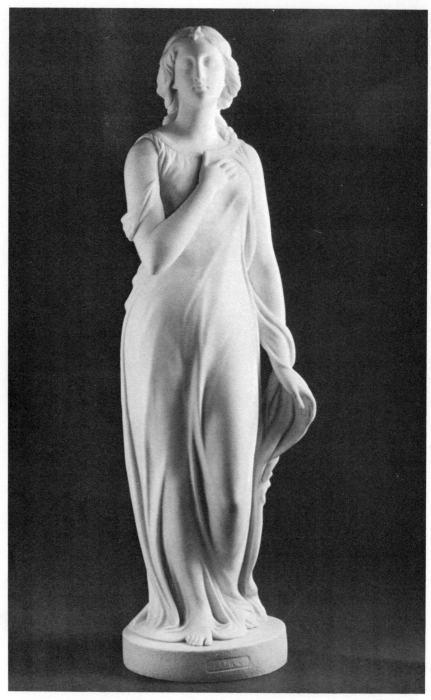

42. A Copeland figure of 'Beatrice'—a simple classical-styled figure typical of several such models. Impressed 'Copeland' name mark. 22 inches high. *Godden of Worthing Limited.*

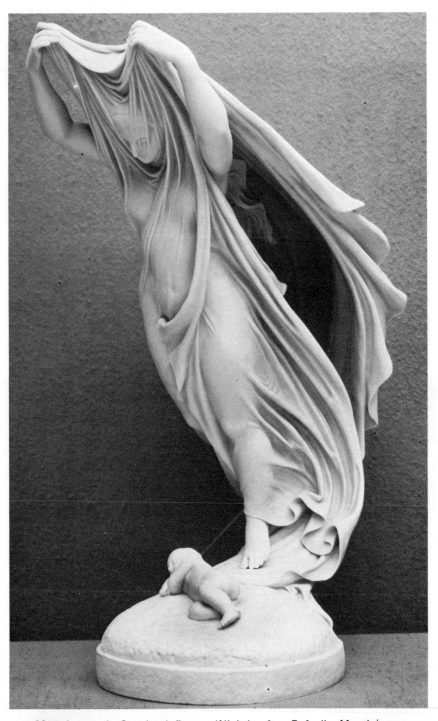

43. A superb Copeland figure, 'Night', after Rafaelle Monti (page 57)—an example that presented many difficulties in the firing. $20\frac{1}{4}$ inches high. *Victoria and Albert Museum (Crown copyright).*

44. Detail of figure shown in
Plate 46, showing broken finger
(see page 50).

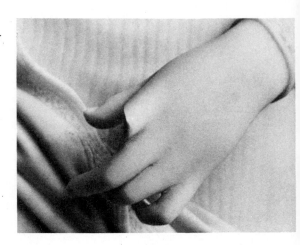

45. A Copeland animal group
in Parian, taken from the original
'Chasse au Lapin' by the famous
French sculptor P. J. Mêne.
c. 1875. 12½ inches long. *Authors'
Collection.*

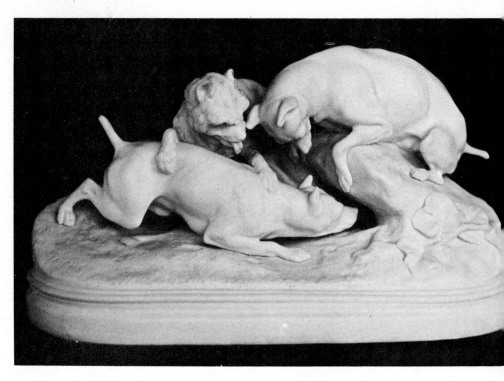

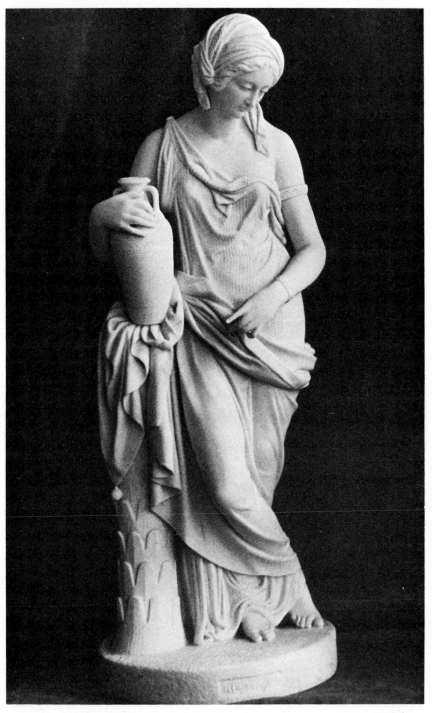

46. Copeland figure of 'Rebekah'. Model by W. Theed, bearing Theed's name mark as well as the normal impressed mark 'Copeland'. c. 1875. 19 inches high. *Authors' Collection.*

47. Pair of Derby figures after eighteenth-century originals, produced at the King Street factory of Stevenson & Hancock (see page 76). c. 1865. 6¾ inches high.
G. Godden Collection.

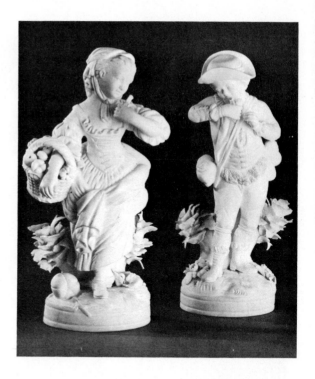

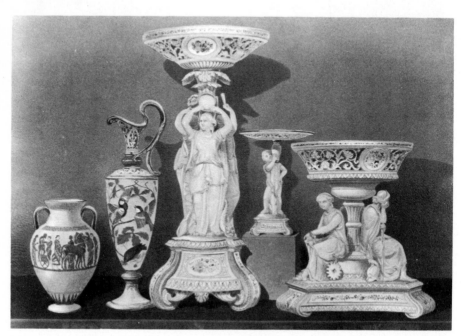

48. A selection of ware shown by Sir James Duke & Nephews at the 1862 Exhibition (see page 77). Reproduced from J. B. Waring's *Masterpieces of Industrial Art and Sculpture at the International Exhibition 1862.*

Goss

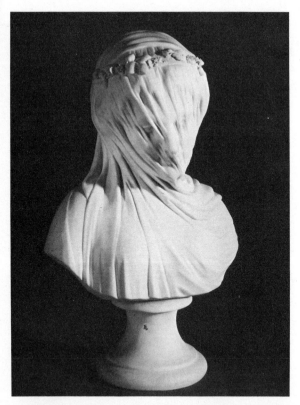

49. A fine early Goss Parian bust in the style of Monti (see Plate 29 and pages 57, 78). Impressed mark 'W. H. Goss'. c. 1865. 10¼ inches high. *Godden of Worthing Limited.*

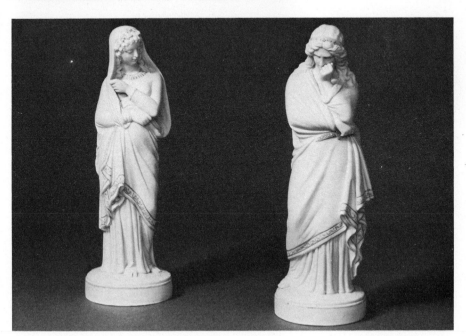

50. A pair of Goss Parian classical figures with gilt enrichments. Impressed mark 'W. H. Goss'. c. 1870. 13 inches high. *Godden of Worthing Limited.*

51. A Goss Parian bust of Sir Walter Scott. Printed crest mark (see page 78). c. 1890. $5\frac{1}{2}$ inches high. *Authors' Collection.*

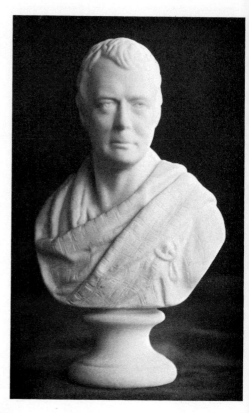

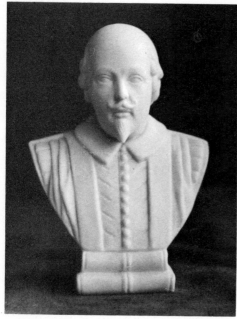

52. A small Goss Parian bust of Shakespeare. Printed crest mark (see page 78). c. 1895. 4 inches high. *Authors' Collection.*

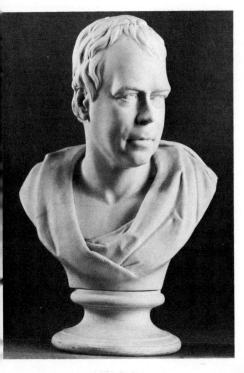

53. A Kerr & Binns Worcester bust, untitled but probably of Sir Walter Scott (see Plate 51, left). Signed by the modeller 'C. Toft, fecit'. c. 1855. 11½ inches high. *G. Godden Collection.*

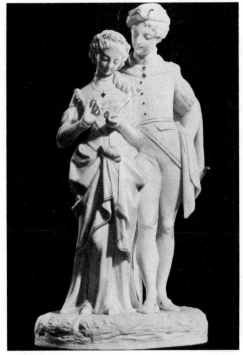

54. A Kerr & Binns Worcester group, 'Faust and Marguerite', modelled by W. B. Kirk. c. 1856. 12 inches high. *G. Godden Collection.*

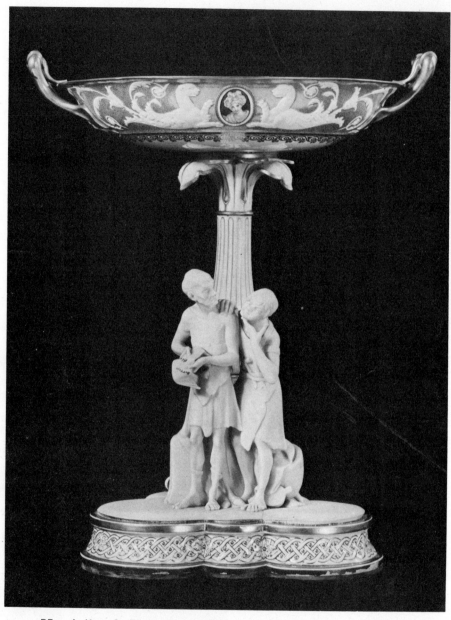

55. A Kerr & Binns Worcester comport, from the famous Shake-
speare service, depicting a scene from *A Midsummer Night's Dream.*
This service was shown at the 1853 Dublin Exhibition. 15 inches
high. *Photograph by courtesy of the Trustees of the Dyson Perrins
Museum, Worcester.*

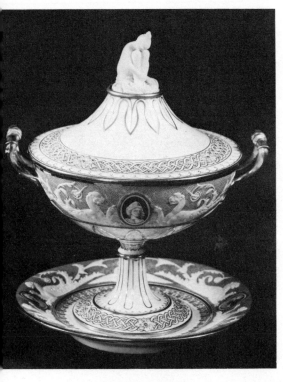

56. A Kerr & Binns covered
tureen from the Shakespeare
service (see also Plate 55).
c. 1853. 9 inches high. *Photo-
graph by courtesy of the Trustees
of the Dyson Perrins Museum,
Worcester.*

57. A Kerr & Binns Parian
salt—a design from the Shake-
speare service (Plates 55 and
56)—and an ornate inkwell.
c. 1855. *Photograph by courtesy
of the Trustees of the Dyson
Perrins Museum, Worcester.*

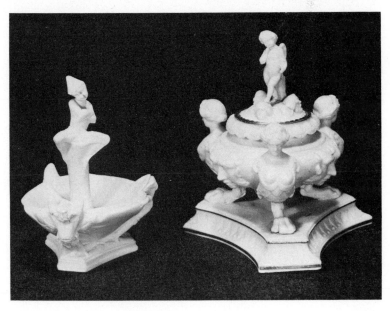

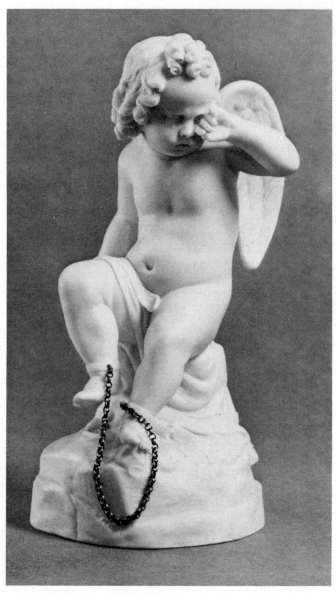

58. A rare impressed marked 'S. Keys &
Mountford' (see page 82) Parian figure, the
'Captive Cupid'. c. 1856. 8¾ inches high.
G. Godden Collection.

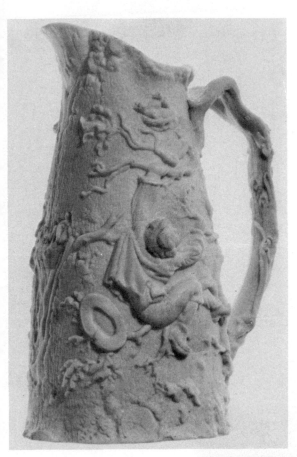

59. A crisply moulded Parian jug registered in the name of T. J. & J. Mayer on 2nd July 1850. See detail of base, Plate 60. 8½ inches high. *G. Godden Collection.*

60. Base of Mayer Parian jug shown in Plate 59. (A) shows relief moulded scroll with design number 29; the figures '36' refer to the size of this jug. (B) shows the printed factory mark as used after the 1851 Exhibition. (C) Registration mark, for 2nd July 1850; see page 84.

61. A Minton biscuit group of fine quality, model number 100 in the factory records. The Duke of Sutherland. c. 1837. 13 inches high. *G. Godden Collection.*

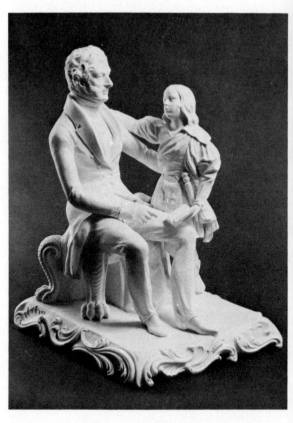

62. Minton biscuit group, 'John Anderson My Jo', model number 103—also made after 1847 in the new Parian body—shown with 'Red Riding Hood' and 'Boy with Sticks' (the bundle of sticks is missing). c. 1837. *Godden of Worthing Limited.*

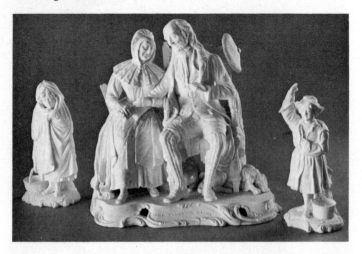

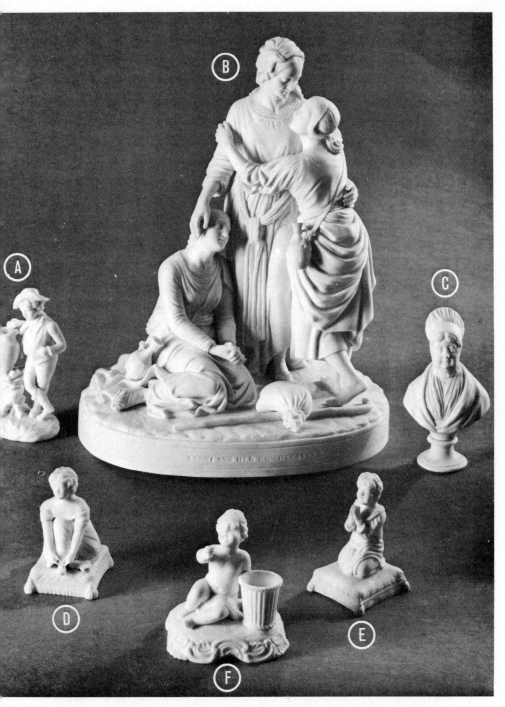

63. A selection of early Minton Parian figures. (A) 'Shepherd', model number 38, (B) 'Naomi and her Daughters-in-Law', model number 183. (C) 'Mrs. Fry', model number 176. (D) 'Good Night', model number 12. (E) 'Infant Samuel', model number 11, the partner to 'Good Night', and (F) 'Boy' match-holder, model number 242. Large group, 13½ inches high. c. 1848–50. *Godden of Worthing Limited.*

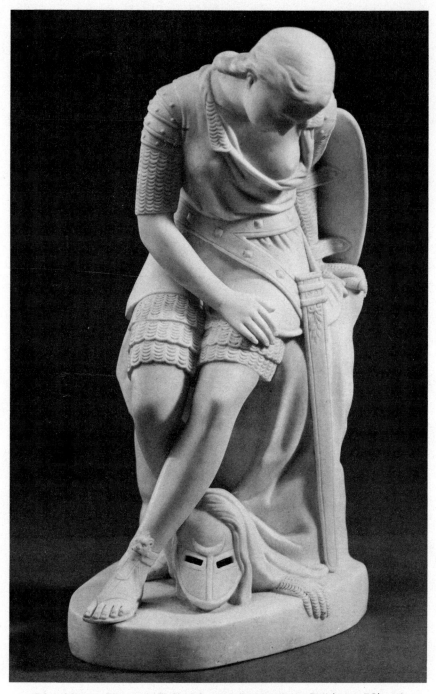

64. Minton figure of 'Clorinda', modelled by John Bell (page 53) and made for Summerly's Art Manufactures, with special mark (see page 108). c. 1848. *Messrs. Minton Limited.*

65. Minton Parian figure, 'Una and the Lion', modelled by John Bell (page 53) and made for Summerly's Art Manufactures, with special mark (see page 108). c. 1847. 14 inches high. *G. Godden Collection.*

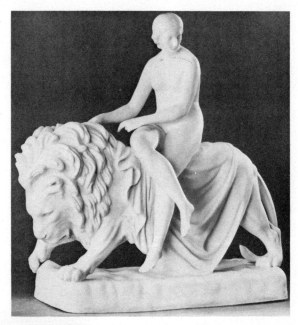

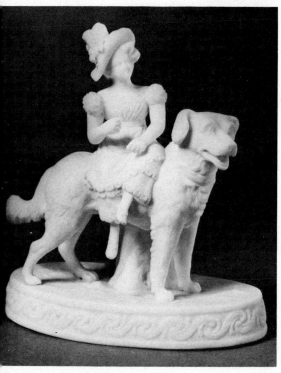

66. A Minton Parian match-holder, 'Peace on Dog'. Model number 263 in the factory records. A slight variation of an early biscuit model but with tree-trunk at rear hollowed to hold matches. Incised potting date for March 1851. 4 inches high. *G. Godden Collection.*

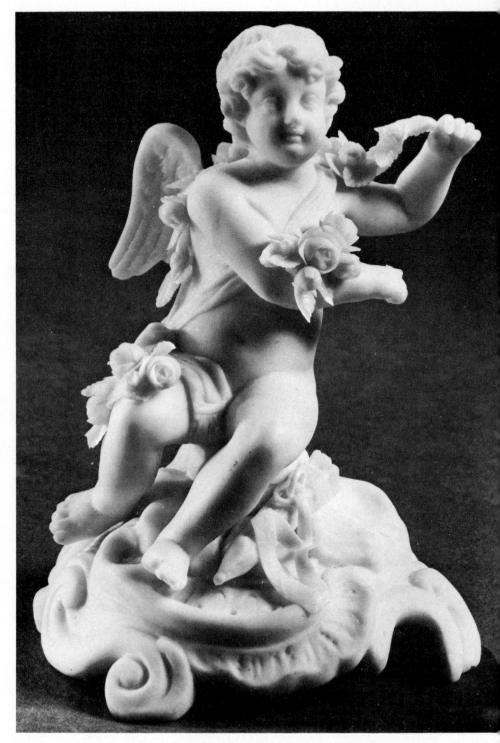

67. A small but superbly modelled Minton figure, the flower orna-
ments of the most delicate nature. Plate 68 shows the underside of
the base with incised arrow-like mark and date of potting (see pages
86–88). 1850. 4¾ inches high. *G. Godden Collection.*

68. Base of figure shown in Plate 67. The numerals 1/50 relate to the date of manufacture—January 1850. The arrow-like device appears below this and is the mark found on so many Minton Parian figures of the 1840s and 1850s.

69. An attractive Minton moulded butter dish, cover and stand. Model number 520, registered on 3rd September 1852. Diamond-shaped registration mark. Diameter of stand 5¾ inches. *Godden of Worthing Limited.*

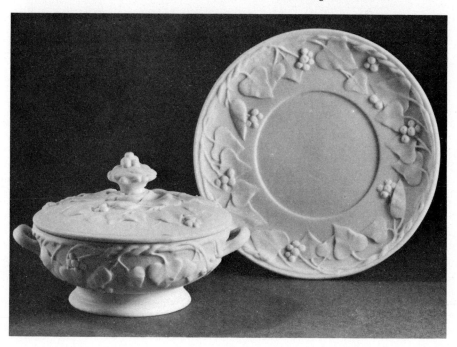

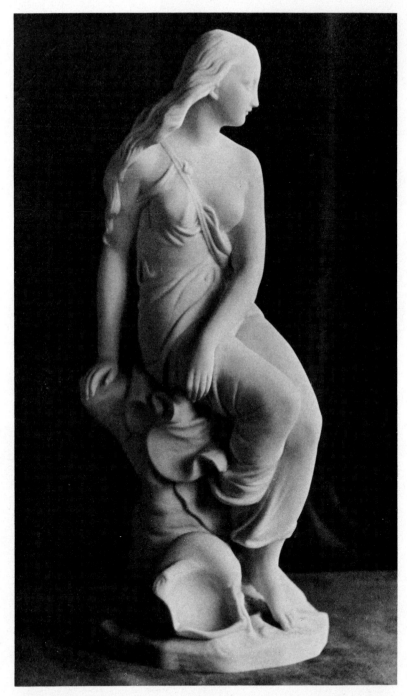

70. Minton figure of 'Miranda', modelled by John Bell (page 53). This model—number 245, introduced in January 1850—proved very popular and was made over many years. 15 inches high. *Authors' Collection.*

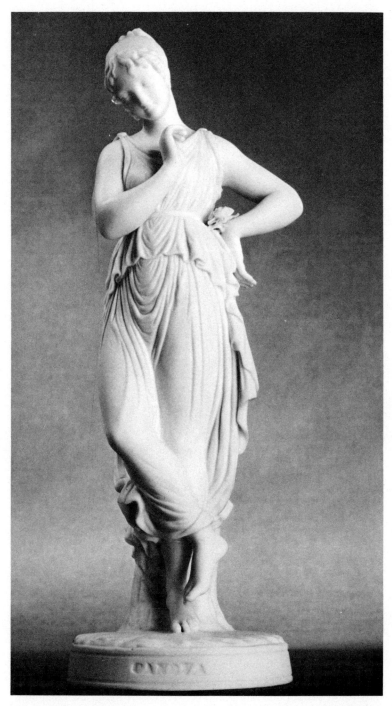

71. Minton figure, Canova's 'Dancing Girl'. Model number 182 in the factory records. This example bears the potting numerals for April 1849 with the arrow-like device (see page 86). 15 inches high. *G. Godden Collection.*

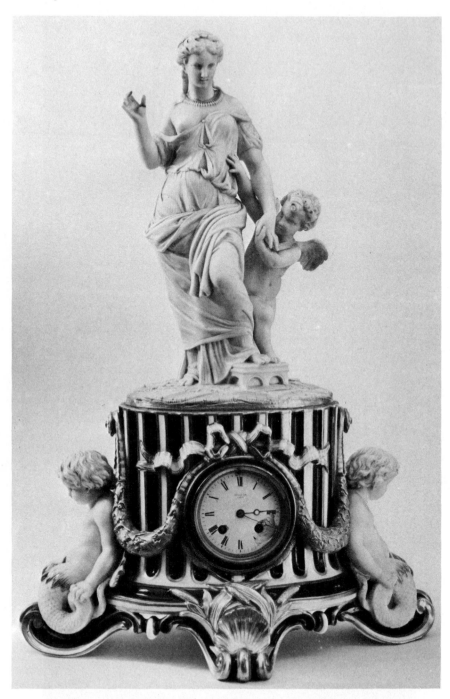

72. An important and rare Minton clock-case in glazed and decorated porcelain with Parian figure surmount. c. 1851. 21 inches high.
Messrs. Sotheby & Company.

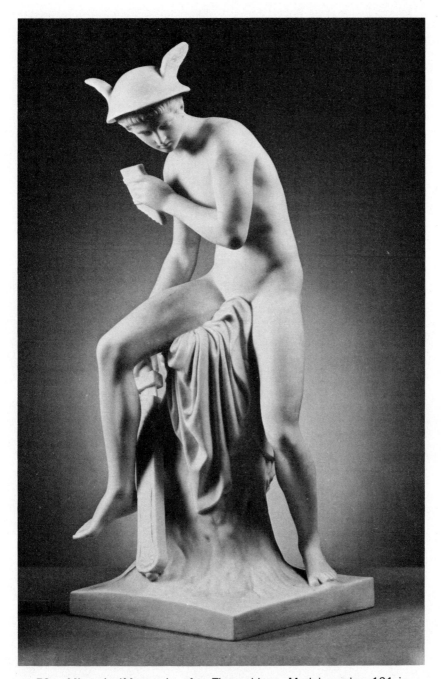

73. Minton's 'Mercury', after Thorwaldson. Model number 131 in the factory records. This figure was shown at the Society of Arts Exhibition in 1847 and at the Great Exhibition of 1851. 15 inches high. *Victoria and Albert Museum (Crown copyright).*

74. Minton figure of Sir Robert Peel (model number 253) with potting numerals for March 1851. 19 inches high. *Godden of Worthing Limited.*

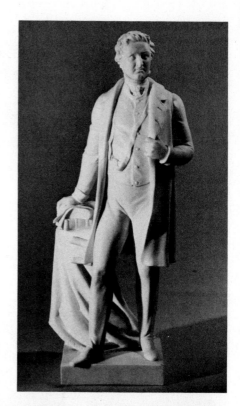

75. Minton's tinted Parian figures of the 'New Shepherd' and the 'New Shepherdess' (models numbered 79 and 80). The shepherdess is shown in Colour Plate I. c. 1851. 6¾ inches high. *G. Godden Collection.*

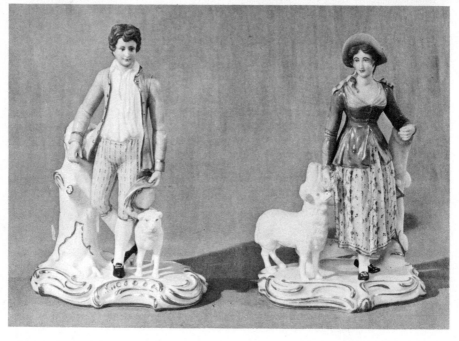

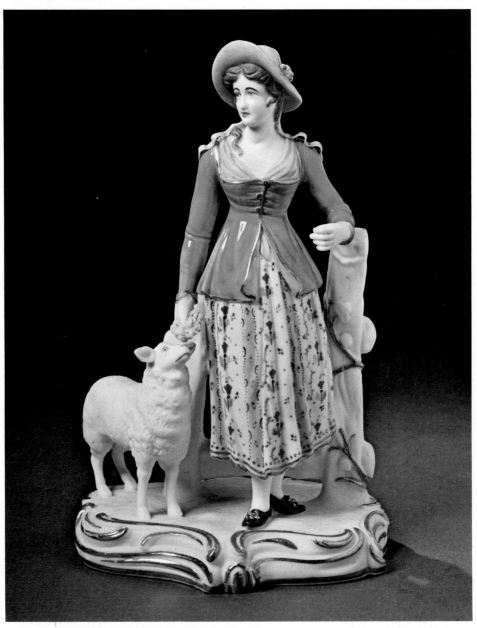

I. A rare Minton tinted Parian figure, of the 1851 period, showing the superb quality of this class of figure, which can be contrasted with some of the later, cheaper examples made by other manufacturers. The companion figure is shown in Plate 75. Incised arrow-like mark (page 86). 6¾ inches high. *G. Godden Collection.*

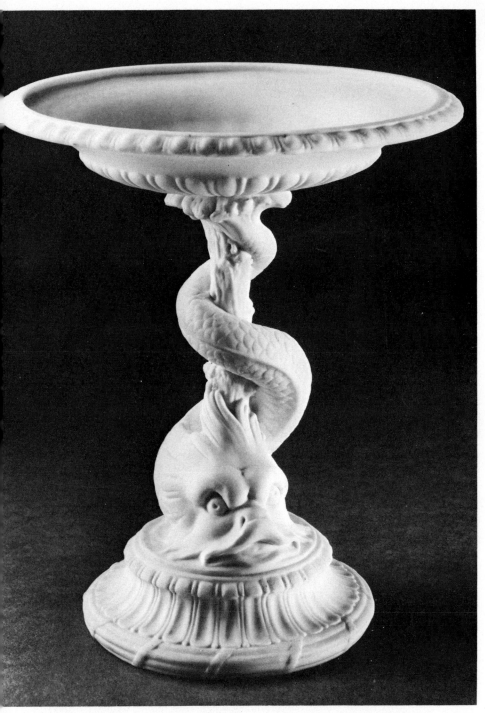

76. A Minton Parian fruit comport. Model number 464, 'Dolphin tazza', in the factory records. Year mark for 1851. $8\frac{3}{4}$ inches high.
Godden of Worthing Limited.

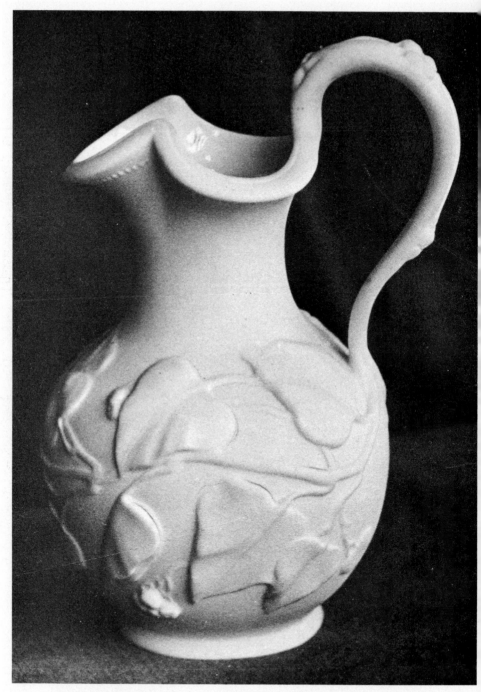

77. A typical Minton relief moulded jug, with branch handle merging
well with the design. Basic shape registered on 14th May 1855.
7 inches high. *Authors' Collection.*

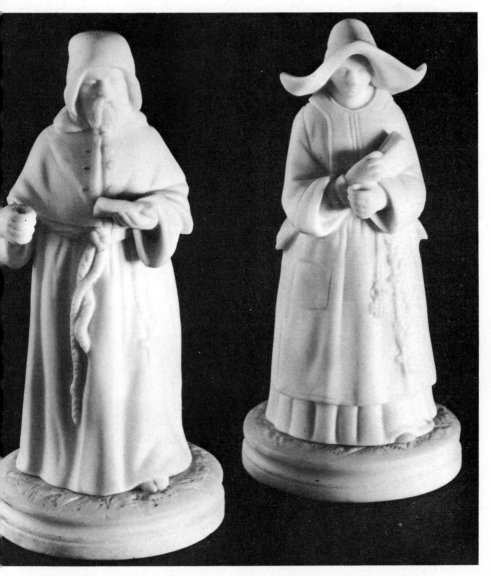

78. A rare pair of small Minton Parian 'snuffer figures'. The bodies are hollow and fit over conical bases. These figures were used to snuff out candles so avoiding burning or soiling the fingers. Arrow-like mark and year cypher for 1856 (see page 87). 4½ inches high. *Godden of Worthing Limited.*

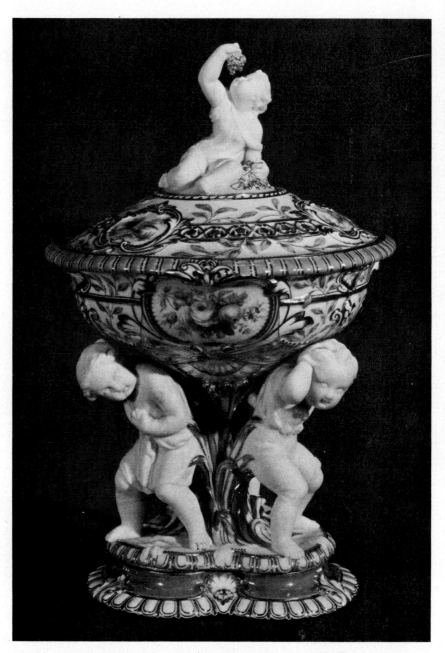

79. A Minton covered bowl of superb quality with Parian figure supports and finial. A duplicate piece matching the 1851 Exhibition service presented by Queen Victoria to the Emperor of Austria. 10 inches high. *Victoria and Albert Museum (Crown copyright).*

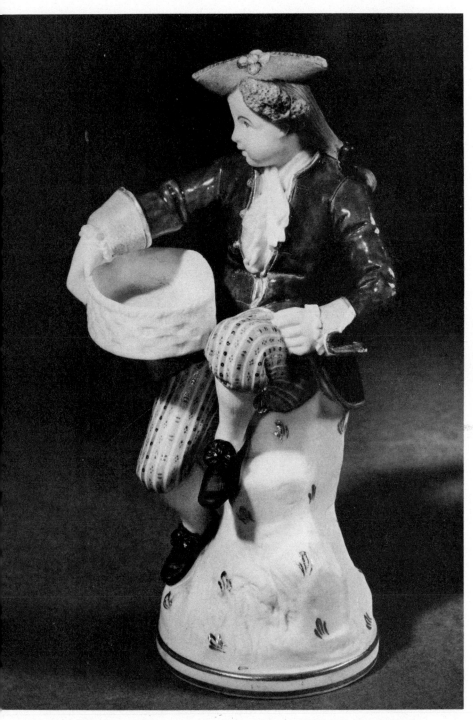

80. A Minton tinted and gilt Parian figure, 'Hogarth Match Boy'. Model number 293 in the factory records. Incised arrow-like mark with year cypher for 1856. 7¼ inches high. *Godden of Worthing Limited.*

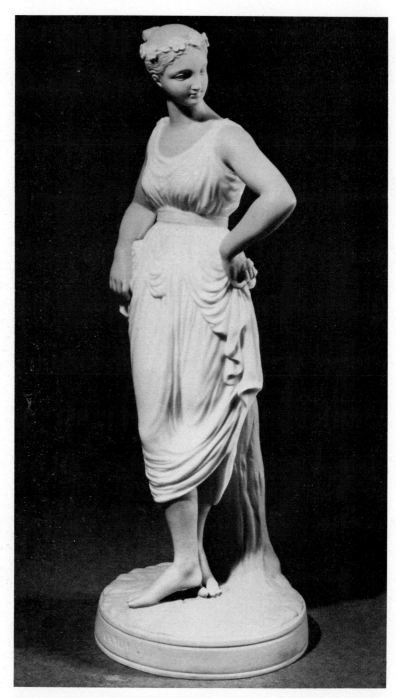

81. A very rare tinted Parian figure of Canova's 'Dancing Girl'. Model
number 195 in the factory records, the partner to that shown in
Plate 71. Note the use of a white glazed dress contrasting with the
celadon tinted matt Parian body. Impressed year cypher for 1869 and
name mark 'MINTON'. 14 inches high. *G. Godden Collection.*

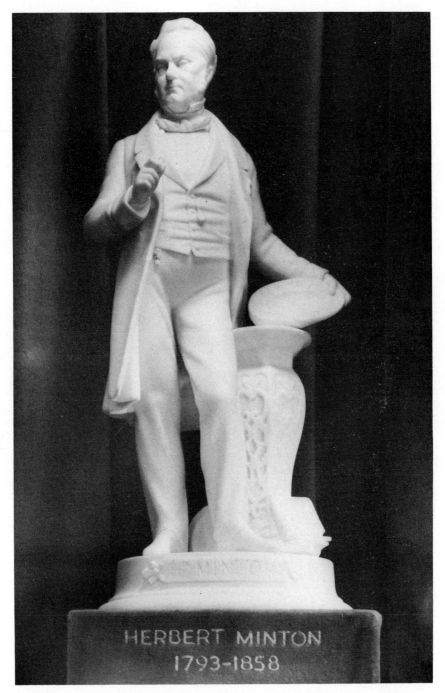

82. Minton Parian portrait figure of Herbert Minton. c. 1860. 15½ inches high. *Minton Works Museum.*

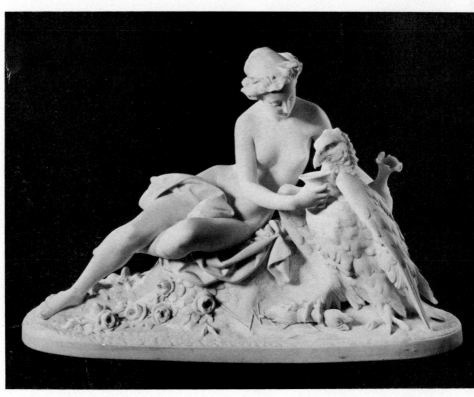

83. A superb Minton Parian figure of 'Hebe and Eagle'. Model number 339. Impressed mark 'MINTON & CO'. c. 1855. 22 inches long. *Godden of Worthing Limited.*

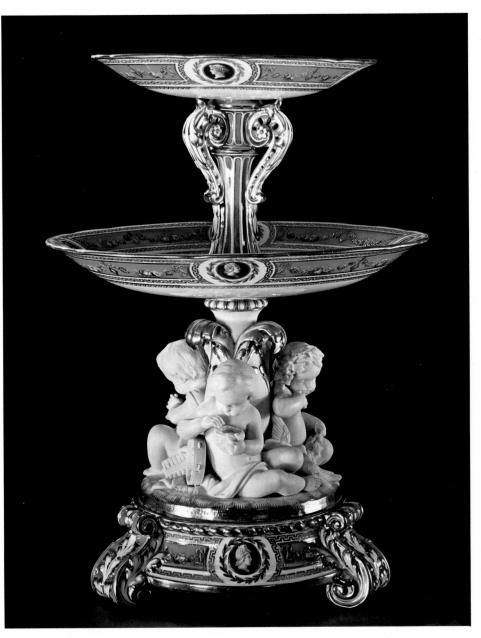

II. A superb Minton decorated porcelain centre-piece from a dessert service, with unglazed Parian child-figures contrasting with the richly decorated porcelain. Several of the leading firms made good use of the matt Parian body in this way, and the complete dessert set must have looked magnificent on a large laid table. Impressed "MINTON" name mark with year cypher for 1872 (see page 87). 15 inches high. *G. Godden Collection.*

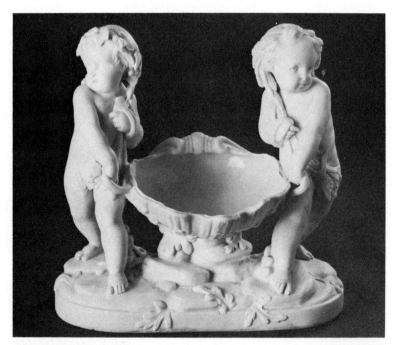

84. A Minton Parian centre-piece of a type made both in this body and in glazed porcelain. Impressed 'MINTON' name mark with year cypher for 1861 (see page 87). $10\frac{1}{4}$ inches high. *Godden of Worthing Limited.*

85. A Minton butter dish, cover and stand. The interior of the dish is glazed to assist cleaning. Minton year cypher for 1878 (see page 87). Diameter of stand 6 inches. *Authors' Collection.*

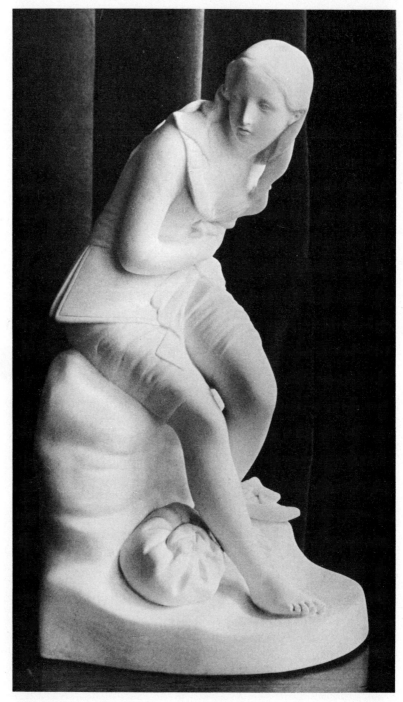

86. Minton figure of 'Dorothea', modelled by John Bell; originally made for Summerly Art Manufactures and registered on 4th October 1847 (see page 108). The model was a great favourite and sold over very many years. This example bears the year cypher for 1885. 14 inches high. *Authors' Collection.*

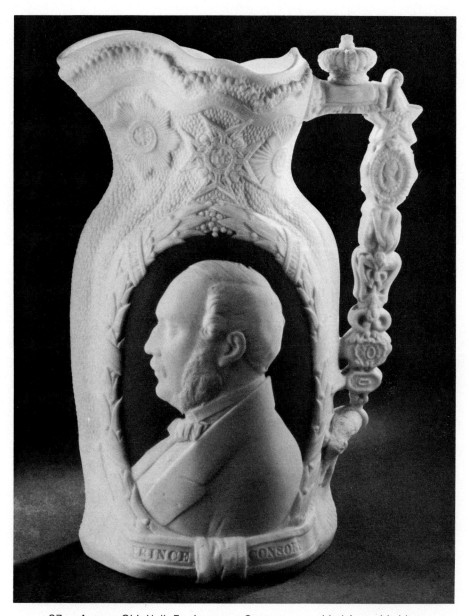

87. A rare Old Hall Earthenware Company moulded jug with blue background to the central panel. Examples also occur without this feature. The basic shape was registered on 9th April 1862. Raised, moulded diamond-shaped registration mark with initials 'O H E Co.' $9\frac{1}{2}$ inches high. *G. Godden Collection.*

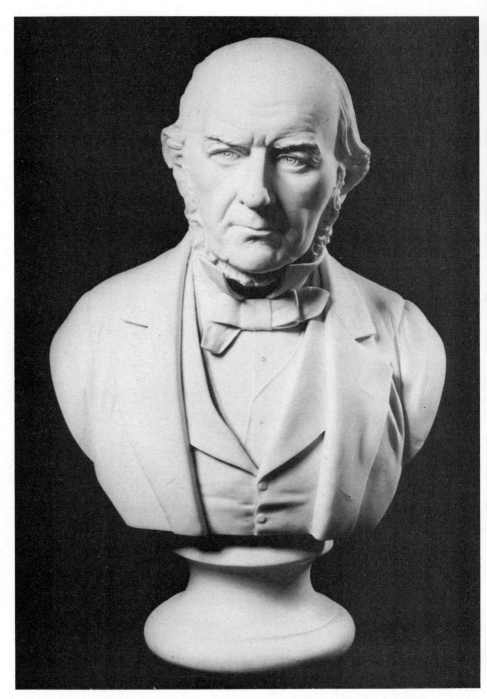

88. A good quality Robinson & Leadbeater bust of 'W. E. Gladstone, M.P.' Impressed initial mark 'R & L'. c. 1870. $15\frac{1}{4}$ inches high. *Godden of Worthing Limited.*

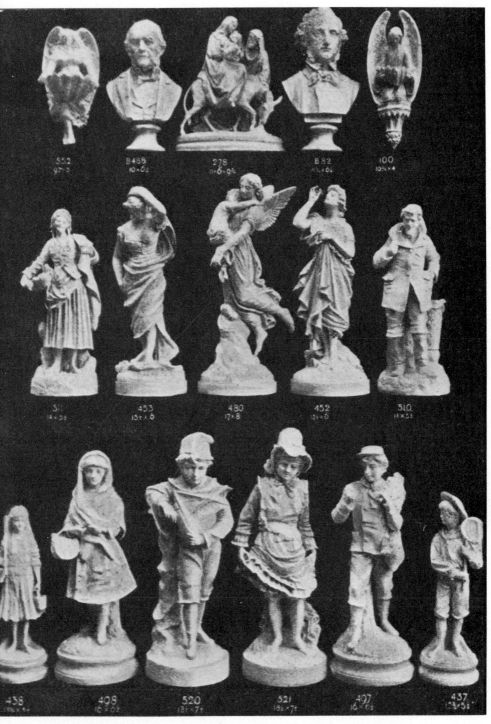

89. A selection of Robinson & Leadbeater figures and busts, re-
produced from an advertisement of 1896 in the *Pottery Gazette.*

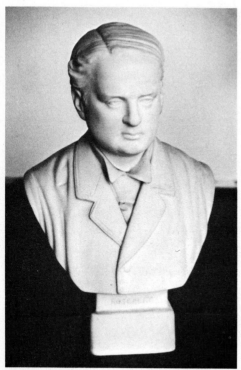

90. A Robinson & Leadbeater
bust-portrait of Lord Rosebery.
Impressed name, with initial
mark 'R & L'. c. 1890. 7½ inches
high. *Saltwell Park Museum,
Gateshead.*

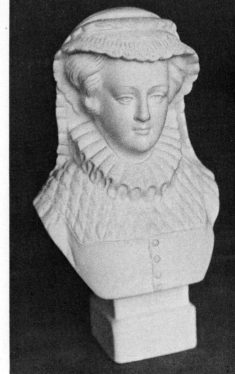

91. A Robinson & Leadbeater
portrait-bust of 'Mary, Queen of
Scots'. Impressed name, with
initial mark 'R & L'. c. 1890.
6½ inches high. *Authors'
Collection.*

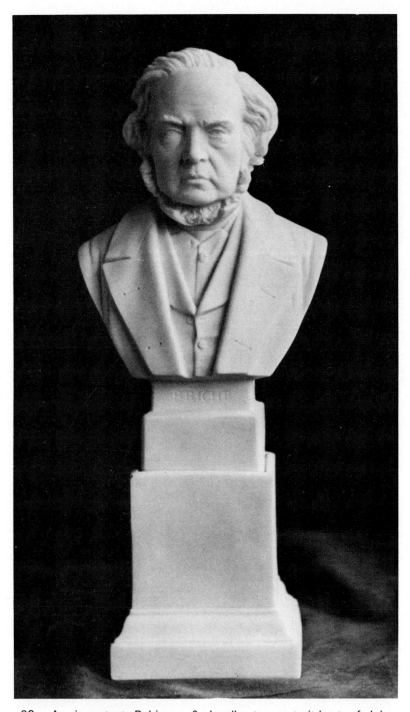

92. An important Robinson & Leadbeater portrait-bust of John Bright. Impressed initial mark 'R & L'. c. 1890. 11½ inches high. *Authors' Collection.*

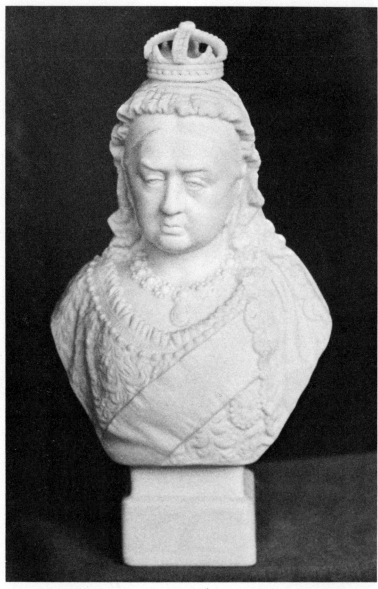

93. Robinson & Leadbeater portrait-bust of Queen Victoria (not amused!), made to commemorate her jubilee in 1897. Impressed initial mark 'R & L' with inscription. 7½ inches high. *Authors' Collection.*

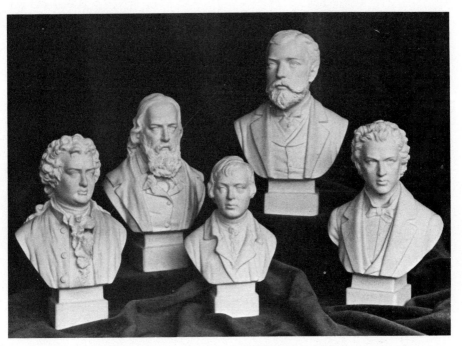

94. A representative group of Robinson & Leadbeater's portrait-busts. From left to right: Goethe, Tennyson, Burns, Nicholas of Russia, and Chopin. Note the typical square bases. c. 1890s. Heights range from $6\frac{1}{2}$ to $8\frac{1}{2}$ inches. *Authors' Collection.*

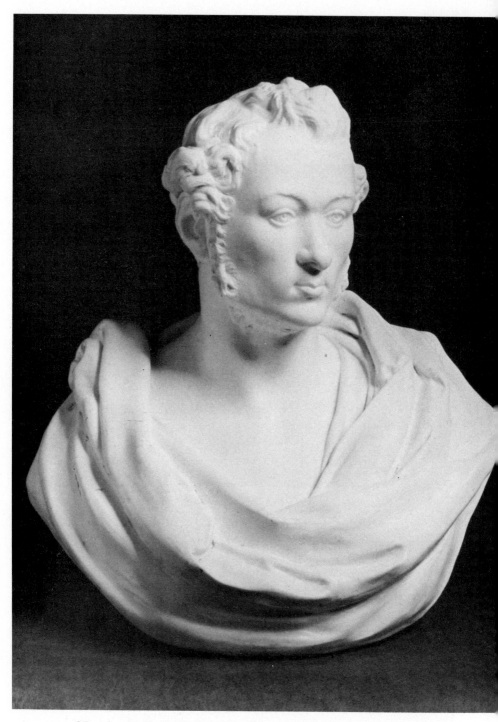

95. A superb early Coalport bust. Incised inscription 'John Rose & Co. Published Jan'y 1847 by Permission of Thos. Smith'. This example now lacks the circular plinth. 10 inches high. *Godden of Worthing Limited.*

96. An important John Rose & Co. Coalport Parian figure with decorated porcelain base. Gilt 'CBD' monogram mark. c. 1855. 16½ inches high. *Godden of Worthing Limited.*

97. An ornamental Parian flower-holder—one of a pair. 'S & S' initial mark of Daniel Sutherland & Sons (see page 109). c. 1870. 6¾ inches high. *Godden of Worthing Limited.*

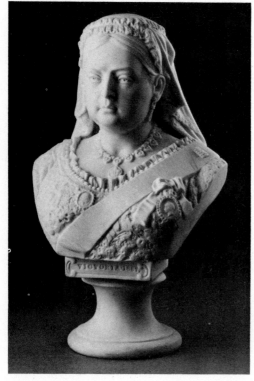

98. A dated 1887 jubilee portrait-bust of Queen Victoria. Impressed mark 'Turner & Wood, Stoke'. 11½ inches high. *G. Godden Collection.*

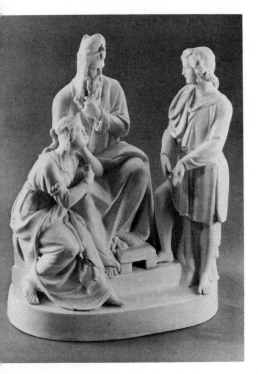

99. A well modelled and fine quality Wedgwood Carrara group, 'Joseph before Pharaoh', by William Beattie. Impressed mark 'Wedgwood'. c. 1856. 19½ inches high. *Godden of Worthing Limited.*

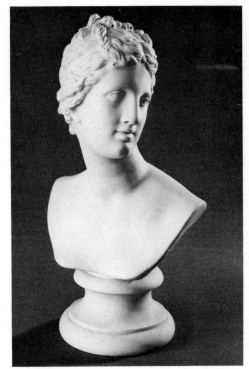

100. A Wedgwood Carrara bust of Venus—a simple but charming model. Impressed mark 'Wedgwood'. c. 1860. 15 inches high. *Messrs. Josiah Wedgwood & Sons Limited.*

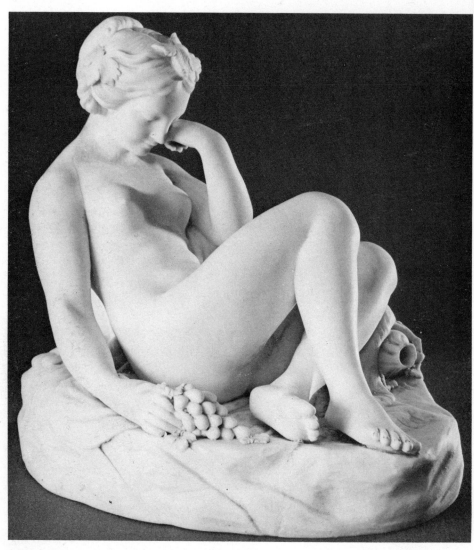

101. An attractive Wedgwood Carrara figure of Ariadne. c. 1855.
9 inches high. *Messrs. Josiah Wedgwood & Sons Limited.*

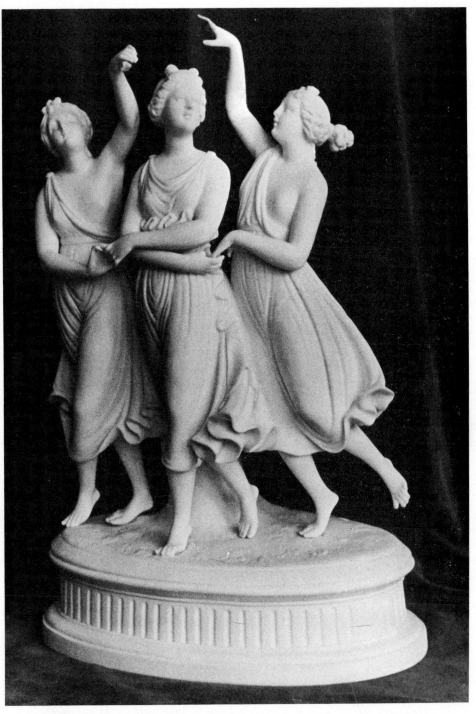

102. A fine Wedgwood Carrara group of the 'Three Graces'. Impressed 'Wedgwood' name mark. c. 1855. 15 inches high. *Authors' Collection.*

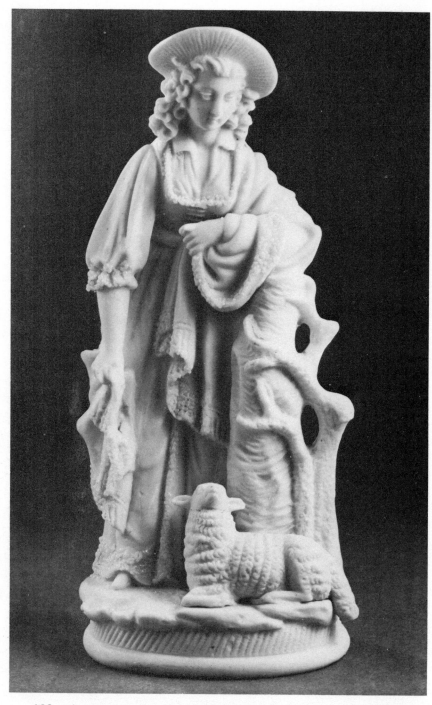

103. A typical inexpensive non-frit Parian figure, as made by many small factories employing only a few work-people. This example bears the diamond-shaped registration mark for 2nd February 1869— an entry in the name of George Yearsley (see page 115). 9 inches high. *G. Godden Collection.*

104. An unmarked biscuit figure
of the young Queen Victoria.
c. 1837. $5\frac{1}{2}$ inches high.
G. Godden Collection.

105. An unmarked biscuit figure
of about 1840. Almost certainly
Minton, and perhaps depicting
Charles Lamb. 10 inches high.
G. Godden Collection.

106. A charming mid-Victorian unmarked Parian group. 16 inches high. *Godden of Worthing Limited.*

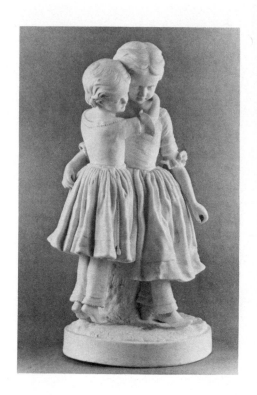

107. A lively pair of unmarked Parian figures of 'Blind Man's Buff', almost certainly by one of the talented Continental sculptors who produced models for the potters. 9 inches high. *Godden of Worthing Limited.*

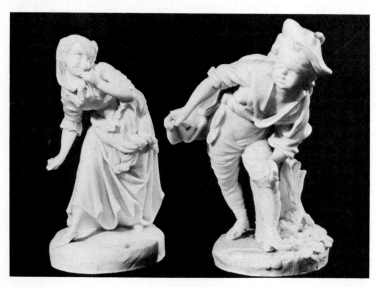

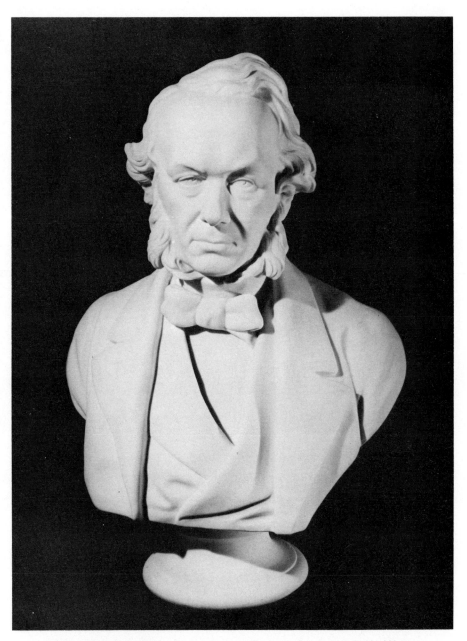

108. A well modelled Parian bust of Richard Corden by E. W. Wyon, and inscribed 'registered June 27th 1865'. Unmarked, but probably a Wedgwood example. 16 inches high. *Godden of Worthing Limited.*

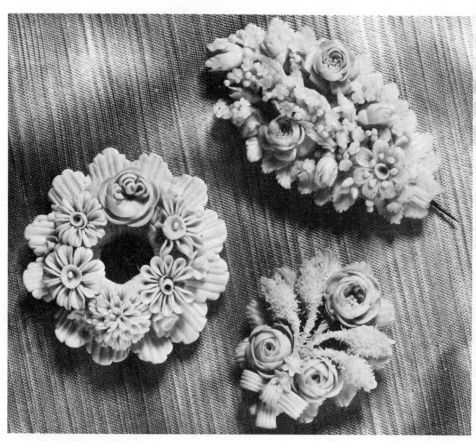

109. Three delicately modelled Parian brooches. These, and similar
Parian jewellery, were built up by hand. Several persons specialised in
the making of these small objects (see page 66). c. 1860. Top example,
$1\frac{3}{4}$ inches long. *G. Godden Collection.*

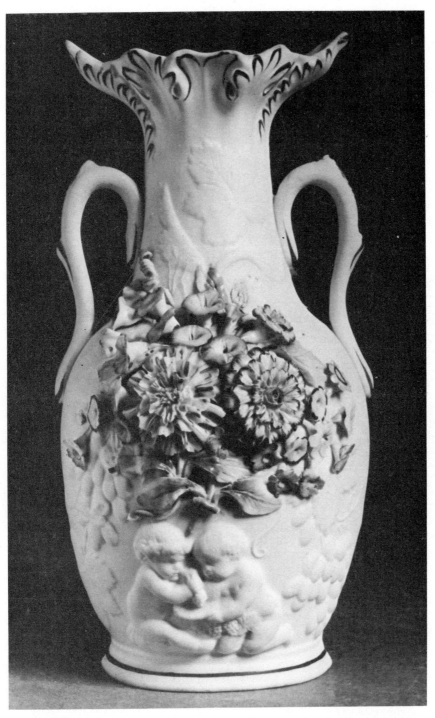

110. An unmarked Parian vase (one of a set of three) with coloured flowers. Many fine and elaborately encrusted vases and jugs were made by several Victorian Parian potters. c. 1865. 9½ inches high. *Godden of Worthing Limited.*

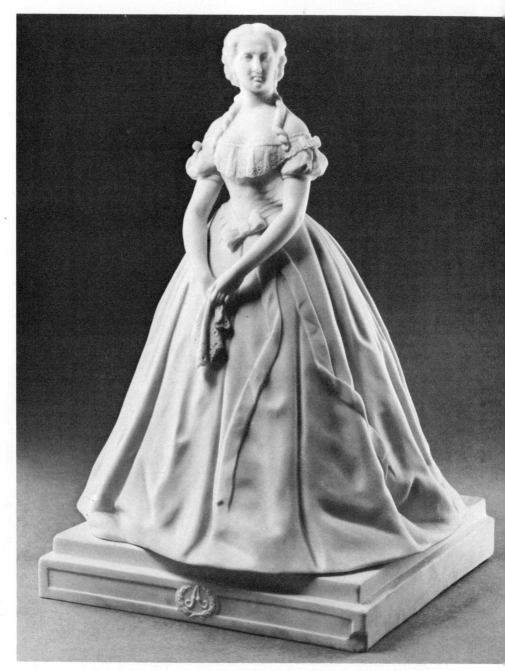

111. A superb Parian portrait figure of Princess Alice. Surprisingly, this example does not bear a maker's mark—although a Copeland mark would be expected, on the evidence of the general high quality of this figure. 13¾ inches high. *Godden of Worthing Limited.*

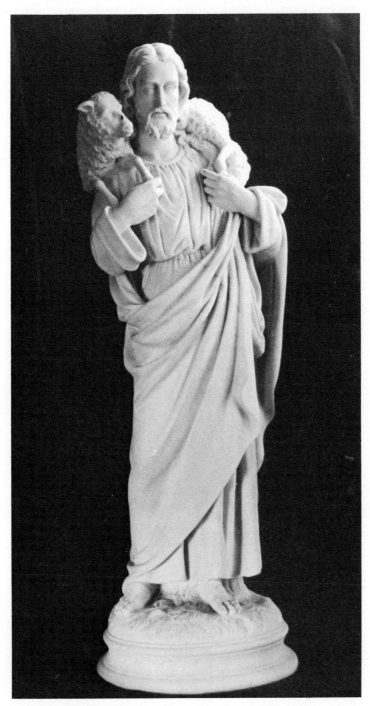

112. A good quality but unmarked Parian figure, 'The Good Shepherd'. c. 1855. 18½ inches high. *Authors' Collection.*

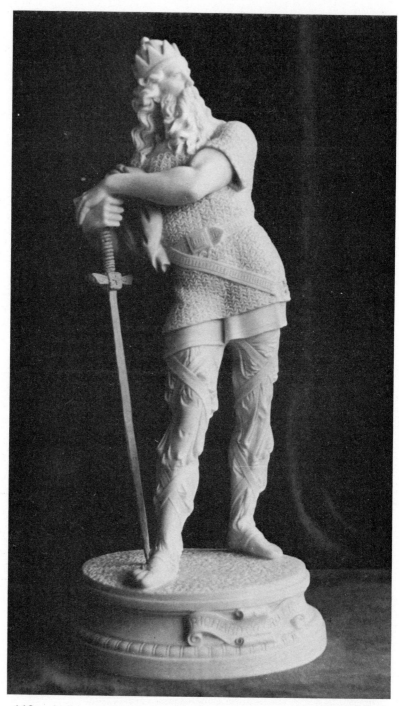

113. A fine quality Parian figure of 'Richard Cœur de Lion'. An unmarked model, full of vigour. c. 1860. 16¼ inches high. *Authors' Collection.*

114. A detail of the back of the figure shown in Plate 113, displaying the fine modelling of these Parian figures.

115. A typical Victorian biblical group in Parian. Unmarked. c. 1865.
13 inches high. *Authors' Collection.*

116. A typical Victorian classical figure, made for the Art Union of
London. Unmarked. c. 1865. 17 inches high. *Authors' Collection.*

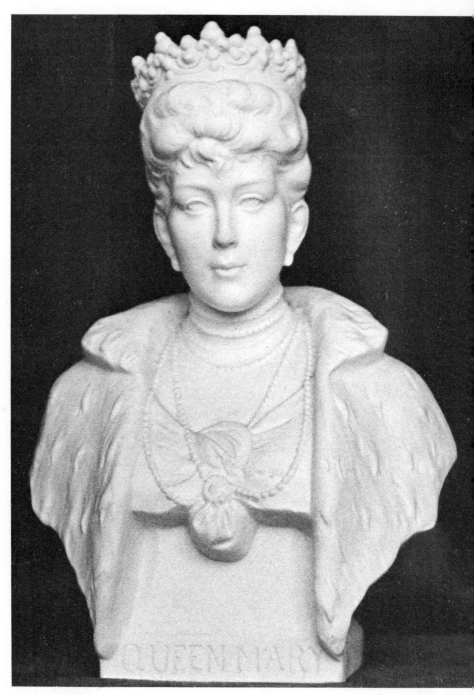

117. An unmarked portrait-bust of Queen Mary. This dates from 1911 and must have been one of the last Parian models to be produced. 5¾ inches high. *Authors' Collection.*

pages 37–8 and Plates 53–7). In 1852, the newly-formed Worcester Royal
Porcelain Company took over from Kerr & Binns. From that date to the
present time, we have a succession of 'Royal Worcester' porcelain (see
page 104).

MODELS

1853 *Comedy* by W. B. Kirk. Made to accompany the 'Shake-
speare Service'.

1853 *Salt-Cellar.* Made entirely of Parian for use with the
'Shakespeare Service'. Surmounted by a figure of Puck.
(See Plate 57.)

1853 *Uncle Tom and Eva* by W. B. Kirk.

1853 *Mr. & Mrs. R. W. Binns* A pair of busts, each 6 inches
high, modelled by W. B. Kirk for private circulation.

1855 *Lady Macbeth* by W. B. Kirk. 15 inches high.

1855 *Hafid and the Fireworshippers* by W. B. Kirk. Taken from
Moore's 'Lalla Rookh'.

1860 *Faust and Marguerite* by W. B. Kirk. Sometimes slightly
gilded (see Plate 54).

1860 *Venus Rising from the Sea.* 15 inches high.

1860 *Plenty.* 10½ inches high.

1860 *Paulina Bonaparte as Venus.* 23 inches long. After Canova,
from the statue in the Borghese Palace in Rome.

1860 *Peace.* 12½ inches high.

1860 *Aristo Ink.* Elaborate inkwell in Parian: female heads sur-
mounted by a cover and a standing figure of Cupid. It is
slightly gilded (Plate 57).

1860 *The Duke of Leinster* by J. E. Jones.

1860 *W. Dargan* by J. E. Jones.

1860 *Robert Stevenson* by Joseph Durham.

The Kerr & Binns pieces may bear one of the two printed marks shown
below. Others may bear marks incorporating the initials 'K & B' or the short
title 'W. H. Kerr & Co'. It should be noted that there is no crown over the
second mark. This feature was added only in 1862, when the new Worcester
Royal Porcelain Company succeeded.

G

Keys & Briggs
(Working period c. 1860–4)

Keys & Briggs of Copeland Street, Stoke, displayed Parian goods at the 1862 exhibition, but we have not been able to trace other details of their ware.

Keys and Mountford
(Working period c. 1850–7)

As related on page 3, in about 1850 Samuel Keys, the Derby trained modeller, joined in partnership with John Mountford to produce Parian ware. John Mountford claimed to have been the inventor of the Parian body while employed by Messrs. Copeland & Garrett (see page 2).

At the 1851 exhibition, this partnership, claiming to be 'Designers, Inventors and Manufacturers', exhibited the following Parian ware:

> Statuettes of Flora.
> Prometheus tormented by the Vulture.
> Venus unrobing at the bath.
> Two Circassian slaves.
> Group of three boys, with perforated baskets for dessert centrepiece.
> Pair of figures, male and female, with glass linings to perforated bases.
> Statuette of Venus extracting a thorn.
> Group of two dogs, setter and pointer, with game.
> Group of three greyhound dogs.
> Bacchanalian ewer from the Antique.

Of these articles, the jury reported that Messrs. Keys and Mountford 'exhibit a series of statuettes in Parian, well executed and of a pretty effect'.

Marked Keys and Mountford Parian is now extremely scarce. The initial mark 'K & M' has been recorded; but the only example known to us is the figure shown in Plate 58, from the Godden collection, which bears the impressed mark 'S KEYS & MOUNTFORD'.

In 1857, John Mountford established his own works (see page 98).

Kirkham, William
(Working period c. 1862–90)

William Kirkham established a factory in London Road, Stoke, in 1862 for the manufacture of Parian goods as well as terra-cotta and earthenware. The Parian does not seem to have been marked. Kirkham's main concern was with the earthenware, which included door furniture and chemists' goods.

Lancaster, James
(Working period c. 1861–5)

James Lancaster had a small Parian works at Longton, where two men and two boys assisted the 'master-potter'. The Lancaster ware was almost certainly unmarked. This entry is included to show the small size of some of the Staffordshire 'factories' which produced the normal range of Parian jugs and ornaments.

Liddle, Elliot & Son
(Working period c. 1862–70)

Liddle, Elliot & Son of the Dale Hall Works at Burslem displayed Parian and other goods at the 1862 exhibition. They were large producers of all types of earthenware during the 1862–70 period. A previous partnership at the Dale Hall Works was that of Thomas, John & Joseph Mayer (see below).

Livesley, Powell & Co.
(Working period c. 1851–66)

Livesley, Powell & Co. of the Stafford Street Works at Hanley were, according to their letter-head, 'Manufacturers of Porcelain and Earthenware, Parian Statuary and china figures'. The firm exhibited Parian at the 1862 exhibition. In about 1866, Mr. Livesley retired and the well-known firm of Powell & Bishop continued.

Massey, Nehemia, & Sons
(Working period c. 1834–66)

Nehemia (sic) Massey occupied various potteries at Burslem from about 1834. From 1860 to 1866, the address was 13 Waterloo Road. Here, the firm produced Parian in addition to Rockingham-glazed earthenware and pottery teapots and jugs. The ware appears to have been unmarked.

Mayer, Thomas, John & Joseph
(Working period 1843–55)

This partnership was one of many which, at various periods, worked the celebrated Dale Hall Pottery at Burslem in the Staffordshire Potteries. Amongst their varied display at the 1851 exhibition, the official catalogue lists only the following Parian articles: 'Vases and card baskets, in Parian ware, with a wreath of flowers. Brooches, pins, etc.'. But the next item listed, 'Bust of Wesley, from the original mould, belonging to the late Enoch Wood, Esq., the sculptor', could also have been in the Parian body.

It is difficult to know which Dale Hall partnership Llewellynn Jewitt was referring to in 1878 in his *Ceramic Art of Great Britain*, but this Victorian authority wrote highly of the Mayer products and of their 'Parian of an improved body'.

A series of relief moulded Parian jugs was also made. One of these is shown in Plate 59, with the underside of the base shown in Plate 60. The base shows the diamond-shaped registration mark, indicating that this design was registered on 2nd July 1850. The moulded scroll has the number '29', which was the number given to this design in the factory records. The number '36' relates to the size of the jug—and it must be remembered that all such jug-patterns were made in three or more sizes. The printed Royal Arms mark is self-explanatory and is a clear trade mark, but the wording above—'Prize Medal 1851'—shows that this version dates from the middle of 1851.

Meigh, Charles (& Sons)
(Working period 1835 to March 1861)

Charles Meigh worked the Old Hall Works at Hanley, in the Staffordshire Potteries. From 1835 to 1849, he traded as Charles Meigh; but in 1850, the trading style was Charles Meigh, Son & Pankhurst. In 1851, this was simplified to 'Charles Meigh & Sons'. Under this style, the firm exhibited at the 1851 exhibition. Its stand included the following Parian goods (with a good range of fine and decorative earthenware):

Statuettes

> Templar and companion.
> Falconer and companion.
> Bather and companion.
> Cupid and Venus.
> Dancer and companion.
> Flora.
> Prometheus.
> Various figures, all Parian.

Busts

> Dr. Adam Clarke.
> Sir Robert Peel.
> Shakespeare.
> Napoleon.

Ornamental objects

> Large vase, history of Bacchus.
> Vases, Maltese.

Clock, 'Night and Morning', in chased gold.
Wine coolers, Bacchanalian.

This Charles Meigh & Sons' ware is often exceedingly 'busy' and somewhat overdecorated to modern eyes, but it is typical of the high-Victorian style. Some simple jug forms in Parian are, perhaps, better suited to modern taste. The Charles Meigh (& Sons) marks incorporate the name or the initials 'C.M.' or 'C.M. & S.'

From April 1861, the firm was retitled the 'Old Hall Earthenware Co. Ltd.' (see page 98).

Meli, Giovanni
(Working period, as a manufacturer, c. 1858–62)

As recorded on page 56, Giovanni Meli was mainly concerned with supplying models to several of the leading Parian manufacturers.

In about 1858, Meli established his own pottery at Glebe Street, Stoke, where, assisted by his son, he produced 'Parian statuettes, vases, ornaments, jugs, butter tubs, dessert pieces etc.' which were shown at the 1862 exhibition. His name was also mentioned in association with models made by Sir James Duke & Nephews and shown at the 1862 exhibition.

Giovanni Meli's period of production was of short duration. In about 1862, he returned to modelling, and his pottery was taken over by Robinson & Leadbeater. After about 1866, he returned to his native Italy and then emigrated to America, where he successfully established a pottery.

A review of his work by J. T. S. Lidstone, in *The Thirteenth Londoniad* of 1866 uses the heading—perhaps taken from a bill or letter-heading or trade-card—'Giovanni Meli, designer and modeller, Manufacturer of Parian figures, ornaments, etc., near the Town Hall, Stoke-on-Trent. Modeller to the principal manufacturers in the Potteries for the last twenty years, ten of which for Mr. Alderman Copeland'.

Mills Brothers
(Working period c.1865–70)

The Dresden Works in George Street, Hanley, were managed by several members of the Mills family. They produced not only Parian jugs, and the like, but also coloured Parian figures. Firstly, in the 1834–51, period, Henry Mills produced earthenware figures. He was succeeded by Mrs. Elizabeth Mills who, from 1851 to 1873, produced Parian ware with a small staff of five men, four women and one boy. But from 1865 to 1870, the trading style was Mills Brothers. Finally, in 1874–5, the Dresden Works were in the name of Edward G. Mills.

Mills, Mrs. Elizabeth (See Mills Brothers)

Minton & Co.

(Working period 1793 to the present day, with various slight changes in the trading name which do not concern the Parian collector)

In the 1830s and early 1840s, the Minton factory at Stoke-on-Trent pro-duced a range of most attractive white biscuit-porcelain figures and groups of outstanding quality (see Plates 5, 6, 7, 61 and 62. These models are listed in Geoffrey Godden's *Minton Pottery and Porcelain of the First Period, 1793–1850* (Herbert Jenkins, London, 1968). From a period in the middle of 1847, several of these earlier models were made in the new creamy-coloured Parian body. Some are therefore to be found in both styles. It is surprising to find however, that as late as May 1847 *The Art-Union* magazine was still reporting on Minton's bisque figures rather than Parian examples. The report reads:

> Minton's bisque figures are now superior to the French in artistic management of drapery, and particularly in the lace imitations, and he gives equal excellence at a cheaper rate.

But from about this period, the old chalky-white bisque-china body gave way to the new body, with its slight sheen and warm creamy tint; and all new Minton figure models were produced in the Parian body. Fortunately, the fac-tory records have been preserved and we thus have records of all these models.

Some of the finest Minton biscuit-china figures and also some of the slightly later Parian examples are delicately ornamented with lace-work. These examples were naturally more expensive than the plain straight-forward examples, although the manufacturing process was not as compli-cated as one might expect. *The Art-Union* magazine of December 1846 contains the following contemporary account:

> The bisque figures of Messrs. Minton have enjoyed for a long time a very considerable sale . . . The imitation of lace as an appendage to most of these figures, is carried out very successfully . . . The process by which this is effected is extremely simple. Real lace is the groundwork which, being immersed in 'slip' (diluted china), becomes saturated, and a coat or crust adheres to it, which in the firing becomes firm, while the lace is of course destroyed, leaving the pattern perfect in 'bisque'.

The Minton Parian figures which occur with this lace enrichment are 'Arabia' (No. 137), 'The Five Senses '(Nos. 145-9), 'Taglioni' (No. 168), 'Ophelia' (No. 171) and 'Cleopatra' (No. 172).

Minton products ranged over a wide field—figures, groups, busts, ornate comports and centrepieces, as well as utilitarian objects such as jugs, butter pots and the like. Very good use was made of Parian set off against glazed and decorated porcelain (see Colour Plate II and Plates 72 and 79).

The early Minton biscuit and Parian figures are not marked, although Mr. Godden has been able to identify these examples by reference to the original factory records. From the mid-1840s, an incised (scratched) arrow-like de-vice is found on many Minton models (see Plate 68 and the drawing opposite).

1842	1843	1844	1845	1846	1847	1848	1849
✳	△	▢	✕	⬯	⌒•	⌣	⊷

1850	1851	1852	1853	1854	1855	1856	1857
♣	∴	⌄	⌢	∽	✳	Q	◇

1858	1859	1860	1861	1862	1863	1864	1865
↯	✶	♌	人	♁	⬦	Z	⌇

1866	1867	1868	1869	1870	1871	1872	1873
✕	A	Ɔ	⊡	Ꮐ	N	⊗	✳

1874	1875	1876	1877	1878	1879	1880	1881
↓	Ɛ	⊛	⊙	△	△	△	⊞

1882	1883	1884	1885	1886	1887	1888	1889
⊗	◔	⊠	⋈	B	♛	⋈	S

1890	1891	1892	1893	1894	1895	1896	1897
⌐	1	2	3	4	1	2	3

1898	1899	1900	MINTON YEAR MARKS
4	5	6	

The arrow-like device appearing on many of the earlier Minton models (see pages 33 and 86).

This is often accompanied by workmen's personal signs and by potting date marks. These date marks normally take the form '4/49', to give an example which would relate to April 1849. In some instances, the year is given in full. After about 1850, this system of dating was replaced by the factory date cyphers, the key to which is given on page 87. Incised numbers also occur, and these relate to the model number in the factory records.

Some Minton figures from about 1850 have the incised or moulded name 'Minton & Co'; and from about 1862, the impressed name 'MINTON' was the standard mark on the Parian. From 1873, this became 'MINTONS' —with the 's' added.

MODELS

(For pre-1847 Minton models originally issued only in biscuit, the reader is referred to Geoffrey Godden's *Minton Pottery and Porcelain of the First Period, 1793–1850* (Herbert Jenkins, London, 1968). Some of these models were reissued in the Parian body. The following list is taken from the above work and also from the Minton factory records. The numbers given are the official model numbers in the factory records, and they are sometimes found incised or impressed into the underside of the base. Model numbers not listed were produced only in the pre-Parian chalky white biscuit-porcelain body. Models listed from 11 to about 162 were produced in both bodies—firstly in biscuit porcelain and later, that is from 1847, in Parian).

11. Infant Samuel (kneeling child; Plate 63).
12. Good Night (the companion figure to No. 11; Plate 63).
18. Greyhound, on cushion.
22. Spaniel, on cushion (Plate 6).
25. War (boy riding a dog).
26. Peace (girl riding a dog).
27. War (boy, standing).
28. Peace (girl, standing; Plate 6).
38. Shepherd.
39. Shepherdess.
41. Bust of Sir Walter Scott.
42. Female with garland.
43. Male companion to No. 42.
47. Wesley, standing.
48. Rowland Hill, standing.
51. Boy sitting between two baskets.
52. Girl companion.
54. Man with basket of fruit and flowers.
55. Woman, companion piece.
56. Male reclining figure, with basket.

57. Female companion.
60. Hannah More (Plate 3).
61. Dr. Adam Clarke.
62. Magdalene.
63. Wilberforce (Plate 3).
65. Chelsea Pensioner.
66. Greenwich Pensioner (Plate 4).
67. Goldsmith's Old Soldier.
68. Flute Player.
69. Guitar Player.
73. Boy with basket.
74. Girl companion.
75. Easy Johnny.
77. Sir Robert Peel (see Plate 7 for biscuit version).
79. New Shepherd (see Plate 75).
80. New Shepherdess (see Colour Plate I for tinted version).
81. Coachee.
82. Sheep Shearer.
83. Gleaner.
84. Standing male with basket.
85. Female companion.
90. Grand Turk (Plate 4).
91. Female companion.
92. Sir Walter Scott (seated in chair).
93. Edmund Burke.
94. Spanish Guitar Player.
95. Male beggar.
96. Female companion.
97. Red Riding Hood (Plate 62).
98. Boy with sticks (Plate 62).
100. Duke of Sutherland and the Marquis of Stafford (a fine elaborate group originally priced at £2. 16. 0., see Plate 61).
101. Tinker.
102. Gipsy.
103. 103. John Anderson My Jo' (Plate 62).
108. Male dancing figure.
109. Female companion.
112. Gamekeeper.
116. Joan of Arc.
117. Burlesque (Monkey) sculptor.
118. Burlesque (Monkey) painter.
119. Persian greyhound.
120. Italian greyhound.
121. Male dancer.
122. Female companion.
123. Napoleon.

124. Boy on a chair.
125. Girl companion piece.
126. Sleeping children, after Chantry.
127. Turk figure, reclining.
128. Female companion piece.
131. Mercury, after Thorswaldsen (Plate 73).
132. Apollo.
133. Skating boy.
134. Magdalene, after Canova.
135. Viennese Chocolate Girl.
136. Cupid, on plinth.
137. Arabia, with lace.
138. Ariadne (middle-size).
139. Cupid on chair.
141. Beginning of Time (Cupid and hourglass).
142. End of Time (standing Cupid).
143. Spanish flower girl.
144. Persia, with lace.
145. Sense of Seeing, with lace.
146. Sense of Hearing, with lace.
147. Sense of Smelling, with lace.
148. Sense of Feeling, with lace.
149. Sense of Tasting, with lace.
 (N.B. Numbers 145 to 149—five seated figures, with lace-like enrich-
 ments—were copied from Dresden porcelain originals, and the models
 were also made by other firms.)
154. La Belle Louise.
155. Admiral.
156. Lady with Muff.
157. Madonna (with plain base, with ornate base and with blue-and-gold
 base, at £1. 8. 0., £1. 13. 4., and £3 respectively).
158. Cerito.
161. The Four Seasons (see note under No. 149).
162. Fanny Ellsler.
163. Ariadne, after Daneker, large size.
164. Charles Wesley.
165. John Wesley.
166. John Fletcher.
167. Emperor of Russia.
168. Taglioni, with lace.
169. The broken pitcher.
170. Fisherman.
171. Ophelia, with lace.
172. Cleopatra, with lace.
173. Venus de Medici.
174. Venus Calipygie.

175. St. Joseph (with plain base, with ornate base and with blue-and-gold base, at £1. 8. 0., £1. 13. 4., and £3 respectively).
176. Bust portrait of Mrs. Fry (Plate 63).
178. Bust portrait of George Washington.
179. Guardian angel.
182. Dancing girl, after Canova (Plate 71).
183. Naomi and her Daughters-in-Law (Plate 63).
184. Una and Lion, by John Bell (Plate 65).
185. Jenny Lind, by Joseph.
186. Music (female figure), after Pradier.
187. Infant Neptune, by H. J. Townsend.
188. Kissing Cupids (small group for paperweight).
189. Dorothea, by John Bell (Plate 86).
190. Bust portrait of Duke of Wellington, by Joseph.
192. Virgin at Annunciation.
193. Angel at Annunciation.
194. Dr. Chalmers, by J. Bell.
195. Dancing Girl, after Canova (Plate 81).
196. Jenny Lind, by Count D'Orsay.
197. Hebe, after Canova.
198. Prayer, by J. Bell (see page 107).
199. Belief (the companion figure, see page 107).
200. Shakespeare, by J. Bell.
201. Comedy, by J. Bell.
202. Tragedy, by J. Bell.
203. Clorinda, by J. Bell (Plate 64).
204. The Rose of England, by Jeannest.
205. The Lily of France, by Jeannest.
206. The Prince of Wales, after Winterhalter.
207. The Greek Slave, by Hiram Power. (This popular model was also produced by other firms including Messrs. Copeland).
208. Infant Bacchus, by J. Bell.
209. The Crucifixion.
210. Distressed Mother, by Sir R. Westmacott.
211. Maternal Devotion, after Pradier.
212. Cupid Indignant, by J. Bell.
213. Angel Lamp, by J. Bell.
214. Child's Play, by J. Bell.
215. Hunter Group, by J. Bell.
216. Temperance.
217. Cupid and Psyche.
218. Babes in the Wood, by J. Bell.
221. Christ, after Thorswaldsen.
222. Triton and Nautilus, by J. Bell.
223. The Flight into Egypt.
224. Angel Font, by J. Bell.

225. Bust of Michael Angelo.
226. Sleeping Cupid.
227. Wolf dog.
228. Wild boar.
229. Two dogs.
230. Lion and shield.
231. Lion asleep.
232. Lion enraged.
233. Fontaine de Ville Borghese.
234. Lion reposing.
235. Sow and pigs.
236. Dying gladiator.
237. Sleeping boy.
238. Lion attacking horse.
239. Companion group.
240. The Archangel Michael.
241. Bust portrait of Dorothea.
242. Boy (match-holder).
243. Girl companion piece.
244. The First Mother.
245. Miranda, by J. Bell (Plate 70).
246. The Amazon, after Veuchere.
247. Bird-catcher.
248. Coquette.
249. Juvenile Contention.
250. Bust portrait of Raphael.
251. Atala and Chactas.
252. Love restraining wrath.
253. Sir Robert Peel (Plate 74).
254. Theseus (companion to The Amazon, No. 246).
255. Venus and Cupid.
256. Flora.
257. Children with Goat.
258. Companion piece.
259. Tinker (match-holder).
260. Gipsy (match-holder).
261. Beggarman (match-holder).
262. Female companion.
263. Peace on Dog (match-holder; Plate 66).
264. War on Dog (match-holder).
265. Standing girl, 'Peace'.
266. Companion boy, 'War'.
267. Venus at Bath, after Falconet.
268. Venus at Toilette, after Falconet.
269. Pan.
270. Bacchante.

271. The Three Maries.
272. Bust of Duke of Wellington, by Carrier.
273. Boy with basket (match-holder).
274. Girl companion piece.
275. Neapolitan boy with Tortoise.
276. The Wounded Indian, by Stephenson.
277. Cupid, bust.
278. Companion piece.
279. Prometheus.
280. Boy with basket (match-holder).
281. Girl companion piece.
282. Boy with bamboo basket.
283. Girl companion piece.
284. Cupid reclining.
285. Companion piece.
286. French horse.
287. Psyche, by Carrier.
288. Pandora, by Carrier.
289. Irish boy, by Carrier.
290. Irish girl, by Carrier.
291. Monkey musician, by Carrier.
292. Companion piece.
293. Hogarth match-boy, by Carrier (Plate 80).
294. Girl companion piece.
295. Victory.
296. The Vintagers, by Carrier.
297. Diana.
298. Organ grinder.
299. Girl with cage.

The 1852 printed catalogue of Minton Parian figures stops at this number. This catalogue might have been drawn up towards the end of 1851 for the following year; or perhaps it was prepared early in 1852.

300. Bust of Nelson.
301. Bust of Napoleon.
302. Christ blessing little children.
303. Small-sized bust of Wellington.
304. Small-sized bust of Nelson.
305. Small-sized bust of Napoleon.
306. Piper.
307. Listener.
308. Lord Ronald Gower.
309. Lord Albert Gower.
310. Bust portrait of Webster.
311. Standing figure of Webster.

312. Grape Bearer.
313. Grape Bearer, companion piece.
314. Seated Cupid.
315. Companion figure.
316. Two Cupids reclining.
317. Hunter (companion to Diana, No. 297).
318. Double shell salt, with cupids.
319. Bust of Bacchus.
320. Bust of Ariadne.
321. Good race (a three-figure group).
322. Goat.
323. Goat.
324. Mother and her firstborn.
325. Lady Constance Grosvenor, by Carrier.
326. Seahorse and shell.
327. Cain and Abel.
328. Vestal Virgin.
329. Adam.
330. Eve.
331. Victory (Alma and Sebastopol).
332. Nun (match-holder).
333. Friar (match-holder).
334. Bust portrait, Lady Constance Grosvenor.
335. Sappho.
336. Venus and Cupid.
337. Leda.
338. Resignation.
339. Hebe and Eagle (Plate 83).
340. Victory, on pedestal.
341. David's Triumph and Reward.
342. Christ and his Disciples.
343. Margaret of Anjou.
344. Havelock.
345. Pair of female bust portraits.
346. Sir Colin Campbell.
347. Bust portrait—Mirth.
348. Bust portrait—Grief.
349. Male Cupid.
350. Female Cupid.
351. Ondine.
352. Prodigal Son.
353. Bacchus.
354. Bust portrait, Robert Burns.
355. Bust portrait, Queen Victoria.
356. Bust portrait, Prince Consort (Albert).
357. Prince Alfred with Pony.

358. Bust portrait, King of Sardinia.
359. Bust portrait, Clodion.
360. Prince Arthur.
361. Boy and donkey.
362. Princess Helena.
363. Princess Louisa.
364. Princess Beatrice.
365. Vintagers—with shell.
366. Major Hodson.
367. Science.
368. Art.
369. Industry.
370. Knitting girl.
371. Skipping girl.
372. Cock and Hen.
373. Cupid and basket.
374. Silence.
375. Vintager, with basket at front and rear.
376. Vintager, with basket in each hand.
377. American slave.
378. Queen Victoria.
379. Duchess of Kent.
380. Water Nymph.
381. Prince Leopold (with net).
382. Prince Arthur.
383. Lady Godiva.
384. Autumn, by Carrier.
385. Summer, by Carrier.
386. Venus.
387. Spring.
388. Summer.
389. Autumn.
390. Winter.
391. Lalage.
392. Clodion Venus.
393. Daniel saved.
394. Princess Alice.
395. Boy and Staghound.
396. Boy and Stag.
397. Literature.
398. Boys with dove.
399. Bust portrait of Princess Alexandra.
400. Hawking.
401. Fishing.
402. Bust portrait of Prince of Wales.
403. Boy and foxhound.

404. Boy and fox.
405. Child vintager with basket.
406. Child vintager with basket.
407. Cupid with basket.
408. Hen and chickens (letter-weight).
409. Chickens (letter-weight).
410. 'Our Good Queen'.
411. Seamstress.
412. The Lion in Love.
413. Male with wheelbarrow.
414. Temperance.
415. Europa and the bull.
416. Road-sweeper figure.
417. Orange girl.
418. Lord Palmerston.
419. Romeo and Juliet.
420. The Star of Bethlehem (Jesus sleeping).
421. Boy with basket.
422. Lord Derby.
423. Penelope.
424. Vintagers.
425. Perseus and Andromeda.
426. Fraternal embrace.
427. David and Goliath.
428. Portia.
429. Elaine.
430. Viola.
431. Girl with basket (companion to No. 421).
432. Boy and shell.
433. Girl with shell.
434. The Mother of Titian.
435. Salvator Rosa.
436. Rhodope (mentioned in the *Art Journal*, January 1866).
437. Cupid with shell.
438. Europa.
439. Faith.
440. Hope.
441. Charity.
442. The Lady of the Lake.
443. Bust portrait of Dr. Livingstone.
444. Andromeda.
445. National Sports, cricket, the bowler.
446. National Sports, cricket, the batsman.
447. No entry.
448. No entry.
449. Donkey with panniers.

450. The Octoroon.
451. Abyssinian Slave.
452. The Last Kiss.
453. Education of the dog, begging.
454. Imogen entering the Cave.
455. The Bathers.
456. Dancing girl.
457. Dr. Livingstone.
458. His Grace the late Duke of Sutherland.
459. Her Grace the late Duchess of Sutherland.
460. Cupid (flower-holder).
461. Nydia.
462. Female with basket.
463. The Reader (flower-holder).
464. Marguerite.
465. Canadian Trapper.
466. Vintager.
467. Marie Antoinette.
468. Female and child, in boat.
469. Fine Arts.
470. Science.
471. Flower of the Town.
472. Flower of the Field.
473. Bacchus on Pedestal.
474. Ondine on Pedestal.
475. Savoyard.
476. Cupid and shell.
477. Confidence.
478. Japanese lady and vase.
479. Bust portrait, Marie Antoinette.
480. Reclining female, with basket.
481. Reclining male, with basket.
482. Male figure, with two baskets.
483. Female figure, with two baskets.
484. Male with flower basket.
485. Female companion piece.
486. Cupid (salt).
487. Infant Neptune.
488. Girl with shell.
489. Boy with shell.
490. Bust portrait, Colonel MacDonald.
491. Sir Sabar Jung.
492. Vintagers (two children carrying basket).
493. Cupid and basket (pair of single figures).
494. Infant Satyr, with shell.
495. Male with basket.

H

496. Female with basket.
497. Male figure with shell.
498. Female figure with shell.
499. Awakening of Aurora.
500. Japanese lady.

Mountford, John
(Working period c. 1857–64)

As related on pages 2 and 3, John Mountford claimed to have discovered the Parian body while in the employ of Messrs. Copeland and Garrett in the early 1840s. At this period, he was only in his early twenties. From c. 1850 to 1857, he was in partnership with Samuel Keys, as 'Keys & Mountford' (page 82); but from 1857 to 1859, he had his own works at John Street, Stoke. A directory of 1864 lists John Mountford at the Dresden Pottery, Stoke—the only recorded reference to him at this time.

The incised signature mark 'J. Mountford, Stoke' has been recorded, but such marked specimens are exceedingly rare.

Nautilus Porcelain Co.
(Working period c. 1896–1913)

The Nautilus Porcelain Co. of the Possil Pottery, Glasgow, produced a range of inexpensive Parian-like figures and jugs from 1896 to 1913. The advertisements do not list only Parian ware:

> Earthenwares in white and ivory bodies, Porcelains in tea, dessert and trinket services, centre-pieces, candelabras, figures, vases, together with a large assortment of fancy ware, cheaply and richly decorated . . .

One of the printed marks found on this Scottish ware is reproduced below.

Old Hall Earthenware Co. Ltd.
(Working period 1861 to July 1886)

This firm succeeded Charles Meigh & Son at the Old Hall Works, Hanley. Good Parian ware—mostly useful ware or vases rather than figures or groups. The ornate Parian jug shown in Plate 87 is rare because the background to the panel is blue. The basic design was registered on 9th April 1862 and the mark

comprises the diamond-shaped registration mark (see page 116) with the initials of the company, 'O.H.E.C.L.', above. The initials 'O.H.E.C.' or 'O.H.E.C.L.' occur on other ware produced by this firm.

From 1886 to 1902, the firm traded under the amended style 'Old Hall Porcelain Works Ltd'.

Platt, Samuel
(Working period c. 1861)

Samuel Platt produced unmarked Parian goods at Hanley in the early 1860s. His works were small and he only employed ten persons.

Podmore, John
(Working period c. 1878)

John Podmore succeeded Beech & Podmore (see 'Beech, William', page 63) at the Bleak Hill Works at Burslem. Jewitt, in the first edition of his *Ceramic Art of Great Britain*, 1878, wrote of the contemporary Podmore wares:

> The goods now produced, besides tea and other services, are the ordinary marketable china and Parian chimney ornaments and toys, which are produced in large quantities both for home sale and for exportation to the United States, the East Indies, the Netherlands, and Australia. In Parian and ivory body, besides flower-vases and other small ornaments, some tolerably large groups have been produced . . .

It is probable that the same general types of ware were made by Beech & Podmore.

Poole, Stanway & Wood
(Working period c. 1875-8)

The earlier history of this Stoke firm trading in Copeland Street is given under 'Turner, Hassall & Bromley' (page 109). The new partners, from 1875 onwards, produced a vast quantity of Parian goods, but these appear to have been unmarked. However, in *Ceramic Art of Great Britain*, 1878, Jewitt gave a good contemporary review of them:

> . . . The present productions of these works are Parian, principally statuary, of the higher quality in body, in colour, and in workmanship . . . The speciality of the works is in Parian, and in this they rank very, and deservedly, high; in this the novelty was introduced by Mr. Turner of decorating the Parian body with majolica colours (see page 110) . . . In statuary Parian, a large variety of groups, single figures, animals and

ornamental pieces are produced. The groups and figures, both after the antique and original designs by celebrated modellers, are of a high degree of excellence. Notably among these is a very charming pair, 'Night' and 'Morning', by Carrier. Busts, too, are produced very extensively, and of various sizes, both copied from classical models and of modern celebrities. In centrepieces, compotiers, etc., Messrs. Poole, Stanway & Wood are particularly successful. A set of four, with juvenile figures representing the Seasons, are peculiarly graceful and elegant, the openwork dishes of these and others being of admirable design and faultless finish; as is also another in which the stem is surrounded by three cleverly modelled cupids. The tinting of these is pleasing and artistic; the creamy richness of the body, of course unglazed, giving a peculiar softness to the flesh, while the drapery and accessories, being delicately coloured and glazed, impart a finish to the designs that is very charming . . .

At the commencement of 1878, J. Poole retired to set up on his own account and Stanway continued as 'Stanway & Son' for a further year. A further change came about in 1880, when Messrs. Turner & Wood took over and continued until 1888 (see page 110).

As related earlier, Joseph Poole retired from the firm of Poole, Stanway & Wood in 1878. He and his son then took the John Street Works at Stoke, where they produced Parian, terra-cotta and earthenware until about 1886.

Robinson, G. A.
(Working period c. 1870–86)

Jewitt noted in *Ceramic Art of Great Britain* that the Church Street Longton Works 'for the production of Parian, jasper, and majolica ware, belonging to Mr. G. A. Robinson, were pulled down in 1876 for town improvements, Mr. Robinson erecting new works in Sutherland Road'. Little is known about this manufacturer of Parian apart from the fact that he continued at Sutherland Road until 1886.

Robinson & Leadbeater
(Working period 1865–1924)

Few if any firms rivalled the quantity of Parian produced by Robinson & Leadbeater at their two factories at Stoke—one in Glebe Street, the other in Wharf Street—for they confined their attention to Parian goods. We cannot do better than quote from Llewellynn Jewitt's contemporary review as published in the 1878 edition of *Ceramic Art of Great Britain*:

These two manufactories belong to Messrs. Robinson and Leadbeater, and are entirely confined to the production of Parian goods, of which they are amongst the largest and most extensive producers, both for the home market and for exportation.

The Glebe Street Works were commenced in 1850, by a clever Italian figure-modeller named Giovanni Meli (see page 56), who produced clever groups and single figures, till 1865, when he sold the entire business, with its plant, moulds, and machinery, to Messrs. Robinson and Leadbeater . . .

The Wharf Street Works were commenced in 1858 by Mr. Leveson Hill, after whose death, which occurred shortly afterwards, they were carried on by his executors until 1870, when they were sold to Messrs. Robinson and Leadbeater, who thus became proprietors of both concerns. By them the works have been considerably enlarged, and as their business operations are rapidly extending, they bid fair to rank among the largest in the district.

The operations of the firm are entirely confined to Parian, and in this they produce statuary groups and figures in large variety; statuettes and busts, both classical, portrait, and imaginative; vases of endless form, variety, and size; centre-pieces and comports of elegant design; flower-stands; brackets and pedestals; bouquet-holders; trinket-caskets; cream-ewers; jugs, and a considerable variety of fancy articles.

By giving their constant and undivided attention to this one branch of ceramic art—Parian, Messrs. Robinson and Leadbeater have succeeded in so improving it both in fineness and purity of body and tone of colour, as to render their productions of far higher than average merit. They have studied excellence of body, originality of design, and cleverness of workmanship, as before that of marketable cheapness . . .

Among the designs produced by this firm are many of more than average merit, and they are issued, in some instances, of large size—'Clytie', a clever reproduction, is a bust about twenty-two inches in height, whilst several others—Gladstone, Disraeli, Cobden, Tennyson, Dickens, and other celebrities, are of various heights. Among their principal groups are 'Innocence Protected', 'Penelope', 'The Power of Love', 'Cupid Betrayed', 'Cupid Captive', 'Golden Age', 'Rock of Ages', 'Guardian Angel', 'The Immaculate Conception', 'Christ and St. John' and 'Virgin and Child', and in single figures are many well designed and faultlessly produced . . . The centre-pieces, comports, and flower-holders, are characterized by the same good taste in design and the same excellence in finish; their variety is great and many of them have a freshness and originality in conception that is very encouraging.

Messrs. Robinson and Leadbeater are very successful in their original portrait busts, many of which they have produced, both for private purposes and for sale. Among the latter, the busts of Abraham Lincoln, Charles Sumner, and Governor Andrew, have had a very extensive sale in the United States, to which market, indeed, the greater part of their general statuary and other goods is sent. An excellent portrait statuette of Queen Victoria may be reckoned among their successful productions. In addition to States and the home markets, the firm export largely to Canada, the Colonies, and Germany. They use no mark.

This firm produced literally hundreds of models, and we can add several names to Jewitt's list of bust portraits: Beethoven; Chopin; General Booth; Goethe; John Bright; Lord Byron; Lord Nelson; Mary, Queen of Scots; Mendelssohn; Nicholas of Russia; Queen Victoria (in several versions); Robert Burns; Tennyson; Washington; and Wesley. Some of the Robinson & Leadbeater Parian products of the 1890s, as evidenced by a *Pottery Gazette* advertisement of 1896, are shown in plate 89.

Some readers may be surprised that Jewitt, writing in 1878, stated that this firm did not use a mark, for several reference books give the factory mark as the initials 'R & L' impressed into the ware. This mark most certainly exists and is found on the back of several figures, not under the base. It could well be that it was used after Jewitt wrote his review of the firm's products.

Geoffrey Godden, in his monumental *Encyclopaedia of British Pottery and Porcelain Marks* (Herbert Jenkins, London, 1964), dates this mark as being used from about 1885 onwards.

A Robinson & Leadbeater trade advertisement of the 1880s is reproduced below. Sixteen models from an 1896 advertisement are shown in Plate 89; a superb bust can be seen in Plate 88; and later bust portraits are illustrated in Plates 90 to 94.

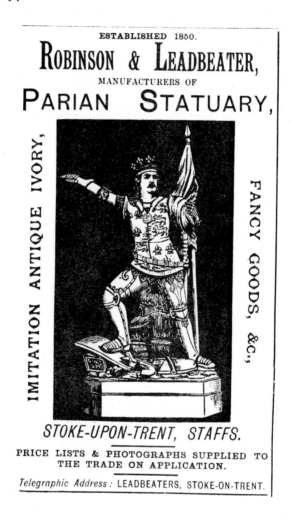

ESTABLISHED 1850.

ROBINSON & LEADBEATER,
MANUFACTURERS OF
PARIAN STATUARY,

IMITATION ANTIQUE IVORY,

FANCY GOODS, &c.,

STOKE-UPON-TRENT, STAFFS.

PRICE LISTS & PHOTOGRAPHS SUPPLIED TO
THE TRADE ON APPLICATION.

Telegraphic Address: LEADBEATERS, STOKE-ON-TRENT.

Roe, Henry, & Son
(Working period c. 1860–4)

Henry Roe and his son of the same name were both born in Derby. In the early 1860s, they produced unmarked Parian goods at their works at Bow Street, Hanley.

Rose, John, & Co.

(Working period c. 1796 to the present day, in the twentieth century trading under the style 'Coalport China Ltd.')

John Rose & Co. of Coalport produced a small quantity of Parian from the 1840s into the 1850s. The marked bust (missing its plinth) shown in Plate 95 is an early example; and the cat-and-monkey-faced figure-group shown in Plate 176 of Geoffrey Godden's standard work *The Illustrated Guide to Coalport and Coalbrookdale Porcelains* (Herbert Jenkins, London, 1970) is an unmarked early example identified with the help of a design in the traveller's design-order book.

John Rose's Coalport Parian in the 1851 exhibition included:

Clock-case, gilt with figures of Time and Cupid.
Elevated flower vase, supported by dolphins.
Pair of wrestling figures.
Group of figures, *The Pleiades adorning Night.*
Basket, supported by three female figures.
Ornamental ewers.
Group of figures: Puck and companions.

Other Coalport Parian includes:

Sir Calepine rescuing Serena

Bacchus and Ariadne

Cornish Wife at the Well of St. Kegne

Two Circassians

The Faerie Queen. A group exhibited at the Dublin Exhibition in 1855 but introduced in 1854.

The Duke of Wellington, after Weigall. Produced after the death of the Duke.

The Duke of Wellington, after Abbot. The Duke is wearing a frock-coat and is seated, with his legs stretched out in front. A particularly fine, and rare, figure.

Her Majesty the Queen. Bust.

H.R.H. The Prince Consort. Bust.

H.R.H. The Prince of Wales A pair of busts issued to celebrate their
and wedding in 1863.
H.R.H. Princess Alexandra.

A superb Parian figure with a glazed, coloured and gilt base is shown in Plate 96.

The John Rose & Co. pieces normally bear this name incised or incorporated in printed marks. The name 'Coalbrookdale' was also used.

'Royal Worcester'
(Working period 1862 to the present day)

The Worcester Royal Porcelain Company—to use the correct title—succeeded Kerr & Binns at Worcester in 1862. The new firm was founded on good stock and, from the first, very fine quality goods were produced. The Parian range, however, is quite small, for the management was mainly concerned with finely decorated porcelain. Nevertheless, some good Parian figures and busts were produced, as well as a selection of useful ware in this material. Some models which are best-known in a glazed and decorated state can occasionally be found in the matt-white Parian body.

Royal Worcester Parian ware is normally marked with the factory trade mark, impressed into the body (being undecorated, the Parian figures do not normally bear the printed mark). The impressed mark is reproduced below. The model number was also impressed or incised and, often, the potting date letters occur in accordance with the following key, which is reproduced from Geoffrey Godden's *Encyclopaedia of British Pottery and Porcelain Marks* (Herbert Jenkins, London, 1964). Sometimes, the month number and last two numerals of the year were incised—for example, 4/77 for April 1877.

Year marks impressed.

1867	A	1879	P
1868	B	1880	R
1869	C	1881	S
1870	D	1882	T
1871	E	1883	U
1872	G	1884	V
1873	H	1885	W
1874	I	1886	X
1875	K	1887	Y
1876	L	1888	Z
1877	M	1889	O
1878	N	1890	a

Sale, William
(Working period c. 1865-6)

Little is known of this potter, but Parian figures have been recorded with the impressed mark 'W. SALE'. William Sale is listed at Bryan Street, Hanley, in Keates & Ford's Annual Newcastle & Potteries Directory of 1865-6; in that of 1867, John Sale is listed at this address.

Salt, Charles
(Working period c. 1853–64)

Several potters named Charles Salt made earthenware figures at Burslem and Hanley over a long period in the first part of the nineteenth century. Charles Salt of Trinity Street, Hanley, was certainly a manufacturer of Parian goods c. 1853–64.

South Wales Pottery
(Working period c. 1839–1927)

This pottery at Llanelly, South Wales, was managed by several partnerships at different times. A range of earthenware was produced, as well as some Parian ware. One of the special lines was Lithophanes, or 'Berlin Transparencies'—relief moulded panels which spring to life when viewed against a light. Geoffrey Godden, in his *Antique China and Glass under £5* (Arthur Barker, London 1966), gives a very good account of these objects.

The Cambrian Journal, Vol. I, 1854, describes the South Wales Pottery and its products and notes: '. . . transparent tableaus of imitation Parian, are beautifully executed and perfected at trifling cost'. Lithophanes were also made by Minton and at Worcester, but most are of Continental origin.

The Llanelly ware might bear name or initial marks such as 'LLANELLY', 'SOUTH WALES POTTERY', 'CHAMBERS', 'W. CHAMBERS' or 'S.W.P.'

Stanway, Horne & Adams
(Working period c. 1865–79)

This partnership succeeded that of Stanway & Horne (1862–4) in Joiner's Square, Hanley, although Llewellynn Jewitt states that the full partnership built the Trent Pottery in 1859. Jewitt was, however, writing of contemporary products when he noted in 1878:

> They were established for the production of ornamental goods in Parian . . . the great speciality is their cheap ornamental Parian, in which jugs of various kinds, vases, figures, groups, busts, and a large number of other articles are made, no less than 460,000 pieces of these alone being made and disposed of during one year. Notably among the designs for jugs and cream ewers are the Indian corn, pineapple, shell and dolphin patterns. Of late years, classical statuettes, groups, busts, etc., in Parian, have been made a prominent feature of the works. The aim of the 'Trent Works' has been the production of good average designs in Parian at a cheap rate, so as to place them within reach of all . . . No mark is used.

The above review could equally apply to several other Staffordshire firms who did not employ any mark for their inexpensive Parian goods. One

gathers the impression that this one, representative firm gained such a good notice in Jewitt's *Ceramic Art of Great Britain* because one of the partners troubled to supply Jewitt with detailed information about its products while other firms neglected to be so co-operative.

This pottery was continued by Edwards & Son from 1887 to 1900. The firm also produced 'Parian and Majolica fancy goods', to quote from its advertisements.

Stanway & Son (See Poole, Stanway & Wood)

Steele, Edward
(Working period 1875–1900)

Edward Steele occupied the Cannon Street Works, at Hanley, for twenty-five years from 1875. Little is known about his products, for they were unmarked, but Jewitt gives a good contemporary account of them in the 1878 edition of *Ceramic Art of Great Britain*:

> . . . Parian statuary is one of the specialities of the firm and is very extensively made; some hundreds of different single figures, groups, busts, and animals, besides numbers of ornamental articles, being issued. The quality is superior to many for the American markets, and the modelling of the figures is artistic and clear. Many of them are of large size, and are produced with remarkable skill. Mr. Steele uses no mark.

Stubbs, William
(Working period c. 1862–97)

William Stubbs, of the Eastwood Pottery at Hanley, was one of the leading makers of unmarked Staffordshire earthenware figures; but he also made utilitarian ware and some coloured Parian goods, particularly in the 1860s. These goods, like his other products, were unmarked.

Summerly's Art Manufactures
(c. 1847–50)

Henry Cole's Summerly's Art Manufactures have already been touched on (page 13), and Geoffrey Godden gives good coverage to this scheme in his *Victorian Porcelain* (Herbert Jenkins, London, 1961). In brief, Henry Cole— using the pseudonym Felix Summerly—won a Society of Arts prize in 1846 for a simply designed tea service. Encouraged by this success, he engaged leading artists and designers to design tasteful articles for everyday use which could be mass-produced by the leading manufacturers. The scheme was

basically a good one, although the artists had little idea of the requirements of the manufacturers.

In 1847, the *Art Journal* reported:

> We rejoice that Felix Summerly has succeeded in inducing such men as Mulready, Maclise, Redgrave, Horsley, Townsend, Bell and others to aid in a project pregnant with immensely beneficial results to British Manufactured Art . . . We understand that arrangements are making to carry out this project upon a very extensive scale . . . we understand her Majesty was pleased to become the purchaser of all the more important works in the series.

It must be understood that Summerly's Art Manufactures caused to be made articles in glass, earthenware, metal, wood and papier-mâché as well as in Parian. Concerning Parian, an early edition of the catalogue mentions:

The Cupid inkstand, in porcelain (the Cupid is in unglazed Parian), designed and modelled by John Bell, price £2. 2. and upwards.

The Infant Neptune: designed and modelled by H. J. Townsend, 27/– in Parian.
(This design was registered on 14th May 1847 and is model number 187 in the Minton records; see page 91.)

'Dorothea', a statuette in Parian, modelled by John Bell, price £2. 2. 0.
(This design was registered on 4th October 1847 and is model number 189 in the Minton records; see Plate 86 and page 91).

'The Lord's Prayer', designed and modelled by John Bell in Parian, £1. 4. 0., or £1. 10. 0., with coloured and gilt bases.

'The Belief', the companion to the above, also by John Bell and issued at the same price.
(These models were registered on 10th December 1847 and are model numbers 198 and 199 in the Minton records.)

'Clorinda', wounded by her Lover, designed and modelled by John Bell as a companion to Dorothea. Retail price £2. 2. 0.
(This is model number 203 in the Minton records; see Plate 64.)

A mustard-pot, in porcelain and Parian modelled by John Bell, 9/–.

'Una and the Lion', a statuette, a companion to Danecker's 'Ariadne'; designed and modelled by John Bell.
(This is model number 184 in the Minton records. The design was registered on 19th August 1847. An example is shown in Plate 65.)

A bust of the Duke of Wellington, modelled by S. Joseph.
(This is model number 190 in the Minton records).

These Summerly works received a very mixed reception. The editor of the *Art Union* turned against Henry Cole and the conditions he placed upon the manufacturers who were producing the finished article. The magazine reported in 1848:

> In hardly one instance have they remunerated the manufacturer; in fact, the only selling object in the entire collection is the statuette of Mr. Bell's 'Dorothea'.

This and all other Summerly Parian was produced by Minton's, who certainly had little cause for complaint and could scarcely keep up with the initial demand. In a letter dated 28th December 1847, the firm wrote to a London retailer:

> We make the figure 'Dorothea' and will send you a copy as soon as possible but the demand is so great that we cannot possibly supply them so expeditiously as we could wish.

The wholesale price from Minton was 28/–, and the listed retail price was £2. 2. 0.; so the retailers had a high margin of profit—fourteen shillings, or fifty per cent of the cost.

Although these figures and other Summerly objects were sold under their name, the "Art Manufacturers" had little to do with the actual sales apart from the initial publicity. The finished objects were sold by the leading London retailers or were available direct from the manufacturers. One assumes that Henry Cole merely took a royalty on each copy sold. In any event, the scheme failed after about three years and Cole concentrated his interests on the preparation for the 1851 exhibition.

The Minton ware made for Summerly's Art Manufactures bears a special raised pad-like mark such as the example reproduced below. This particular mark incorporates the name of the modeller, John Bell, The monogram above relates to Felix Summerly, and the arrow-like device is the standard mark found on Minton Parian figures of this period. Summerly-marked models are shown in Plates 64, 65 and 86.

Sutherland, Daniel, & Sons
(Working period c. 1863–78)

The first edition of Jewitt's *Ceramic Art of Great Britain*, 1878, recorded the following facts about this Longton firm and its Park Hall Street Works:

> Messrs. Daniel Sutherland & Sons entered on these works in 1863, and they are now carried on by the sons under the same style. The

productions are majolica and Parian of various qualities . . . In Parian, the firm produce groups, figures, busts, etc., in considerably variety, as well as all the usual lesser articles, jugs, brooches, crosses, and trinkets . . . The mark of the firm was formerly S & S but none is now used.

An 'S & S' marked Parian flower holder is shown in Plate 97. Such marked pieces were probably produced between 1863 and about 1875. As Jewitt noted in 1878, no mark was subsequently employed. It is amusing to note that an 1864 directory lists Daniel Sutherland not only as a manufacturer of Parian and terra-cotta but also as proprietor of the Temperance Hotel in Longton.

Till, Emma
(Working period c. 1865)

Emma Till, a manufacturer of Parian figures at Salem Street, Etruria, is listed in Keates & Ford's Annual Newcastle & Potteries Directory of 1865–6; but the name does not occur in other contemporary records.

Timmis, Henry
(Working period c. 1850–4)

Henry Timmis, of the Market Place, Burslem, produced some delightful floral brooches, earrings and the like in the Parian body. Many were modelled on the fuchsia.

Timmis, John
(Working period 1860s)

John Timmis was born in Derby in about 1820. In the early 1860s, he was making Parian statuary at Shelton in the Staffordshire Potteries. His work is as yet unidentified and his products were probably unmarked.

Turner, Hassall & Bromley
(Working period c. 1859–63)

In 1859, George Turner, Joseph Hassall and William Bromley established their Albert Works in Liverpool Road, Stoke, where the general run of Parian goods was produced until 1863. The partnership appears to have varied its trading name from time to time, for during the period of the 1862 exhibition the names Bromley Turner & Co. and Turner, Bromley & Hassall were used.

In 1863, a new and larger factory was built and was known as the Copeland

Street Works. At this time, too, the trading style was changed to Turner, Hassall & Peake—Thomas Peake replacing William Bromley, who had died in 1862. These partners continued until 1871, when a further change of partnership took place, resulting in the firm of Turner, Hassall & Poole. The impressed initials 'T.H. & P' fit both these partnerships. Two years later, in 1873, Hassall retired and was succeeded by Stanway, leading to the formation of Turner, Poole & Stanway. In about 1875, George Turner retired and Josiah Wood entered into partnership; thus the firm of Poole, Stanway & Wood was formed (see page 99).

Jewitt records the fact that George Turner introduced a novel treatment for some of this firm's Parian—'of decorating the Parian body with majolica colours. By this means a greater clearness and brilliancy as well as softness of colour is attained, crazing is avoided, and a more pleasing effect and finish gained.' These majolica colours were really tinted semi-translucent glazes.

Turner, Hassall & Peake (See Turner, Hassall & Bromley)

Turner, Hassall & Poole (See Turner, Hassall & Bromley)

Turner & Wood
(Working period c. 1880–8)

Turner & Wood succeeded Stanway & Son (formerly Poole, Stanway & Wood, see page 99) at the Copeland Street Works, Stoke. They were among the leading manufacturers of the less expensive types of Parian figures and groups.

In the later part of 1881, this firm was able to advertise that it had recently brought out:

> A pair of figures, supported by cupids, representing Night and Morning Morning is supposed to be rising upwards through the air and throwing off the veil of darkness; Night is sinking to repose, drawing the veil around her, with the cupid closing its eyes in slumber.

> Bacchus, the god of wine, is another recent introduction. It stands thirty-eight inches high and is one of the largest figures made by this house.

> 'The Combat', the subject, which to our mind is the most finished piece in the Parian department, is really a masterpiece, and represents two warriors, in complete armour, engaged in what may be seen to be mortal strife . . .

> Another beautiful piece of something of the same class is the mounted Indian warrior, attacked by a panther . . .

Two excellent full-length female figures represent 'Labour of Love',
the first represents the going forth in the morning, and the second the
return in the evening.

Among the single statues shewn in full length, poets, painters, statesmen,
soldiers and engineers, are well represented. There are also various

subjects representing Art, Science, poetry, literature, navigation, etc. . . .
In animals we have some well modelled varieties, among others the
'Gamekeepers Pets', 'Pointer & Setter'. In the scriptural department
two large full length figures of Ruth and of Rebecca are very beautiful.
In the mythological class there is a large figure, at full length, nude, of
Bacchus . . . another of the same kind is Cupid and Psyche and is
thirty inches high and twenty-four inches in breadth. There are a vast
number of other subjects in every department . . .

These Parian goods were only part of the Turner & Wood output. The
trade advertisement of 1884 reproduced on p. 111 will give some idea of the
range of products of this firm, which must have been a keen rival to the better-
known partnership of Robinson & Leadbeater. The portrait bust of Queen
Victoria (Plate 98), impressed marked 'TURNER & WOOD', is a good
example of its products.

Turton & Gregg
(Working period c. 1851–4)

Turton & Gregg produced Parian figures at Miles Bank, Hanley, during the
1851–4 period. Reginald G. Haggar, in his excellent book *Staffordshire
Chimney Ornaments* (Phoenix House Ltd., 1955), has recorded the mark
'TURTON & GREGG'.

Wardle, James, & Co.
(Working period c. 1864–84)

James Wardle was born at Burslem in about 1823. From c. 1864 to 1870, he
traded under his own name at William Street, Hanley; and from 1871 to
1884, he traded as James Wardle & Co. But earlier, between 1859 and 1863,
he was in partnership with George Ash, as Wardle & Ash. Earthenware, as
well as Parian, was produced.

Wedgwood
(Working period 18th century to the present day)

Wedgwood are mainly known for their tasteful earthenwares, black basalt,
and coloured Jasper wares; but in the middle of the nineteenth century, they
did produce some fine Parian groups and portrait busts. These are now
rarely found. Many busts originally produced in black basalt were also
reissued in the matt-white body which Wedgwood termed 'Carrara' (see
page 5).
 The Wedgwood 'Carrara' or Parian ware bore the standard factory mark—
—the impressed mark 'WEDGWOOD'.

Venus and Cupid, 27 inches high.
Cupid, 24 inches high.
Infant Hercules, 20 inches by 17 inches.
Morpheus, 24 inches long.
Venus, 19 inches high.
Venus, bust (Plate 100).
Mercury, 17 inches high.
The Preacher on The Mount.
Crouching Venus.
Nymph at the Fountain.
Cupid and Psyche.
Cupid with bow.

The above twelve subjects were included in the 1851 exhibition.

Shakespeare, bust on pedestal.
Sleeping Boys.
Ariadne Reclining (introduced in 1849, Plate 101).
The Three Graces, 14½ inches high. (Plate 102).
Joseph before Pharaoh, 19½ inches high, after W. Beattie (Plate 99).
Triton.
Diana (introduced in 1849).
Infant Bacchus.
Charity, by Carrier Belleuse.
Stevenson, bust. Reduced from the work of E. W. Wyon, and said to be 'the best likeness of the great engineer'.
Washington, bust.

Worcester (See 'Royal Worcester')

Wilkinson & Rickhuss
(Working period c. 1856–62)

Wilkinson & Rickhuss established the Kensington Works at Hanley in about 1856. They produced both glazed porcelain and Parian and exhibited at the 1862 Exhibition, the official catalogue of which gives the names Willkinson, Rickhuss & Badock. J. B. Waring noted, in his *Masterpieces of Industrial Art and Sculpture at the International Exhibition, 1862*, that:

In Parian Messrs. Wilkinson & Rickhuss obtained honourable mention, which they fully merited, if only for their colossal Parian vase ornamented with foliage, passion-flowers, etc.

After several changes of ownership, the Kensington Works passed to John Bevington in 1872. He also made Parian goods (see page 64).

I

Wilson, James
(Working period c. 1879–97)

In the second edition of Jewitt's *Ceramic Art of Great Britain*, 1883, this Victorian author noted:

> Mr. Wilson having erected new works off Heathcote Road, has recently transferred to them his Parian works, formerly in High Street, and has added the manufacture of china to his other business.

In the 1880s, James Wilson advertised himself as 'Manufacturer of Statuary, Pearl and all kinds of cheap Parian'. In 1881, the address was the Etruscan Works, High Street, Longton. James Wilson continued until 1897, but his products appear to have been unmarked.

Worthington & Harrop
(Working period c. 1852–73)

This partnership succeeded Edward Raby (1843–52) at the Dresden Works, Hanley, in 1852. John Worthington and his son-in-law William Harrop were in command from 1852 to 1864; then Harrop continued with Thomas Worthington until 1873, after which Harrop continued alone. Parian ware of average quality was produced, but examples were apparently not marked—although some of their earthenware bears marks incorporating the initials 'W & H'.

The works were of average size, employing thirty work-people in the 1860s.

'W. & R.'

Some writers have attributed the initials 'W & R' (often over the initial 'L') to Wayte & Ridge of Longton in the Staffordshire Potteries; but as Geoffrey Godden points out in his *Encyclopaedia of British Pottery and Porcelain Marks*, the Patent Office records show that models bearing these initials were registered by the London retailers Wittman & Roth, who had their initials added to ware made for them. The ware is normally of Continental manufacture.

Yearsley, George, & Co.
(Working period c. 1860–75 and continued by Mrs. Mary Ann Yearsley until 1890)

George Yearsley was born at Hanley in about 1823. His works were in Market Lane, Longton, where he made Parian figures of an inexpensive

nature. The firm was listed in Keate's Directory of 1875, and as George Yearsley & Co. The works continued until about 1890.

Yearsley Parian ware was apparently not marked; but the example shown in Plate 103 can be identified as it bears the diamond-shaped registration mark granted on 2nd February 1869 to George Yearsley of Market Lane, Longton. This documentary example has thick spots of glaze applied to the fringes of the garment to look like lace or embroidery. The figure shows traces of unfired pigment and gilding in crevices, but it is not known if this decoration was applied at the factory.

Registration Marks

From 1842, it became possible to register designs at H.M. Patent Office. Parian came under Class IV, with other types of earthenware and porcelain. The following tables relate to the two marks in use between 1842 and 1883. Registration gave the manufacturer protection for three years from the date his application was made. After 1883, an entirely different system of numbering the designs was adopted.

While this system of registration is of great assistance in discovering the earliest possible date of manufacture for a vast mass of Victorian manufactured ware, in general very few Parian pieces were so registered. Apart from the Minton figures produced for the Summerly's Art Manufactures (see page 13), most of the registration of Parian designs was confined to useful ware such as jugs, butter dishes and the like. Some of these registered designs are shown in Plates 11, 13, 20, 27, 28, 60, 65, 69, 77, 85, 86, 87 and 103.

TABLE OF REGISTRATION MARKS 1843–83

Above are the two patterns of Design Registration Marks that were in current use between the years 1842 and 1883. Keys to 'year' and 'month' code-letters are given below.

The left-hand diamond was used during the years 1842 to 1867. A change was made in 1868, when the right-hand diamond was adopted.

INDEX TO YEAR AND MONTH LETTERS

YEARS

1842–67		1868–83	
Year Letter at Top		*Year Letter at Right*	
A = 1845	N = 1864	A = 1871	L = 1882
B = 1858	O = 1862	C = 1870	P = 1877
C = 1844	P = 1851	D = 1878	S = 1875
D = 1852	Q = 1866	E = 1881	U = 1874
E = 1855	R = 1861	F = 1873	V = 1876
F = 1847	S = 1849	H = 1869	W = (1–6 March)
G = 1863	T = 1867	I = 1872	1878
H = 1843	U = 1848	J = 1880	X = 1868
I = 1846	V = 1850	K = 1883	Y = 1879
J = 1854	W = 1865		
K = 1857	X = 1842		
L = 1856	Y = 1853		
M = 1859	Z = 1860		

MONTHS (BOTH PERIODS)

A = December	G = February	M = June
B = October	H = April	R = August (and
C or O = January	I = July	1–19 September
D = September	K = November (and	1857)
E = May	December 1860)	W = March

Registration Numbers

After the diamond-shaped registration mark ceased to be used, in December 1883, registered designs were numbered consecutively from 1. But these numbers seldom appear on Parian wares for few new designs were introduced or registered after 1884. The following table, however, shows the first and last number used in each year between 1884 and 1900. On objects, these numbers are normally prefixed with the abreviations 'Rd No' for Registered Number.

January 1884	Reg. No. 1 to	19753
„ 1885	19754 to	40479
„ 1886	40480 to	64519
„ 1887	64520 to	90482
„ 1888	90483 to	116647
„ 1889	116648 to	141272
„ 1890	141273 to	163766
„ 1891	163767 to	185712
„ 1892	185713 to	205239
„ 1893	205240 to	224719
„ 1894	224720 to	246974
„ 1895	246975 to	268391
„ 1896	268392 to	291240
„ 1897	291241 to	311657
„ 1898	311658 to	331706
„ 1899	331707 to	351201
„ 1900	351202 to	368153

Named but Unmarked Figures and Busts

There are a number of named Parian figures which carry no maker's marks, and identification is not always possible. Plinths (or socles) will sometimes yield a clue as they were inclined to be individual to each firm. Some named figures and busts of unknown make are:

America
Romeo and Juliet
Comedy
Richard Coeur-de-lion
Tragedy
Lord Nelson
The Good Shepherd

St. David
Aphrodite
Maidenhood
Empress Eugenie
Female Figure of War
Girl with Pitcher.

Several of these unmarked Parian figures are shown in Plates 104 to 117. From a decorative point of view, they are quite equal to the marked examples; but the serious collector will naturally prefer his Parian to bear the mark of one of the well-known manufacturers.

It would be superfluous to enter into an analysis of the merits of Mr. Gibson's beautiful statue;—they are of the highest order, and the work is well known. This reduced copy is admirably executed, and will, we are sure, be highly valued by those who have been fortunate enough to obtain a copy.*

We insert the annexed group, Paul and Virginia, by Cumberworth—the original group was exhibited at Paris—to show that this material is capable

of expressing the emotions, and even delicate shades of feeling. In a preceding part of this article we have noticed the hazards to which these productions are exposed from the shrinking in the mould, and the subsequent firing.

* We claim for ourselves the merit of having introduced this project to the Art-Union of London; in consequence of our suggestion, the subject was considered by the committee, specimens were submitted to them, and the order was given. We have been equally successful in reference to the Royal Irish Art-Union, who are now arranging for the reduction of one of their prize-statues.

We have a brief story to tell of this group that may interest our readers. Mr. Cumberworth is the son of an English officer by a French lady: he was born in America, but has resided in Paris almost since his birth. He was a pupil of the sculptor Pradier. In 1842 or 1843 he obtained in Paris the prize which entitled him to be sent to Rome by the Academy: but on the eve of his departure, it was ascertained that he was not a Frenchman, and he was deprived of the honour by a very stringent rule. The rule, stringent as it was, however, found its parallel in our Royal Academy. Mr. Cumberworth was extremely anxious to have it placed in our exhibition — supposing that if he was not a Frenchman he was an Englishman. We took charge of his group, and conveyed it from Paris to London, but on our arrival, we found we were two days after the last day for receiving works; the group of Mr. Cumberworth was consequently refused admittance at the door. We immediately stated all the particulars through the keeper to the council—but in vain. The laws of the Royal Academy were like those of the Medes and Persians; and the young artist's work is known to the British public only by the copy of it produced in statuary porcelain.

The next of these articles to which we shall direct attention is a very charming figure (at the top of the third column) and equally distinguished by its simplicity and its grace. There is a natural ease combined with great elegance in the attitude, and a marked display of anatomical knowledge in the treatment of the muscles. As we believe the cheap multiplication of works of art to be a matter of vast importance to the intellectual advancement of the nation, we take a very sincere interest in the progress of these productions. We cannot, of course, assert that the material is quite equal to marble or ivory, but we do assert that it very closely approximates to them in its powers, and is far superior to any of the varieties of composites that have hitherto been used in casting.

But here, probably to the gratification of the reader, and certainly to that of ourselves, criticism must be suspended to make room for the free expression of unmixed and merited admiration. The figures which follow (on the third column),

whether we regard the sub-lustrous material, the classical purity of the design, or the exquisite finish of the execution, are among the most gratifying evidences of artistic progress which have appeared in the present century. They are beautiful in themselves, and still richer in progress.

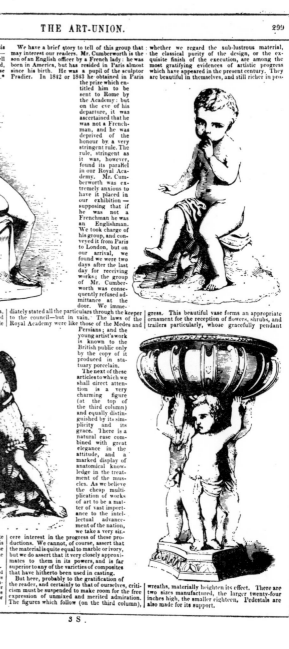

This beautiful vase forms an appropriate ornament for the reception of flowers, shrubs, and trailers particularly, whose gracefully pendant wreaths, materially heighten its effect. There are two sizes manufactured, the larger twenty-four inches high, the smaller eighteen. Pedestals are also made for its support.

Bibliography

The serious collector of Parian has several contemporary first-hand sources of information available. Of these, the most rewarding are the last four issues of *The Art-Union* magazine. This interesting journal was published by How & Parsons of 132 Fleet Street, London, from 1839 to 1848. Bound sets are available in many reference libraries, but copies seldom appear on the open market. From 1845 to 1848, several important and interesting references to the newly introduced Parian body will be found, including the names of early models and their manufacturers. The page reproduced opposite is a good example of the material to be found in *The Art-Union* magazine.

From 1849, the above-mentioned magazine was continued under the new title *The Art Journal* (published by Virtue & Co., London). Like its predecessor, it is a rich source of material for those who care to search the hundreds of closely-printed pages.

Related to these Victorian journals are the catalogues of the various exhibitions which followed the highly successful 1851 Great Exhibition. Several of these exhibition catalogues were published by *The Art Journal* as special volumes or as extra sections to the regular monthly editions. Again, these catalogues—at least, those of the more important exhibitions—are available in many reference libraries.

Other Victorian magazines, such as the *Illustrated London News*, occasionally included references and engravings of new Parian figures or groups. Such engravings can be valuable in dating the period of introduction of a given model. An example from the *Illustrated London News* of 14th October 1848, is reproduced on the following page. References to Parian are, however, quite rare.

From our point of view, by far the most valuable reference book is Llewellynn Jewitt's *Ceramic Art of Great Britain* (Virtue & Co., London).[1] The first edition was published in 1878, with a revised edition published in 1883. This book can really be considered a source of contemporary information rather than an exposition of the author's unsupported views, for regarding Parian and its makers, Jewitt was largely reporting first-hand on the current ware. In many instances, he seems to have visited the factories or at least been supplied direct with current lists, catalogues and publicity material.

After the publication of Jewitt's standard work on British ceramics, very many reference books were published; but in the main, these catered for the collector of eighteenth century ware and there is little or no useful new information on Parian. The rare exceptions include G. Bernard Hughes' *English Pottery and Porcelain Figures* (Lutterworth Press, London, 1964) and Geoffrey A. Godden's *Victorian Porcelain* (Herbert Jenkins, London, 1961). The latter is particularly helpful for,

[1] A new edition of this work edited with corrections and new material by G. A. Godden is to be published shortly by Barrie & Jenkins.

STATUETTE OF THE PRINCE OF WALES.

This beautiful Portrait of the young Sailor Prince has been modelled, by permission of his Royal Highness Prince Albert, from the picture painted by Win-

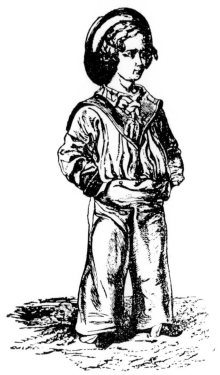

STATUETTE OF H. R. H. THE PRINCE OF WALES, AFTER WINTERHALTER.

terhalter, of which a print has been published by Alderman Moon. The statuette is from the establishment of Messrs. Minton and Co., of Stoke-upon-Trent. The material is Parian. The likeness is very striking, and the characteristic accessories of the nautical costume very nicely executed.

This is certainly one of the most interesting presentments of the youthful Royal Family yet published. It may be seen at Mr. Cundall's, 12, Old Bond street.

as always, Mr. Godden gives the sources of his material and provides contemporary quotations, so that the enquiring collector can delve deeper, if he so wishes, or even double-check the basic facts.

Mention of Mr. Godden's *Victorian Porcelain* leads naturally to his standard book on marks. His *Encyclopaedia of British Pottery and Porcelain Marks* (Herbert Jenkins, London, 1964) contains thousands of British marks and initials, and it is a most valuable aid to dating the working periods of the very many Staffordshire firms which produced Parian. In this respect, we must acknowledge the help which Mr. Godden has given in compiling the dated entries given in Chapter VIII.

Books giving further information on the ware of a particular factory are noted in the section relating to that factory in the alphabetically arranged list in Chapter VIII.

INDEX

Index